PRAISE FOR 'SACRED MAGIC OF 1

David Goddard's *Sacred Magic of the Angels* is a guide to a profound form of theurgic intercession. If you follow the instructions given, you will find yourself drawn into a living, transformative communion with the angelic world. The practices in this book will continue to unfold to new, radiant levels for a lifetime and beyond.

John Plummer, author of *Living Mysteries*

We are extremely fortunate that David Goddard has offered us this ancient angelic tradition in written form. At a time when the West needs to reconnect with the Sacred for its own healing, this book is required reading... intimate, wise, and very practical.

Simon Buxton, *The Sacred Trust*

David Goddard is one in a line of teachers entrusted with the arcane lore of Angel Invocation... *Sacred Magic of the Angels* departs radically from the rash of 'encounter' books in its focus on teaching the reader how to work directly with the Angelic Hosts in daily life. It is a hands-on guide... a treatise on positive magic, and quite probably the start of a whole new realm of spiritual avocation.

NAPRA Review

Thank you, David, for sharing this deep and essential magic!

Brooke Medicine Eagle, author of
White Buffalo Woman Comes Singing

I have sold, read and enjoyed each of David Goddard's books. He has a wonderful way of conveying difficult concepts in memorable ways that comes from his many years as practitioner and teacher. There is not another writer today who illumines the Western Mysteries with such deep knowledge or style.

Geraldine Beskin, proprietor of *Atlantis Bookshop*, London, UK

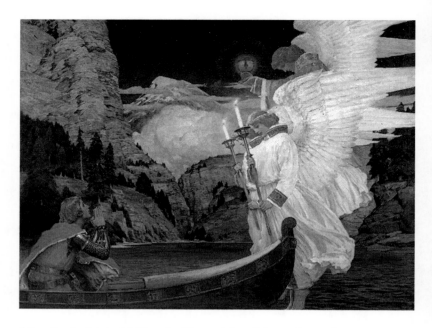

After Frederick Judd Waugh, *The Knight of the Holy Grail*

SACRED MAGIC
OF THE ANGELS

REVISED & EXPANDED EDITION

David Goddard

rising
phoenix
foundation™

www.sacredmagicoftheangels.com

Published by
Rising Phoenix Foundation, Inc.
Flat 3, 224 Nether Street, London N3 1JD, United Kingdom

SACRED MAGIC OF THE ANGELS
Revised and expanded second edition
© 2011 David Goddard & Rising Phoenix Foundation
First edition 1996, Samuel Weiser, Inc., USA
Second edition reprinted 2011

ISBN-10 0983246904
ISBN-13 9780983246909

David Goddard asserts the moral right to be identified as the author of this work.

British Library Catalogue in Publication Data
A catalogue record for this book is available from the British Library.

Designed by Heleen Franken-Gill, ROOT 2 DESIGN, Keswick, UK
Printed by Selby Marketing Associates Inc., Fairport, NY, USA

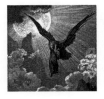

To John of the Eagle,
Opener of the Royal Way,
and for
my mother, Roma, on whom be Peace,
who taught me that Life is a book
written by God

ACKNOWLEDGEMENTS

I give honor to:
Harry Farrow, who taught me to enchant with the Devas,
Bill Shepherd, who taught me the beauty of sacred ceremony,
and Olive Ashcroft, a noble mentor...
 These three now fly with the angels.

And to Marthie van Rooyen, saving me hundreds of hours
 by typing the text,
Jim Pym, for never-failing encouragement,
Tony Willis, for sagacity and help,
John Plummer, bishop and mage,
Al and Susan Olsen-Smith, for constant support and kindness,
Jorge Eagar, brother to the Seraphim,
Richard Davis, Kerub of the temple,
Catharine Christof, priest and philangeli,
The Moon-bright Guru,
Heleen Franken-Gill, my Sister in Light,
and Phillip H. Burmeister, the wind beneath the Phoenix's wings.
 To all of you, I bow in gratitude.

CONTENTS

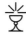 *When this symbol appears in the margins of the text, it refers to someone's personal account, which you can read in* APPENDIX III *under the relevant number.*

CD TRACKS			*page*
1	PRACTICE 1	**The Temple of the Angels**	*43*
2	PRACTICE 2	**Circle of the Moon**	*67*
3	PRACTICE 3	**Litany of Raphael the Archangel**	*85*
4	PRACTICE 4	**Rite of Archangel Sandalphon**	*121*
5	PRACTICE 6	**Daily Angelic Ritual**	*163*
6	PRACTICE 7	**The Fount of Mercy**	*170*
7	PRACTICE 8	**Temple of the Heart**	*178*

LIST OF TABLES AND FIGURES

Gustave Doré, *The Empyrean*
illustration for Dante's *Divine Comedy*

PREFACE

I am just one link in a chain of teachers who have preserved this sacred Angelic Magic down the centuries. This lineage was select and secret until modern times. After being blessed to receive these teachings, I was then entrusted with the task of making them publically available, so that many people could benefit.

I have included some of my experiences and insights from thirty years of practice and teaching. Any spiritual system needs to grow and be re-written if it is to help future generations.

This sacred magic enhances Life and cannot be used to diminish it. It is incorruptible against any evil intentions, and it is simple to use. Magic is a holy force, which exists to help us when we cannot help ourselves. And, when they are correctly called, the angels will help us overcome life's hardships.

Since its previous edition (Samuel Weiser, 1996), this book now has the reputation of being the most effective magical system for bringing results – for health, prosperity, fulfillment, and yes, the miraculous. This sacred magic has brought transformation, wholeness, and joy to thousands of people. And so, also included in this edition, are other peoples' accounts of the wonderful help they have received by invoking the angels in the way taught in the following pages.

Because of this book, there are now *Angelic Gatherings*, annual retreats – in Europe, the USA and Africa – where attendees work intensively with the angels to beautify their lives, and to heal the Earth.

It has also birthed a growing number of 'Angel Sanctums' – groups that assemble each month to perform angelic ceremonies to broadcast peace and grace across the world. And recently it has also initiated the 'Angel Magic Trainers' program, in which I teach apprentices how to train other people.[1] I am delighted that this revised edition is being made available again, so that the beauty and wisdom of the angels may reach even more people.

What the angels bring us is the experiential knowledge that we live in a world where even the blind darkness has Grace hidden within it. Grace that is the source of all magic, of all miracles – Grace that resides within every single soul.

David Goddard
2nd October 2010
Feast of the Holy Guardian Angels

CHAPTER I

IN THE BEGINNING

Angels transcend every religion, every philosophy, every creed.
In fact angels have no religion, as we know it...
their existence precedes every religious system that has ever existed
on Earth.[1]

Before all beginnings The ONE existed. Beyond understanding, transcending comprehension, alone in unutterable bliss, The ONE dwelt from eternity to eternity. Deep within the secret counsels of its being, The ONE desired to create. From an overflowing of its love, The ONE desired to mirror Its bliss, to pour forth the plenitude of Its infinite life, and thus express Itself as a multitude of beings, and so It became The ONE-in-All. And, The ONE continues – in every single second – to create and sustain all that is.

The angels emerged when it was proclaimed: *'Let there be Light',* for they are one with the Light. From the heart of the Eternal ONE sprang forth seven great angels. They are the Elohim, the Seven Spirits before the Throne. The Elohim are the prism refracting the white brilliance of The ONE as the colorful display of Creation. Seven are the Elohim, seven Angels of the Presence, named: Michael, Gabriel, Samael, Raphael, Anael, Sachiel and Cassiel; through them the Divine splendor shines. They are the celestial agents through whom the Will is outpoured into all Creation.

The Light manifested as the various planes of existence: the radiant Spiritual and fabulous Astral planes – with all their subdivisions. Until, through the interaction of the subtle Elements, the physical universe was born. Through these realms of existence the Divine life flowed, outpoured Itself, becoming the superabundance of all creatures and things. Everything was 'dreamed' into being by the glorious Mind of God.

By the will of The ONE, mediated by the Elohim, the angelic hosts came into existence; spirits of pure light, celestial hierarchies to fulfill the innumerable functions required to maintain Creation. Around the white sun of The ONE, the angels ranged – like a corona of countless crystals – reflecting and refracting the Divine glory.

Each angel was created as a deathless entity, a being of pure consciousness, unlimited by time or space. Each single angel is in profound union with The ONE, exulting in perpetual bliss as it bathes in the radiant energy of the Godhead. Because angels reflect the Creator, each angel, in its degree, is a beautiful focus of power, wisdom, and love. An angel transmits the Divine light without distortion as a perfect channel for the Will of the All-Good.

The archangels inhabit the Spiritual plane. Then, the angels were created to function on the Astral plane. To fulfill the Will the angels became as 'cups' into which the Infinite ONE poured Its power, so that through them the universe, and all that was destined to inhabit, might come into actuality. By the agency of the angels all galaxies and solar systems are sustained and maintained. It is the outpouring of The ONE's infinite energy – through the angels – that is the primal substance of the physical universe.

The archangels, being spiritual consciousnesses, receives the 'thought-form' of Creation directly from the Divine Mind. The archangels then transform this down and relay it to the angelic hosts. Like an architect's blueprint that builders follow, the angels receive the Great Plan into their consciousness from the archangelic Spirits of Creation. As agents of the Creator, the angels focus the creative power on to their various charges. The ONE eternally creates, and the archangels and angels, in their degrees, implement the details of the Great Plan. It is as if The ONE were a great Sun, raying out glory everywhere, which the angels draw into themselves to then focus it through themselves and shine it upon their specialized area. The angels are the unseen intelligences in Creation; they are the connection between our material world and the Source of all Being.

However, the angels are not celestial robots who just blindly build, they are artistic craftsmen who beautify what they are given to

manifest and care for. When we gaze at a starry sky, or see a mountain, or take delight in a flower, we are touching the immortal minds of the angels.

The all-pervading energy of The ONE is focused by the angels into templates upon which forms can be built. They define the perimeters of Creation – its height, depth, and breadth. These are the boundaries of the enclosed garden of time and space in which Life will be grown.[2]

As an archetypal idea emerges from the non-dual consciousness of The ONE, it passes to the Spiritual plane where the archangels empower it with cosmic force. Then it is mirrored down into the Astral plane where the angels multiply it into many forms. And finally, these forms become physical – are born, endure and finally pass back into the Astral Light in due season. Everything that exists upon the physical level was first conceived in the Divine Mind, then was given spiritual force (an energy-pattern) that becomes an astral form, and is finally embodied. Creation flows from the inner planes into the physical. Because everything originates in the mind of God, it is eternal in essence – but not in appearance.

The reason why we suffer is because we confuse the results with causes. We confuse the outer garment with That which wears it. We think that the 'unreal' is the Real. But those people who have extended their consciousness – through meditation, astral projection, or ceremonial exaltation – come to the first-hand knowledge that, in essence, we are immortals at play in time and space, we are manifestations of Eternity.

Creation

The great template is the universe's Web of Interconnected Being. Atoms of matter form on the web. Hydrogen atoms bank upon each other to form huge clouds of gas. Then, when there is sufficient, one of the Solar Archangels takes on the cloud and ignites – and a star is born!

The stars are the first physical embodiment of the Divine light, but they are also the physical bodies of archangels. The Sun of our own solar system, is the physical body of a great archangel. This

particular type of angel is a 'Stellar Logos'. The stars are their physical bodies, and their auras extend throughout the whole solar system that form around them. The orbiting planets within the solar system are their chakras. For all life in that solar system, its Solar Archangel is the source of all light, life, and love. On our planet, everything is formed from solar energy; and every living creature receives the life-force flowing from our Solar Archangel, who is the creator of this system. The Solar Archangel receives the influence of the Elohim and, in turn, distributes it to the planets. Each planet in our solar system is a chakra of specialized energy. This knowledge forms the basis of esoteric Astrology and planetary magic.

Once a Solar Archangel has birthed its planets and established its system, various angelic hosts come to assist the evolution of sentient life in that solar system. These angelic hosts supervise the development of the planets and their moons so that, over the course of eons, each one unfolds as a perfect expression of the primal idea held in the mind of The ONE.

Terra

Our planet is not an inanimate mass, it is ensouled by a living, evolving being. Its Guardian Angel is the Archangel Sandalphon, who protects it and all life upon it. And there are the Angels of Nature – the Devas – who oversee incarnate life.

A planet evolves through the lives of the creatures upon it. In the early stages of its existence, our planet's need to experience and grow was met by the elementals, the spirits that indwell the elements at the etheric level, and this was sufficient. Later, more sophisticated, complex life-forms, became necessary for the Earth's expanding awareness.

The Devas, the Angels of Nature, began to build advanced forms through which life could express itself; first bacteria and single-celled organisms; then more complex forms that could extract energy directly from the Sun (the plant kingdom); then forms that extracted the energy held in other life-forms (animals which extract nourishment from their environment via plants or other animals). By their

absorption of energy, these flora and fauna were able to sustain a body in existence; and in due course they shed their bodies, which then nourished the rest of the ecological system. Each time a more sophisticated organism was brought into physical existence, the planet's awareness was raised.

A body, a vehicle, is necessary for the indwelling soul to be effective upon the level from which the body is constructed. Without a body, the soul cannot sense or react to the stimuli of that particular level. So we need a physical body to acquire the experiences that are part and parcel of the physical level. And this is true of all realms. We have an Etheric body, which sustains the physical vehicle, and an Astral body, which functions upon the psychic levels. These vehicles enable us to focus our consciousness and become effective in whichever realm they are manifesting in.

All the multitudes of species of minerals, plants, and animals are each a unique expression of the vision of the Eternal Artist; and they were all brought into existence through the instrumentality of the angels. The incredible beauty we see around us on this wonderful planet was created through the angels. The sense of beauty, the *numen* we sense in nature, is our soul's response to the angelic minds that manifested the natural phenomena around us. The beauty of this world is indeed a 'Creation of the created'. But at the heart of every atom is a photon of light that is the omnipresence of The ONE, Who is All-in-All.

And the wonders we see when spirit-travelling in the Astral realms – magnificent landscapes and temples – are also the creations of the angels. (To learn more, see *www.sacredmagicoftheangels.com/astraltravel*)

Sacred Animal Powers

Once the Earth had become a balanced ecosystem, the angels began the manifestation of the animal kingdom. An animal has a physical and an Etheric body, and often has a personality too, as any pet-owner knows. Where an animal differs from a human is that an animal does *not* have a personal Higher Self; it shares a collective spirit with the rest of its species.

If we take the cat family as an example, the Higher Self of *all* cats is an angelic being. Ever since felines first manifested on this planet, this particular angel – the Great Cat – has ensouled the collective spirit of all cats. This aspect of angelic ministry is powerfully portrayed in Charles Williams' novel *The Place of the Lion*.[3] The Great Cat oversees all embodied cats, great and small. And over time, this Angel of all Cats has refined the evolution of the cat family, producing the kinds of cat most suitable for particular environments. The Angel of Cats is aware of every single cat in existence – from a lion to an alley cat. And the experience of each single cat enriches the original archetype. This angelic Great Cat is the answer to the question that the poet William Blake asked of the tiger: *'What immortal hand or eye could frame thy fearful symmetry?'*[4] Because all cats are united at the deepest level, to hurt one cat is to hurt them all. The purpose of the cat family – its destiny – is to express on Earth a unique aspect of the Divine vision, in a way that no other life-form can.

In our planet's history, some species have become redundant, extinct. They were useful to the planet at a certain stage, but were then outgrown, and removed from the physical level. These extinct species can still be encountered in the Upper Worlds, and perhaps they might manifest again upon other planets in the universe. The dinosaurs are an obvious example, but there are many others. Angels are the ultimate realists. Like any breeder, they will encourage successful strains and cut back others. As W.E. Butler said, *'No bird ever studied aerodynamics; but the angels did'* – in fact, they invented flight!

There is nothing 'sweet' or sentimental about the Devas of nature. But their seeming ruthlessness is not because they are callous; which is more than can be said for most human-animal relationships. An angel *knows* that life cannot be extinguished. A being may change, wear many forms on its Great Journey, but the being *is* eternal. There is no death, only a change of worlds.

Most animals come to maturity in a short space of time, compared to humans. Apart from a few basic lessons taught by their parents, most young animals have amazing instinctual knowledge. This is because the entire experience of a species is pooled in the *group*

mind, and this is accessible to every member of that species. It is this group mind that is ensouled by the angel of the species, who is the species' overall spirit, its Holy Guardian Angel.

In the shamanic tradition, these angels of the species are often called the 'Sacred Animal Powers'. When an entranced shaman journeys through the inner levels, he or she seeks out a 'power-animal'. Having found it, that creature becomes the shaman's helper in their work. The shaman will receive counsel and energy from the power animal. They talk of 'The Great Buffalo' or 'The Great Hawk' – denoting the Divine proto-animal, the angel – to distinguish from the physical animals which manifest from it. Anyone who has spirit-journeyed and found a power-animal, knows that it is imbued with Divine energy. And, your soul thrills every time you see a manifestation of your totem.

Humanity

A zoologist used one year as a model to portray biological history. Using this model, humanity arrived upon Earth at 23:50 on December 31st. With the coming of humankind, planet Earth had a quantum leap in evolution.

The human body has the same number of cells as the number of human bodies it would take to make the mass of one single star. Poised between the vast and the infinitesimal, a human being is the microcosm (the small face) and the Universe is the Macrocosm (the Great Face). A human being looks upon the Universe with awareness.

The human body was evolved from the great apes, or primates. However, there is a difference between the human constitution and the animal kingdom. It is taught that the Elohim designed humans using themselves as a template: in Genesis, Elohim says, *'Let us make man in our own image'* (Genesis 2:26). This does not mean that we were made to look like the Elohim; the image is more poetic than that. Unlike any other creature on the Earth, humans have seven chakras,[5] which are centers for the reception and distribution of universal energies. The seven-branched candlestick (the Menorah) that stood in the Temple of Solomon, symbolizes this seven-fold nature of

humanity – our co-creative powers. This means that the Elohim are within us, as well outside of us, and that is why we can communicate with them.

When the human form was completed, for the first time in this system, the Solar Archangel called Divine Sparks from the heart of The ONE. These Divine Sparks had volunteered to take on physical form. They did this to consciously experience their God-nature in time and space. And so that this potential might be complete, they were given free will.

Free will is not just the ability to make a choice, a decision; it is also the ability to function on different levels of awareness ranging from the Physical to the Sublime. We can use 'will' – which is consciousness-in-action – and direct it. Human beings have free will because we each have an individual Higher Self. This means that every human being has full individuality, and the potential to achieve *conscious* union with the Divine.

The first humans were vulnerable and defenseless creatures in a hostile environment. By observing the Animal kingdom, our ancestors learned which roots, herbs, berries and barks were nourishing or healing; how to hunt; how to foretell the weather. They had empathetic sensitivity with the land and its creatures. As humanity increased, certain of the sacred animal powers became clan or tribal totems, creatures of great significance for the tribe's well-being. In time, the cults of various tribal totems developed into early deities, with their own myth and cult. So it was that the angels were the first gods worshipped by humanity. The ensouling angels of the Animal kingdom, the Devas of mountains, lakes, and forest (the *genius loci*), were venerated by early humans. In time, their cults of worship grew into the great pantheons of gods and goddesses of classical cultures like Egypt, Greece and Rome.

It was in pre-historic times, that the Teaching Angels first came to early humanity. These angelic teachers came to explain the nature of the universe and the role of humans in the overall scheme, and to prepare humanity for its task. The Teaching Angels communicated with those individuals who were naturally sensitive to the inner levels.

Nowadays we call such people psychics, then they were known as 'dreamers', individuals whose imaginative and intuitive faculties were highly developed.

Imagination – the ability to mentally form images – is essential for communication between the levels. Mental images are forms, just as concrete on their own level as a physical form is here. It is all a matter of vibration. The angels built everything by mental projection. The creation of the universes by The ONE was, and is, an act of mental creation. This is the *Magia Divina*. There is nothing we see in the physical world today that was not first imaged by the mind. The human ability to imagine is part of the Divine potential of our God-Self. As the poet Samuel Coleridge put it:

> *The primary imagination I hold to be the living power and prime agent of all human perception, and as a repetition in the finite mind of the eternal act of Creation in the infinite I AM.'*[6]

The Teaching Angels instructed the early dreamers and seers by signs and symbols, and by using the vegetable and animal kingdoms as their messengers. In time, the dreamers became the early priests and priestesses, and crystallized the teaching they had received from the angels into a system of Theurgy, a sacred magic. Its purpose was to empower individuals to get further help from the angels to assist them on their evolutionary journey.

All human tribes, nations, civilizations, and cultures have accounts in their myths and legends of the Bright Beings. They tell how these Winged Ones came to help and succor, to bring healing to those in need. Among some of the Native Americans, these celestials are called *Manitous*, the Little Mysteries. Hindus and Buddhists call them the Devas, which means 'the Shining Ones'.

Angels are the only means by which we can have complete knowledge of all levels of Creation. In all cultures, angels have been the companions of Prophets, Mages, Mystics and Shamans. From Biblical times to the present day the angels can be contacted by using their sacred magic.

Origin of the Sacred Magic

Tradition says that this angelic White Magic originated with Enoch, the seventh son of Adam and Eve. Through out-of-body journeys Enoch journeyed in the Astral plane and higher; and the Archangel Uriel guided him during these ascensions. Uriel introduced Enoch to other angels, those who had 'rulership over Creation', and also to those angels who were 'appointed to answer petitions'. Archangel Uriel confided to Enoch the secret names and signs of these angels. This hidden knowledge was called the 'Secrets of the Kingdom'. This secret knowledge was passed down the centuries to a few initiates in each generation. It was always closely guarded. Many of the prophets used it – especially Elijah. And the royal mage, Solomon the King, used it to build the great Temple of Jerusalem.

In the temple, Initiates of the Qabalah used this knowledge to work wonders, and to gain access to the higher dimensions. It was transmitted down the generations by 'mouth to ear' teaching. Jesus (and his disciples) was deeply versed in this Angelology. The reason why many of his sayings are misunderstood today is because people do not have the 'key' – the Qabalah – with which to understand the esoteric level in his teachings.

When Paul the Apostle was visiting Athens, he met a man called Dionysius[7] – named for the Greek god of bliss. This Dionysius was a judge in Athens. The law-court met in a precinct called the Areopagus, and so history calls him 'Dionysius the Areopagite'. Paul taught this angelic magic to Dionysius, who turned it from Hebrew into Greek, the philosophical language of the time.

The reason why Paul passed this hidden knowledge to Dionysius is revealed in one of his letters. Paul writes that, although he himself had entered the Second Heaven[8] while still incarnate (by astral projection), he had met a man who had entered the Third Heaven.[9] Tradition says that this man was Dionysius the Areopagite.

Few of Dionysius' writings survive. The best known is his *Celestial Hierarchy*.[10] In it, he classified the angels into nine celestial hosts: Angels, Archangels, Thrones, Dominations, Principalities (or Princedoms), Virtues, Powers (or Dominations), Cherubim, and Seraphim. This classification is still in use today.

But it was Dionysius' *unpublished* teachings on angelic magic which taught how to use this knowledge. It taught *who* the specific angels are, which angel to invoke in what needs, how to *contact* them and *how* the angels reply to us. (The same knowledge that is in this book.)

Dionysius' angelic teachings were only given to the innermost circle of the Great School of Alexandria. This was the foremost school of mystical Christianity of the time. Nowadays there is a mistaken idea that Christianity has always opposed magic. But in fact, until the Reformation there was a sacred magical line running through the Church. Like the Egyptian and Greek priesthoods before them, they confined the practice of it to their own priests, and would only allow *angelic* magic to be used. And we know from early writings that Jesus and his disciples also worked, and taught, angelic magic.

So venerated was Dionysius the Areopagite, for giving these teachings, that the deans of the Alexandrian School took the name 'Dionysius' as their official title. Within that School, the students copied these teachings and diagrams from their teachers own hand-written book while it lay open on his lap.

With the fall of Alexandria to the Muslims, the Great School divided and scattered – some eastwards, others west, and some up north into 'barbarian' Europe. A portion of the School came to a small town by the River Seine – that the Romans had named 'Par-Isis', the 'Garden of Isis' – which later became the city of Paris. There, on the hill of Montmartre – where now stands the Basilica of Sacre-Coeur – the School reestablished itself. The School continued its work of training specially selected individuals in the high White Magic of the Angels.

A few centuries later the School moved again, this time to Char-tres (also in France). This Cathedral-university of Chartres became one of the greatest centers of Theurgy of the age. There is evidence that certain enclosed Orders in the medieval church specialized in the practice of angelic magic. It was also true of certain monasteries and hermitages of the Greek, Russian and Ethiopian Orthodox churches. Some of these orders also specialized in Healing and in Alchemy. In the late 1800's the teachings came from France to England; and in time they were passed onto me.

Recently, a few ill-informed people have claimed that this system was the invention of an occultist named Madeline Montalban. Although she seems to have known some of it, she did not possess anything like the entire system. And sadly what she *did* have, she disfigured (but then, her first teacher was Aleister Crowley).

So, to put my readers' minds at rest – let me state that I was *not* taught this sacred magic by Miss Montalban. I did dine with her once; but all I learnt was that she was a bitter apple on the Tree of Life.

But why, after all these centuries of secrecy, am I now sharing this sacred angelic magic with you? Why am I passing it on in this way?

In the springtime of the world, humans and angels communicated together. But later, as humanity descended deeper into matter, to develop other aspects of consciousness, this ability became confined to just a few. However, there is a prophecy that a time will come when angels and humans will walk together again. And that is one reason why I am sharing this angelic magic.

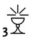

But there is a second, more practical reason – this Sacred Magic of the Angels changes lives for the better: it brings wholeness, it makes dreams prosper and reveals the wondrous. And, since I first published it, 'Sacred Magic of the Angels' is now known world-wide for delivering results. How so? Because – regardless of what centuries of misunderstanding and fear would have you believe – the truth is: *Magic is a holy force given to help us when we cannot help ourselves.* It exists to assist us with the hardships of life. The angels brought this knowledge to us as a gift from God.

CHAPTER 2

THE ANGELS OF LIGHT

Who maketh His angels spirits,
and His ministers a flame of fire.[1]

All the workings of this sacred magic involve the nine principal angels, that tradition calls the 'Teaching Angels of Humanity'. They are also the Planetary Angels, and they have connection with everyone. It is by working with these nine Angels of Light that we are helped forward in our evolution – from individual to universal.

Some people think that an angel is some kind of celestial robot, having no will of its own. But this is not true – angels are sentient and evolving beings. The angels chose to align their consciousnesses with The ONE – they are highly realized beings. And they are still evolving. The reason why this isn't well known is because an angel's evolution spans great periods of time.

Angels are beings of superhuman condition. They do not have physical bodies. Angels have cosmic responsibilities, they organize and control the forces inherent in Creation. They have no gender, and their true forms are beyond our current ability to understand. But angels do take on forms that we can recognize and relate to. They do this for two reasons: so that we can perceive them on a level closer to our own; and to veil, or step down, the intensity of their vibrations so that we can bear them. Generally, angelic beings appear as very tall and human-like in form. Their eyes are large and slightly slanted. Their immense auras often give the impression of great wings of living color. And sometimes they appear just as living pillars of light and color.

I am going to teach you about each of these nine Teaching Angels in turn. And I will also share visualizations of them, to help you forge your own relationship with these Shining Ones.

Archangel Michael

Archangel Michael is the Sun Lord, the Prince of Heaven, who rules the zodiacal sign of Leo, the sign of the royal lion. Sunday is his day of power. And his name means: 'Who Is Like God?'.

Archangel Michael helps to achieve any legitimate ambition. And he controls all aspects of authority, management and leadership. This archangel's help can also be asked for to help you achieve your willed destiny in this incarnation. He also rules marriage – and so wedding rings are sacred to him. The Archangel Michael rules music too – from its composition all the way through to its performance. He is the patron of all true priests of Light. And he is the angel of the summer season, the period of greatest light.

The 'time-orbit' of Archangel Michael (the *longest* he takes to bring about results) is one year. This is the time that it takes for the Sun to pass through all twelve signs of the zodiac.

Many creatures answer to Michael's energy signature. All cats – from tabby-cats to tigers – are his and he can be called upon to help a cat who you share your life with. The Stoat *(Mustela erminea)*, whose winter fur of ermine is used for the mantles of kings, is Michael's. This archangel's birds are the Blackbird *(Turdus merula)*, honored by the Druids, and all hawks. His insects are golden or yellow butterflies and the 'Daddy Long-legs' – the Crane Fly *(Tipulidae)*. His tree is the laurel, which was sacred to the Sun god Apollo in ancient Greece. Oranges and pomegranate fruits, sunflowers, marigolds, and all types of orchids, and the metal gold are all empowered by this archangel.

Archangel Michael may be visualized as a figure formed of warm, living sunlight, with great aura-wings of gold and salmon pink. He carries the Spear of the Sun – a lance of flame. His dazzling countenance is difficult to look upon, for he is like the Sun's disk.

Archangel Gabriel

Gabriel is the Moon Lord, ruler of the inner tides and keeper of the Treasure-house of Souls. Working mainly through the Astral plane, this archangel is important in most magics. The name 'Gabriel' means 'Mighty One of God'. He instructs mainly through the sub-conscious mind, where he acts as the herald of the Higher Self. He is also petitioned for the development of psychic faculties, because their unfoldment is related to the Astro-etheric body. Gabriel is the ruler of the harvest season of Autumn.

The nights of New Moon and Full Moon are sacred to Archangel Gabriel, as is each Monday (Moon Day) of the week. All domestic matters come under his sway, from furnishings to appliances. If, for example, you need new beds but can't afford them, then Gabriel is the angel to invoke.

In most matters for which you need to call upon the Archangel Gabriel, use the Tablets of Power given in Chapter 3. However, there are times when his assistance is needed and the Moon is not in the right phase. In these cases, use a 'Letter-of-Petition,' with his own 'call-signs', given in Chapter 5. There is also a special talisman of Gabriel for use with domestic needs and appliances explained in Chapter 7. Gabriel is also the angel to invoke for finding a new home, but make sure to ask for a 'good and happy home'.

The 'time-orbit' of the Archangel Gabriel occurs in multiples of three: three weeks, three or nine months. Suggestions on how to visualize Gabriel, a discussion of Gabriel's signs, and examples of his creatures and plants, are given in Chapter 3.

Angel Samael

Samael is the Great Protective Angel. He rules the planet Mars and the two zodiacal signs whose energies are mediated by that planet: Aries the Ram and Scorpio. Samael's sacred day is Tuesday and this is when he should be invoked. Some texts give Angel Samael a bad reputation that is quite undeserved. Mars and Scorpio share in it too.

Angel Samael should be invoked for all matters that need courage or perseverance until victory is won, such as the overcoming of

obstacles. He protects the physical body, oversees manual dexterity and muscular tonicity. Samael protects those in the armed forces. He also defends us from our enemies.

There is a big difference between 'enemies' and 'rivals'. Rivals compete with us in some sphere of activity, and in fact *help* us, for they bring out the best in us, make us strive harder, and make us more aware of ourselves and our potential. Enemies wish us no good and desire only our downfall. Yet these enemies can be our teachers by telling us things about ourselves that most friends would never dream of doing. But there are times when we need to protect ourselves against the maliciousness of people bound to us with the bonds of hate. The strongest ties forged between people are those of hatred and of love, for hate is an inverted form of love.

Angels do not like hatred or violence – whether physical, emotional or mental – but Angel Samael will not destroy your enemy. The ways of angels are far more subtle.

Although you may think that your 'world' is large, it is not. *Your* world really consists of the places you know, and move in regularly – your familiar environment. When an angel like Samael is asked to help protect you from an enemy, the angel simply removes your enemy from your 'world'. I have seen this in many cases when – after invoking Angel Samael – a person's enemy has a new opportunity open up in their life. It may be an offer of a new job, or a promotion that offers the 'enemy' more fulfillment and happiness – elsewhere! Then, of their own free will, that enemy moves to a distant location.

Now you might think, *'But I wouldn't wish something nice to happen to my enemy, after all the pain they caused me.'* But therein lies the difference between most humans and the angels. An angel can achieve the desired solution without violence. An angel removes the aggression or maliciousness of an enemy by preventing that enemy from any future influence in your life. In this way, you have not polluted your mind or soul with the dark stain of hate.

Angel Samael's personal call-sign is an unsheathed upright sword. Creatures that resonate to his influence are: the fox, sheep, and the scorpion, as well as the sparrow and the Robin-Redbreast.

His trees are the Horse-Chestnut, the Monkey-Puzzle and all pepper trees. His sacred plants are: thistles, nettles, Peonies, Poppies and all red flowers. And all stinging insects – except the bee – are also sacred to the Angel Samael. This angel works very fast and usually brings his results to pass in less than three months.[2] The Angel Samael is visualized as a great being of scarlet flame, with sparks of green. He wears mirror-like armor, wields a sword of pure flame, and bears a white shield upon which appears the Name of God.

Samael is the angel of Mars, a planet that is often misunderstood. Mars is often interpreted as the 'planet of violence and war'. This is not totally accurate. Mars is the fiery sphere through which 'will' and 'energy' flow into Life, into us. The Martian influence gives us physical energy, gives strength to our muscles, and gives us an immune system. It also fuels our sex-drive. The flipside to all this is that, if a person cannot find a fulfilling expression for this energy, they often become, irritable, angry, and prone to violent outbursts. It is the same with nations, where their violent outbursts manifest as war.

The real role of Mars is to eliminate imperfections, fight infections, and to strengthen us for our life-work. We need to harness this Martian influence and so become energized, vital and determined. The 'warrior' symbolism of Samael and Mars should be understood as an 'interior battle' to overcome weaknesses and fears.

Eliphas Levi, a famous French occultist, wrote that an adept has to be able to distinguish between the false notion of Samael as evil, and this angel's *true* function in the Universe. Other Qabalists have also taught that Samael is an angel of the Lord – a Spirit of Light.

In truth, the holy Angel Samael is a fighting Spirit of Divine Love, whose role is to transform our lethargic resignation into transfiguring action. We can also call on him for help with manual jobs, because Mars is the planet of energy, drive and enthusiasm.

In Qabalistic vision, Angel Samael of Mars is seen in his original glory – ablaze with heavenly jewels and celestial fire – and we should invoke him for the protection of the innocent, and for added power with which we can serve.

Archangel Raphael

The name 'Raphael' is Hebrew for 'God Heals'. And he is the healing angel *par excellence*. Archangel Raphael is the ruler of the planet Mercury, and therefore of two zodiacal signs: Gemini the Twins, and Virgo the Heavenly Virgin. Raphael's day of power is Wednesday. In ancient Egypt, Raphael was Thoth, the Scribe of the Gods and the inventor of alphabets.

Raphael is also the angel of communication, and is a rapid worker. He is very fast with his results; so fast, in fact, that he usually drops them in your lap and leaves you to sort them out. His rulership extends to all forms of communication, contracts, advertisements, documents, FAX, e-mails, and language itself. Raphael will help you develop fluency of thought and language, improve memory and concentration. Raphael is therefore the angel to invoke for help with examinations of any kind. Businesses that use documentation or paperwork, and the act of writing itself, come under Raphael's regency. He is of great assistance in 'completing contracts', and helps you deal with bureaucracies. This archangel rules young children up to about age seven, as well as young and small animals.

If you don't know who governs a particular matter you can invoke Archangel Raphael with the petition, **'To the angel who has rulership, through the Archangel Raphael'.** Raphael can be asked to 'carry' your petition to another angel; this is particularly useful if the angel who has rulership is slow with results (e.g. Cassiel of Saturn). Going *through* Raphael brings the matter into his time-orbit and his omens.

Creatures that vibrate to Raphael's influence include monkeys, squirrels and birds in general. The magpie and the lark, and all non-stinging flies are sacred to him. Aspen and silver birch trees, and all yellow-flowered plants, ferns and 'weeds' are also his. Raphael is associated with the Egyptian god Thoth (who is shown with the head of an ibis bird). Thoughts are likened to birds flying across the sky of consciousness, and so Raphael is the angel of the mental sphere. Raphael is the angelic ruler of the season of Spring, when the life-force awakens and rises from Winter's slumber and all is renewed.

The Archangel Raphael is visualized as a being formed of yellow

and golden light. He has six wings – two at this temples, two at his shoulders and two at his ankles. He carries the caduceus staff. And his vibrations are very rapid.

Angel Sachiel

Sachiel is the angel of Jupiter and, in ancient Astrology, he is the ruler of two zodiacal signs: Sagittarius the Centaur, and Pisces the Twin Fish. In Astrology, the planet Jupiter is a great benevolent power, and Sachiel certainly reflects this in his dealings with humanity. Sachiel 'shares' the day of Thursday with the Angel Asariel of Neptune. Although in modern Astrology the sign of Pisces is attributed to the planet Neptune, in the ancient days it was associated with Jupiter, and that is how it still works in magic today.

Angel Sachiel's rulership is over all financial matters, such as increase of earnings, pay-rises, help to recover debts owed to you, or to earn money to repay debts. Call on this angel to help you *earn* money, and he will make clear the way for you. But ask for money while expecting to make no effort for it, and that request will fall on deaf ears. These mighty beings well deserve their name of the *Teaching* Angels.

In all legal matters, from minor issues to full court cases, the Angel Sachiel deals with the reconciling of human justice with Divine Justice. So he rules lawyers and solicitors. Sachiel also helps to secure the help of people in authority (the old texts speak of 'judges and kings' – nowadays we say the 'powerful and influential'). Sachiel can be invoked to help improve all money situations. Specific talismans for invoking Angel Sachiel's help in money or legal matters can be found in Chapter 7.

Flora and fauna that convey Angel Sachiel's influence include: fish, whales, dolphins, elephants, cattle (whether bulls of cows), and horses. The plants lilac, lavender, honesty and all purple flowers or shrubs are his; and the great oak tree, and grape-vines. Water birds are special to this angel, particularly the swan and duck. The bee is Angel Sachiel's in the insect kingdom. His time-orbit is benevolent, and no longer than six months.

Visualize this angelic servant of the eternal Mercy, in purple and

violet light. His aura-wings are sapphire blue. His vibration is stately and serene. Above his head shines a blue flame, signifying he is one of the Chasmalim, the host that serves under Archangel Tzadkiel.[3]

Angel Asariel

This angel rules the planet Neptune and 'shares' the day of Thursday with the Angel Sachiel. He rules trance work and expanded consciousness. He also rules a stage of spiritual unfoldment that has led Asariel to be named as the 'Angel of Adepts'. Asariel is rarely invoked, because his rulership is so rare and specialized. Horses are sacred to him, and he can be called upon to help heal them. He can be invoked through the agency of either the Archangels Gabriel or Raphael. Asariel's color vibrations are the greens of the sea, and his symbol is the trident of Poseidon (Neptune).

Angel Anael

The name 'Anael' means 'The Joy of God'. Much of Anael's work is connected with the Devas of nature and the Hosts of Faerie. Anael is the angel of the planet Venus and ruler of two zodiacal signs, Libra the Scales and Taurus the Bull. Anael's principal function is the creation of all beauty and the increase of love and affection, peace, and harmony. One of his special talismans is the 'Wheel of Love' that is used to heal bonds of love that have been damaged by quarrels, adverse circumstances, or ill feelings (see Chapter 7).

Friday is the day sacred to Anael and the magics of love. This angel presides over love and *all* matters of affection between all life-forms. He rules the creative arts, particularly drama, and the enhancement of beauty in all its forms (hairdressers, too). For any creative work in which you need inspiration and help, summon this angel. Anael's time-orbit is two years.

Swallows and doves (birds of Venus), blue-tits and blue budgerigars are all sacred to Rose-Angel Anael, and so too are rabbits. The apple tree and its fruit, the persimmon, Delphiniums and all kinds of roses also belong to this angel of Venus. All butterflies are sacred to Anael, except for yellow butterflies, which are sacred to Archangel

Michael, and white butterflies (and all moths), which are sacred to Archangel Gabriel.

Tradition says that Angel Anael was charged with beautifying the Earth. To do this he was given the 'Root of Creation' with which to create a spirit for every single tree, bush, shrub and flower – all the Nature-spirits that exist. This is why in Faerie-lore Angel Anael is known as Oberon, High King of the Fey. By using the Root of Creation to bring the Nature-spirits into being, Angel Anael clothed the Earth in emerald splendor – with forests, jungles, and vast plains of verdant grass. And thus the Earth was adorned like an altar – as an offering to The ONE – and as an exquisite home for the children of The ONE, for you and me.

The magical secret behind this teaching is, that you too can use the 'Root of Creation' to summon to you whatever is needed to fulfill your destiny. Your destiny is what you were created to fulfill. There is something that only you can give to the Universe – no other being can do this – in exactly the same way as you. And fulfilling your destiny is ultimately the only lasting joy. But, the magic of the Root of Creation can only be used *once* in an incarnation. This magic is called the *'Almadel of Anael of the Evening Star'*. (To learn more about this visit *www.sacredmagicoftheangels.com/almadel*)

Because Angel Anael's major rulership is 'matters of love and affection', he is probably invoked more than any other angel. Abusive or unrequited love is one of the greatest emotional sufferings that a person can undergo. It can warp their response to other people, and to Life itself, for many years – sometimes for several incarnations. And it is a hard truth that one of the greatest lessons we need to learn is to love un-possessively and responsibly. Yet, many requests for Angel Anael's help come from people who already have a particular individual in mind, a person whom they think 'must' be made to love them.

Sometimes we attract people who are not good for us; our psychological make-up draws chaotic or destructive individuals to us for whom we develop feelings. Although past karma is sometimes repaid through emotional attachments, it is *not* repaid by emotional martyrdom. The repayment is made, in more cases than not, by accepting the

unpleasant fact that, this time around, the emotional bonds from the past must lie fallow until *both* of you have grown up a little more. Do not try to change another person against his or her will. Remember that anyone we fall in love with, is really a 'trigger' that stimulates our awareness of the Eternal Love that is forever within us. All true and enduring change must come from within.

Instead, focus your energies upon becoming a more responsible and affectionate lover *yourself.* Then, by the universal law of attraction, love must come to you. Real love you can touch, argue with, cry and laugh with – not some mental obsession for what cannot be. Invoke Anael to help bring to you an *unnamed* 'affectionate and responsible lover', and the angel will bring you the perfect person for your current stage of growth and needs. The angel knows far better than you do who will enhance you as a being, and whom *you* will enrich in turn. For this is the secret of real love: that the spiritual energies that are channeled by two particular people together are greater than what they could produce as separate individuals. Through this love, all who come into contact with them are enriched, humanity is ennobled and the universe is nourished. It is truly said that no man liveth unto himself; it is equally true that the love of every man and woman is not for themselves alone. All life-forms on this planet consist of three aspects – female, male and Divine – and love is the primal unity.

Although Anael is not much concerned with healing, he is the angel to petition to heal diabetes.

The Angel Anael may be visualized formed of pale blue and pink colors, with a white rose at the heart-center region. The angel's features are of celestial beauty. He brings a sense of deep love that is healing and reassuring. Anael's atmosphere often lingers for days after an invocation, like the scent of roses.

Angel Cassiel

This angel supervises the energies of the planet Saturn and the zodiacal sign of Capricorn the Sea-Goat. In modern Astrology, Saturn has a poor reputation as a 'malefic', due to its influence of limitation, rigor, and the teaching of life-experiences. In fact, this planet is the great

teacher who frees us from false teaching, and teaches us how to over-come obstacles, particularly during the time of the Saturn-return (every 28 years). One of the most valuable aspects of Saturn's discipline is to teach people not to overstep their current place in the universe, not to *'rush in where angels fear to tread'*.

Obstacles in our lives are beneficent for us. If everything were smooth and easy, we would make no effort to achieve, and our hidden strengths and talents would never blossom. We are never tested beyond our strength, but Heaven's knowledge of our strengths is deeper than our own. Life is not meant to be a holiday, it is an opportunity to evolve. Incarnate life is an education preparing us for a greater destiny. We get our holidays *between* incarnations. Situations, people and circumstances come to help us develop our full potential – they are not punishments from a 'vengeful god', but lessons we have chosen to learn to become fully human – to grow from 'animal-man' to 'angel-man'. And this is why the Teaching Angels will help and guide us if we ask them to.

If you fear a time of testing is looming on the horizon, do not petition the angels to take it away. Instead ask for the *'strength and wisdom to endure the ordeal that may come'*.[4] Sometimes, the fact that you have asked for this kind of assistance makes the test redundant, and then it doesn't come at all. Or, if it does come, you will find that you are supported and upheld during it, and the teaching that the test conveys is clearly understood.

One of the greatest lessons that we humans – both as individuals and as a species – need to learn is that we are not, and never have been, self-sufficient. The universe is a great, interconnected web of life, so total self-reliance is impossible. Everything, and anything, that happens to any one person affects the Whole, concerns the Whole, and is important to the Whole. The worm trodden underfoot shakes the very throne of God.

But because we have free will, no Power or angel in the universe may interfere with humanity – without first *being invited*. The angels may look on sorrowing, but they may not force their help on us, because our free will is a part of our Divine heritage. The lesson

we need to learn is never to be too proud to ask for help. 'Help' is the most powerful prayer in the universe. With trust, stretch your hands up towards the stars and ask for help – you will not be alone. I tell you this of my own knowledge.

The Angel Cassiel shares the day of Saturday with the Archangel Uriel. Cassiel's rulership consists of all matters of property, land and agriculture. He also rules the physical structure of houses and buildings, to help them endure, and to enable good restoration. He is concerned with elderly people (and elderly animals too), and with the unique gifts and lessons that old age brings. He helps to overcome poverty and long-standing ailments. With the elderly, he will certainly bring relief from the illness of old age, though not necessarily heal them completely.

He helps with the settlement of wills and all matters of inheritance. Cassiel serves karma, the Universal Law of Cause and Effect, and the trials which must be endured. It is because of this that Cassiel is sometimes called the 'Angel of Fate'. He brings his blessings late in life, unless Saturn is well aspected in your birth chart. Cassiel works very slowly, but very thoroughly. His time-orbit is four years – the time it takes the planet Saturn to orbit the Sun.

Creatures sacred to Angel Cassiel are: the tortoise, vole and field mouse. Among birds: the parrot, the raven, the crow and the rook. Slow moving insects and worms resonate to Cassiel. All evergreen trees and slow-growing trees are his. This angel also uses: the mineral coal, the metal lead, bitter aloes, dried fruit and all bitter herbs.

The Angel Cassiel may be visualized as a pillar of iridescent darkness – black like the raven's wing. There is a silver chalice at his heart-center. His vibrations are immense and slow moving, an energy that was ancient before time was born.

Archangel Uriel

This great archangel shares Saturday with Angel Cassiel as his day of invocation. Uriel's name means 'Light of God', or the 'Lamp of God'. He rules the planet Uranus and the zodiacal sign of Aquarius, the Water-Bearer. This archangel rules the season of Winter and is the

Regent under God of the element of earth. Uriel is a 'Throne Angel of God'. As the Transmitter of Magical Force itself, he is a being of tremendous power – and must *never* be invoked lightly. Uriel's main function is to lead a person from soul to Spirit, along the Path of Initiation. So, except when being petitioned to heal diseases of the nervous system, Uriel is only invoked in high magic.

According to one tradition, it was the Archangel Uriel who was sent to destroy the lost land of Atlantis because of its dark corrupting of the magical arts. This is symbolized in the sixteenth Tarot card, 'The Lightning Struck Tower'. Uriel has a great affinity with electricity. His presence is often signaled by electrical appliances popping and fusing – and by light bulbs blowing. Uriel also manifests in thunderstorms.

Archangel Uriel also rules separation and divorce, and will sever the bonds peacefully, but effectively. He is also the Patron Angel of Astrology and Alchemy. Once he has been called, Uriel's ways of bringing about results are sudden, and often devastating; so be prepared for sudden upheavals in your life, if you call on him. Archangel Uriel can perform 'eleventh hour miracles'. When all hope seems gone, invoke him – and he will suddenly descend and sweep aside natural laws and turn the world on its head. And then you will know that the age of miracles is not gone!

Uriel doesn't really have a time-orbit. He answers according to need; and should the petition be granted, it is answered almost instantly. Again I deliberately emphasize that Uriel is an archangel of devastating power, the celestial embodiment of magic itself, and must never be invoked lightly.

Quartz crystals, as the most accurate transmitters of electrical energy, are sacred to Uriel. The rainbow is an omen Uriel often uses to communicate with us. Multicolored flowers and hydrangeas (which change their color) are his. Mangos and bananas, lizards, chameleons, dragonflies and the fabled unicorn all resonate to this archangel.

Most students of occultism know Archangel Uriel only in his aspect of Regent of the element of earth. They are unaware of his 'higher' nature. Uriel is Archangel of Da'ath (Gnosis)[5] on the Tree of

Life; and he is the great Alchemist among the angels.

Archangel Uriel can be visualized formed of rainbow brightness, with aura-wings of electric blue and a crystal diadem on his head. He is often shown holding a flame, or a lamp. Uriel is the tallest of the angels, and his vision spans the universe.

What is in a Name?

For over a decade now the topic of angels has become very popular. This has its 'up' and 'down' side. The 'up' is that people are now more open to the existence of spiritual beings, and to developing a harmonious relationship with them. The 'down' is the lack of discernment, which often results in confusion and foolishness; added to which there are those self-appointed teachers who take advantage of people's hopes and gullibility. It is a source of continual amazement to me, how people who would only go to a qualified dentist or brain-surgeon, yet in 'spiritual' matters, will indiscriminatingly accept things taught by self-appointed teachers who have the authenticity of car-salesmen.

Understandably, people want to experience angels. The word 'angel' is from the Greek *'angelos'*, meaning 'a messenger'. So the proven existence of angels answers many deep questions: that the Universe is brooded over by a benevolent Intelligence; that our lives are not random or meaningless; that Spirit is everlasting, and that help is freely available to us, if we open ourselves to it.

But it is the last point – *'...if we open ourselves to it'* – where many people get into a mess. It is not a matter of just opening ourselves to anything that floats into our minds. We have to attune ourselves to a specific frequency, to the specific being we are asking for help. Why?

It is not for nothing that over the centuries this kind of work has had a 'handle with care' label stuck on it. Evil and mischievous spirits can impersonate even the Sons of Light, and are ever seeking to ingratiate themselves into an advancing student's aura and confidence. Just because an entity looks radiant, winged and beautiful, doesn't automatically mean that it is 'of God'. Have you never met a beautiful, well-dressed human, who had wicked intentions? Have you never observed some lawyers, insurance-salesman, fashion-dolls or actors? Do you

give your well-being over to a complete stranger, just because they are looking good? Should you compromise your sanity by allowing any entity into your consciousness?

This is why the Magic of Light teaches us to 'test the spirits'. Many people have been misled by the powers of evil because they didn't observe this law. The Esoteric Tradition is crystal clear about this matter. It says that God has appointed *certain* angels to answer prayers. Notice the key-word is 'certain angels'. These are specific angels, who are known, named, and vouched for. These individual angels have been tried-and-tested by sages and mystics for centuries. These are the Teaching Angels of Humanity. They are *'the holy angels who present the prayers... and go in and out before the glory of the Holy One.'*

Wings and Archangels
Throughout history, myths and legends, folklore and visionary accounts have all spoken of messengers of Heaven as having 'wings'. This attribution of wings to angels is the result of the subconscious minds of human seers 'clothing' the auras of angels with a form that their conscious minds could understand.

I often use the term 'aura-wings'. The aura is the energy-field that surrounds each being and creature. Angels have immense auras. A mountain Deva has an aura that extends for a few miles.

Certain of the Teaching Angels are called an 'arch-angel', while others are 'angels'. An archangel is the head of an entire angelic host. For example, Archangel Gabriel is the head of the Host of the Cherubim. Under The ONE, the archangels command the shining Hosts of Heaven. An 'angel' is a member of an angelic host: for example, Angel Samael belongs to the Host of the Seraphim.

This angelic system of celestial Theurgy has always been the secret aspect of the Holy Qabalah[6] – revealed only to Priests and Levites, to *Navim* (prophets) and *Mekubalim* (the Chariot-riders). But now, with permission from Above, I am openly sharing this sacred science – as never before. Why? So that you – and through you others as well – may personally experience the wonderful help and love of the Shining Ones – the Angels of Light.

Illustration by Gustave Doré

PRACTICE 1
The Temple of the Angels

This interior journey can be used as an introduction to the Teaching Angels, and a way to periodically strengthen your connection with them.

Make sure you will be undisturbed, sit and breathe deeply and rhythmically, but without any strain. Then starting from your feet, and moving upwards, tense your muscles in turn, and then relax them.

Then picture the images as they are described, letting them acquire clarity and three-dimensional vividness. Try to use your senses in this inner journey, allowing touch, smell, hearing and sight to give you the full benefit of this experience of the Angels of Light.

See before you a trilithon gate;[7] its rearing uprights and the overhead lintel are great flawless crystals. From the lintel hangs a violet-blue curtain – colored like the sky just after sunset – with a single star shining at its center. Focus your attention on this gate-between-the-worlds... and soon your concentration causes the crystals to glow – brighter and brighter – as a halo of rainbow light emanates from the portal. Now you can hear a single note – like a silver-toned bell – and you approach the gate, draw back the curtain... and step through the veil.

You are now standing upon the shore of a lake, its waters are still as glass, and there is a gentle mist rolling over its surface. Overhead a soft light shines down from a silver sky. You are robed in an olive green robe, with stout leather sandals on your feet. There is an air of serenity about this place, a peaceful feeling – just the silence, the gentle light, and the still waters.

Now you hear the sound of rippling waters... and from out of the mist comes a high-prowed boat. It is formed of ancient wood, and on the rim of the hull are carved letters of gold, in a script that you don't recognize, but which somehow stirs you. The boat's tall prow is carved in the likeness of a hand holding a lamp, in which burns a clear violet flame. There are six oars, three on either side, which propel the strange

vessel forward. And the tall rowers are clothed in silver robes with upraised hoods.

As the boat draws near, it turns and so you can see it lengthwise. Near the stern is a empty wooden seat. The boat stops about ten feet from the shoreline. The oars rest. Then, the silver-clad rowers rise and look across to you. Silence falls again as the lake returns to its former stillness.

You feel somewhat embarrassed as the silence deepens and nothing is said. *'Perhaps'*, you think, *'these beings can't speak.'* Tentatively, you reach out with your feelings, trying to communicate that you come as a 'Seeker for the Light'. And as soon as you reach out to the silver-clad beings, you feel their welcome flood into you, like a starburst of joy!

With their greeting, that transcends speech, comes the knowledge that they have come from far away to meet you. In fact they started out on their way to you the moment that you decided to undertake this inner journey. But they cannot, they may not come any closer to the shore. It is up to you to cross this last space that separates you from each other.

Now you must decide, do you wish to go on to the Temple of the High Servants of The ONE? Or is it too great an undertaking? What do you really know about the strange beings in their fantastic boat, so close – and yet a lifestyle away? Weigh your heart. If you feel doubt or dread, then go back through the crystal gate, back to the ways of sleeping humanity. There will be other opportunities to retrace your steps back to this shore. But if your heart lights up within you, then step forward into the still waters. Now decide!

You place one foot into the waters, feeling the lake bottom beneath you... then another step... and a third. The waters are up to your knees now – you realize that the waters are wonderful. The touch of the still waters fills you with well-being. They soothe away unhealed pains and hurts. Like rain upon a desert, they fill the deep places of your soul and melt away all hardness. With wonder, you kneel down in the waters, letting them rise to your shoulders... then you bow your head and they cover you.

And then you leap up from the waters like a playful dolphin. Your senses are heightened, clean and clear – and on the surface of the waters, between you and the boat, is a path of golden light. It comes from the vessel, from the glorious beings you *now* see upon its deck. Tall and bright figures, robed in light and winged with glory; and their eyes – shining with endless joy – looking at you. Their arms are reaching out to you. You are lifted up from the waters by angel-thought, onto the golden pathway. And your robe is now snow-white, and your sandals are woven of fresh grass and summer flowers. And gently moving like a soft breeze, you are brought aboard, and welcomed by these living embodiments of love.

It is like being reunited with old friends, whom you have always known, but had lost for a while. There is a sense of completion, of wholeness. The closeness of the angels clears your mind, and invigorates your aura. Communication is now unimpeded and rapid, because your vibration-rate is quickened by these Angels of Light. They are of the Host of the Cherubim, and they have been sent to bring you into the presence of the great Teaching Angels of Humanity.

The boat turns about as the six oars rise and dip in the still waters, and then glides forward like a swan toward the pearly-gray mist. As it enters the mist, your vision becomes limited, seeing less and less, until even the sides of the boat disappear. Then the angels too seem to vanish. And for an instant you feel on the verge of heartbreak: have your newfound companions gone? Have you just found, only to lose so soon? But a mind-touch speaks, saying **'Look to the prow'**. There you can still see the violet flame burning clear and strong. Opening your inner senses... you find the presence of the angels soothing your fears, letting you know that, although they are not always in sight, they are *always* there.

The mist begins to thin, there is a warm golden light ahead into which the boat carries you. All around are the still waters, but now they reflect a gold sky that shines with the beauty of a sun and the softness of a moon. And up in the golden sky you see bright points of light flying and hovering. On board, your angelic companions begin to sing a paean of joy – high and pure like temple bells. You realize they

are communing with those flying lights, which respond by swooping closer, singing too as they come. Now you can see that they are also angels. Unbounded by any limitation, they soar in the light of the endless day. Some carry chalices, and they swoop down to the surface of the glass-like lake, hovering like celestial dragonflies. Then they fill the chalices from the lake and fly from sight with the speed of comets. Your curiosity is aroused; so, one of the Cherubim explains:

> **They are the Ministers of Consolation. In answer to true prayers, they take cups filled from the Still Waters to those who are in need. Have you not realized yet what these waters are? Look into their depths.**

So you do and see beneath their placid surface billowing tides of fire! The Cherub explains:

> **The Still Waters are pure Grace. From this lake, all healing-centers upon the Earth draw their power. To this lake the winged ones bring those who suffer, while they are asleep. And from this lake, angels draw Heaven's Dew[8] and take it to those of the Earth plane who have need. This is why it was necessary for you to bathe in the waters before coming with us.**

One of the other Cherubim on board approaches, holding a crystal cup within which the Still Waters glow, and offers it to you. You take the cup, and you drink of the Life of Worlds.

Ahead appears a tree-covered island, with a high hill in its center, upon which stands a great temple seemingly built of sunlight. The radiant structure is ornamented with domes, cupolas, and graceful minarets; and its image is reflected on the surface of the healing lake. The boat approaches the mystic isle. A warm breeze blows from the island, it carries the scent of laurel and frankincense trees. Looking at the island you cannot see any path up to the temple, and you wonder how to reach it.

Then, a sound like wind-chimes makes you turn back to the

Cherubim, and so you learn that angels *do laugh!* Smiling, two of the Cherubim place their strong arms about your waist, spread their great wings, and rise with you up into the air. The other angels accompany you, singing as they fly. And with this joyous escort you are flown up the hill, to the temple, and through a rose-window set high in one of the walls. And then you are set down on the mosaic floor of the sanctuary.

The temple is vast; it soars up almost beyond sight. Inside, the golden walls are the color of gleaming amber. In the East is a great seven-branched candlestick – the Lamp of the Elohim[9] – its seven flames make the rainbow spectrum. On one side of the candlestick is a pillar of black obsidian, and on the other side is a pillar of diamond. In the center of the temple, on a dais of four steps, is a simple white cubic altar, its simplicity is stark in this glorious edifice. From above, a shaft of gentle starlight shines down upon the altar, and reveals what lays upon it – a golden-yellow rose on which gleams a single drop of dew from the first dawn.

The Cherubim have formed a semi-circle around you. The descending shaft of star-light brightens, as a great Voice cries:

'Michael!'

There appears by the altar a column of gold and pink light, some twenty feet high. Then the Voice speaks again:

'Gabriel, Samael!'

And now two great columns – one silver and blue, the other a fiery scarlet – flank the first column. Again the Voice sounds:

'Raphael, Sachiel, Asariel!'

Three more bright columns appear, one a vivid yellow, another violet-purple, and one more of sea-green light. And for a third time, the Voice fills the temple:

'Anael, Cassiel, Uriel!'

Another trinity of luminous columns appears to join the other six – one of rose and turquoise, one of dark green and blue, and the third one is as brilliant as frozen lightning. These nine resplendent columns rear about the altar. Great chords of music are heard, and rapid flashes of color pass between them, as they speak one to another. The attending Cherubim brighten in response to the presence of the great angel lords.

Now the Voice speaks again, calling you by name. Encouraged by the Cherubim, you step towards the great columns of light and color. The columns begin to move from the altar... sweeping around you, as if examining. Each column brings a different emotional response from you. After a while, your sense of awe changes into pleasure before the wonder of these great lights. You feel the mind-touch of Raphael first, your consciousness 'tingles' at his mental touch.

> **Greetings, Child of Earth. My companions and I are pleased that you have won through to this place. We were appointed by the Ineffable ONE to help instruct your kind for its journey back to Godhead. And now that you have come here, our work together may begin in earnest. Know this – we will never turn away from you, when you call, we will always come – however, you may, if you wish, turn away from us. But we are constant – like THAT of Whose Light we were born – we abide.**
>
> **We are Servants of The ONE; what you see of us now, is a veiling of our true forms, whose light would sear the unprepared. Because we are those of our kind with whom you will work the most at first, we will now take on thought-presences, forms more familiar to your mind. Thus, shall we become more than teachers and pupil – we shall become friends; for your life, and ours, are one in God.**

As he speaks the columns change into winged human-like forms. The yellow column of Raphael becomes a Mercury-type figure with winged sandals and a caduceus. The purple column of Sachiel forms into a violet-clad king of great benevolence. Gabriel appears as a Grecian ath-lete in a blue chiton, Samael as a knight in a scarlet surcoat wielding a bright sword, Michael as a gold-vested priest, Asariel is robed in sea-green and holds a silver trident, Anael in a turquoise robe wearing a coronet of pink roses, Cassiel is crowned with jet and robed in deep green and blue, and finally, Uriel wearing a rainbow robe with a bright flame upon his head. With the Teaching Angels in these forms, you feel less awestruck, and more able to approach them – as they intended.

Together you share some moments of private communion.

Then Uriel gives a signal to his brethren. You draw back, as they resume the appearance of tall columns of coruscating light. They form a ring about the altar, and begin to circle it... faster and faster, until they no longer seem to be separate columns, they merge and create a great vortex of colored light. They stretch upward, growing brighter in intensity and power, and then... they are *gone!*

And where the altar stood is now the crystal gate-between-the-worlds, with its indigo curtain on which shines a single star.

You make your farewells to the Cherubic crew of the boat... with the intuitive knowledge that you will meet them again. Then you go to the crystal gate... its curtain billows open, and as you step through, poised between the Worlds, you hear Archangel Raphael's voice again, saying: **'When you call, we will come'.** The curtain closes behind you.

You have traveled far and deep, so it is important to earth yourself. Focus on the weight and warmth of your physical body, your breath, and the moisture in your mouth. Repeat your name a couple of times to establish your identity. Make sure you have a warm drink and a biscuit or sandwich to help you close down. Then write your record of this vision-journey as soon as possible, because, like a dream, the details and impressions soon fade.

Gustave Doré, *Gabriel*

CHAPTER 3

MOON MAGIC

In the first rank I saw Gabriel...
like the Moon amongst the stars...
He is the most beautiful of angels.[1]

Since time immemorial, the Moon has been associated with mystery and magic. Its beauty has inspired countless poets and artists. Lunar power is the basis of many magics. For millennia, those-with-knowledge have used the lunar energy because it governs the tides of physical life itself. By the waxing and waning of the Moon, the tides of oceans and seas are regulated, plants and animals are brought to birth, growth, and the secret dreams of humans are empowered.

On the physical plane, the Moon exerts a gravitational pull on all fluids – most clearly seen with seas and oceans. And most earthquakes happen at either a New or Full Moon, because the fluidic magma – on which the continental plates 'float' – is also affected by the gravitational pull of the Moon.

Our physical bodies are 90 percent water. And at Full Moon, when the monthly high tide is reached, we are affected in the depths of our psyche – strange memories and thoughts stir – and our latent psychism is brought close to the threshold of consciousness. This is why esoteric exercises that are designed to bring about psychic unfoldment – clairvoyance, astral travel or scrying – are best undertaken at Full Moon.

Full Moon is also a cause of mental instability (lunacy); and more help could be given to the mentally sick, if those who cared for them also studied the Lunar Lore. In a person's horoscope, the position of the Moon signifies the soul-type (the psyche), while the Sun indicates which aspect of Spirit is seeking expression through the individual.

As one ritual states: *'... with the Mother (Moon) are the keys of life; but with the Father (Sun) are the keys of the spirit.'*[2] In the same way that the Moon reflects light from the Sun to the Earth, so the soul receives its illumination from the Spirit. And, it depends upon our development as to how much of our Inner Light is reflected into manifestation. So, like a crescent moon, some souls show only a fraction of their Spirit's splendor. Others, like a dark moon, are hidden under the Earth's material shadow and are unaware, as yet, of the Upper levels of Being. And then there are those beautiful souls who, like a full moon, shine like lamps upon the Earth, turning night into a silver day.

To the ancients, the Moon was known as the 'Queen of Heaven'. The Moon was worshipped as the symbol of Great Isis. The Alchemists used a Moon as a symbol of the 'World-Soul'. All birth, nurture and growth on a global scale is Moon-ruled. The New and Full Moons are the high points in the life-regenerating tide. This is why ancient priesthoods observed the New and Full Moons as times of intense magical focus. And still today, Tibetan Buddhist monasteries observe the days of New and Full Moons as times of auspicious spiritual work. In synagogues around the world, special prayers are said on the Sabbaths before a New or Full Moon. In fact, many religious cultures still use a lunar calendar to calculate their high and holy days. The celebration of Easter is calculated as the nearest Sunday after the Full Moon that follows the Spring Equinox.

The Lunar Tides

It is by the Moon that we can determine the tides of the life-giving energy that sustains all manifested life. Yet physical substance is transitory compared to the Higher Worlds. The cells of a human body are in a constant flux of renewal and decay, of birth and death. Our bodies replace nearly a third of their cells every twenty-four-hour cycle.

It is the Etheric body (sometimes called the Subtle body), which is real in any permanent sense. The Etheric body draws its nourishment from the tides of vital energy that are regulated by the Moon. This life-sustaining energy is known in the East as *prana,* or *chi.* Western occultists call this *Etheric* energy. It is the Etheric energy that

manifests as a person's physical vitality and health; which is why the Etheric aura (the energy-field closest to the body) is used to diagnose with clairvoyant sight.

This dynamic sea of Etheric force pervades and penetrates all living things, animate and inanimate. It interconnects all manifest life. The planet Earth's aura extends far beyond its atmospheric belt; it reaches out as far as the orbit of the Moon. And it is the movement of the Moon through the planet's aura that causes the life-tides to ebb and flow. Like an ocean-going ship causes a wake in the waters through which it passes, so the passage of the Moon creates great currents in the etheric Sea of Life.

If we cut ourselves off from the Etheric flow of energy, we invite sickness to be our guest. The Etheric life-force flows through everything on Earth; we live and move in it. It can be increased by excitement, dance or by magical ritual. It can be depleted by isolation, psychic vampirism and organic illnesses. It is the chakras in the Astro-etheric body which distribute this energy, and a network of channels (meridians or *nadis*) carry it throughout the organism.

The knowledge and study of these channels forms the basis of Acupuncture. Acupuncture frees channels that have become blocked or distorted, so that the flow of the life-energy may be unobstructed. In classical China, an acupuncturist wore white (a Moon color) and used silver needles (the metal which resonates with lunar energy), and would only give treatments during the Moon's waxing tide.

The planet Earth also has its own channels to conduct Etheric energy throughout its global body. These channels were called 'Moon Roads' in the West, while the East called them the 'Paths of the Dragon'. Nowadays these channels are known as 'ley lines'. This global network carries the vital energy all over the planet's surface. Where two, or more, Moon roads meet their intermingling causes a spiral of energy to form. The ancient priesthoods built their sacred edifices on these spirals – dolmens, stone circles, pyramids, or temples. At the times of New and Full Moons, the initiates worked their awesome rituals to add that energy to the lunar force, which would then radiate throughout the land, bringing renewed energy, vigor and

fertility to all within its sway. Seen with the inner eye, the great network of Moon Roads appears as a vast web of silver, pulsating with the vital energy that nourishes and sustains the world. It is from this torrent of living power that the Faerie Hosts (Nature-spirits) draw their energy. And for this reason, the wise ones worked their ceremonies at the Full Moon to work with that power. It is a wonderful sight to see the land en-silvered with moonlight, and the Elven folk dancing the Moon roads, filled with the cool, white fire of their Mother.

Lunar Lore

In the cyclic life of our solar system, the Sun is like the hour-hand of a clock, because it takes twelve months to pass through all twelve signs of the zodiac. And the Moon is like the minute-hand of the same clock, because it passes through those signs every twenty-eight days (one lunar cycle). The Moon travels so fast (the width of its disc every minute), that when viewed from deep space, our planet seems shrouded by an aura of silver light, as our satellite moon weaves a veil of protection as it orbits the Earth.

It is the knowledge of the phases of the Moon that enables us to empower our magics. By attuning ourselves to the energies of the Moon's phases, we can add those powers to our own efforts. In Magic, like swimming, it is wiser to move with the tide than against it – although every experienced practitioner has to learn how to swim against the tides in emergencies.

The Moon has two major tides: the *waxing* tide, which is from New Moon to Full Moon. And the *waning* tide from Full Moon to 'Dark-of-the-Moon' (the day before a New Moon). Each of these tides has its use. Also, each of these twin tides has an halfway point. So each complete lunar cycle has four quarters, these are:

◆ the First Quarter is from New Moon until seven days later;
◆ the Second Quarter is from First Quarter until Full Moon;
◆ the Third Quarter lasts from Full Moon until seven days later;
◆ and the Fourth Quarter is from the Third Quarter until the Moon appears to vanish on the 'Dark-of-the-Moon'.

A complete lunar cycle is twenty-eight days long, which in ancient texts are called the 'Twenty-Eight Mansions of the Moon'.

The Mighty One of God

The archangel of the Moon is Gabriel; his name means 'God is Mighty'. Gabriel is the Prince of the Foundation, and ruler of the zodiacal sign of Cancer the Crab. The Archangel Gabriel is the bringer of the Word, the Giver of vision, Ruler of the angelic host of the Cherubim, and Regent of the element of water. In sacred art, Gabriel is often portrayed holding 'a branch from paradise' – a staff with lilies – and lilies are sacred to the Moon. This staff is the rod-of-power and – like the miraculously flowering staff of Aaron (and that of St. Joseph of Arimathea) – it symbolizes the Etheric tides that are the regulators of life-vitality. The annual resurgence of plants at Spring-time is caused by these hidden tides. Gabriel sometimes appears in female form, because of the nurturing aspect of the Moon. When he appears in masculine form, it indicates the initiating aspect of the same force. In the ancient pantheons there were both Moon gods, as well as the Moon goddesses.

Gabriel may be visualized with eyes green as a storm-tossed sea, and aura-wings colored violet and silver. The presence of this archangel is heard like the sound of many waters.

Creatures of the Moon

Dogs are sacred to the Moon. In Egyptian myth, Anubis, the Jackal Lord, is the guardian of Moon-Mother Isis. And all breeds of the canine family – from wolves to Pekinese – come under Gabriel's rulership. Gabriel may be invoked for the healing and well-being of pet dogs. Also, hares (but not rabbits), owls, large spiders and night-flying moths are messengers of the Moon's archangel. All types of shellfish are moon-ruled; and a lobster (crayfish) appears on the eighteenth Tarot card, 'The Moon', along with a wolf and a dog.

In the vegetable kingdom, the willow tree, melon, lychee, and pear resonate with lunar power. Pearls, moonstones, mother-of pearl, and the metal silver all carry lunar magnetism well, and can be used in Moon magic. All white flowers, especially lilies, hold Moon

vibrations. To attract the Moon's blessings, you can place white flowers in the window (where the Moon can 'see' them) at either New or Full Moon. The colors of white, silver, and a curious silvery-green are visual Moon vibrations.

Your Moon Angel

All magics of the Moon come under Gabriel's presidency, but to practice this aspect of the Sacred Magic of the Angels, a practitioner must also invoke the assistance of his or her 'Personal Moon Angel'.

A person's 'Moon Angel' is the angel who rules the sign of the zodiac that the Moon was in at the moment of their birth. A horoscope is a snap-shot of the universe at the moment of a person's birth (when they took their first breath).

Table 1 gives a list of the ruling angels for each of the twelve signs of the zodiac. Information of the Moon's position through the months and years can be obtained from an *ephemeris;* you can purchase one for each year, and they are inexpensive. By looking in the tables, you can find the sign that the Moon was in on the day, and at the hour, of birth. The Moon takes between two and three days to pass through a sign, but it is variable, so one must consult an ephemeris for the exact year. The ruling Sun Angel is the angel who rules the zodiacal sign that the Sun was in at the moment of birth. If you were born on the 18th of March 1954, the Sun was in Pisces (Sachiel) and the Moon was in the sign of Virgo (Raphael), so your Moon Angel is Raphael, and your Sun Angel is Sachiel. (You can go to *www.sacredmagicoftheangels. com* to see my video on how to find out who is your personal Moon Angel.) Knowing who are your personal Moon and Sun Angels is very important, because both of them are invoked in various ways for different parts of the sacred magic.

The angels work from the Astral plane (which is also the emotional plane). Invoking them is an act of concentrated thought, which is empowered by your Astral body. This causes your aura to light up. Then, your intention is amplified by your personal Moon Angel, transmitted to Archangel Gabriel, and so brings your desired goal into the physical realm.

Table 1 The Zodiacal Rulerships of the Teaching Angels

ZODIACAL SIGN	ANGEL	ZODIACAL SIGN	ANGEL
Aries	Samael	Libra	Anael
Taurus	Anael	Scorpio	Samael
Gemini	Raphael	Sagittarius	Sachiel
Cancer	Gabriel	Capricorn	Cassiel
Leo	Michael	Aquarius	Uriel
Virgo	Raphael	Pisces	Sachiel

The Talismans of the Moon

Angelic Moon magic uses the two great etheric tides of the Lunar cycle: the waxing-tide, because that is when things increase and prosper, and the waning-tide, during which things diminish and die back. To use these tides two sacred talismans are used. They are called the 'Tablets of the Moon', and they are the *Invoking Tablet* and the *Banishing Square*, both are holy to the Archangel Gabriel. For best results, these talismans are made during 'The Hallowing' ritual (see page 64).

The Invoking Tablet

This talisman of power is used during the First Quarter – the closer to a New Moon, the better. Its function is to bring about the increase of anything good. But, this does not mean that you can invoke for everything all at once. Each matter needs to have a separate Invoking Tablet made, and consecrated, for it alone.

In shape, the Invoking Tablet resembles the Tablets of the Law, the Ten Commandments (see figure 1 on page 58). This is because Moses received the Law – which underpins Western civilization – on the day of the New Moon. And Moses received the tablets on Mount Sinai, which was named for *Sin,* a Chaldean Moon god. This tablet first appeared in print in *The Greater Key of Solomon*[3] – as the 'First Pentacle of the Moon' – but this talisman is far older than that book, by many centuries.

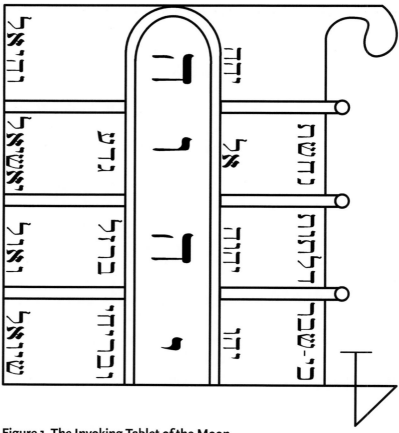

Figure 1 The Invoking Tablet of the Moon

The Invoking Tablet of the Moon can be used to increase anything that is wholesome in your life. It may be used to increase health, business, or money earned. It can be used to bring anything 'to birth', for example, to start a new job or a new project. It is good for convalescents, because it brings physical rejuvenation. It is also particularly useful for matters of female health, such as menstrual problems, conception, childbirth, or menopause. This Invoking Tablet can be used to bring into manifestation any of the matters that the Archangel Gabriel rules (see Chapter 4), and also to invoke the other angels through the agency of Gabriel.

The Invoking Tablet of the Moon is drawn upon white paper

using any color ink. You could use a variety of colors, making of the tablet a thing of beauty. You can also use the colors of any other angel who rules the matter you are invoking for (see page 112).

First, draw the outline of the whole tablet; then the letters in the far right-hand column, and then those in the far left-hand column. Finally, you draw the Tetragrammaton – the four letters of the Sacred Name of The ONE – in the central arch. Because all of these letters are Hebrew, it is important that you write them from right to left. The Hebrew words on the tablet are various Divine titles, the names of certain angels, and verse 16 of Psalm 107 (*'He hath broken the gates of brass and smitten the bars of iron asunder'*), which refers to limitations being overcome by the power of the Invoking Tablet.

Your petition is then written on the reverse side. This must be written in the *Theban Script* (see page 108). The *Theban Script* is one of the magical scripts that are used in angelic Theurgy. All you simply do, is change the letters of the wording of your petition from those of our Roman alphabet (English) to the corresponding symbols shown in the chart of the *Theban Script*.

You may invoke any angel by the Invoking Tablet of the Moon, but only during the phase from New Moon till the First Quarter. Chapter 5 gives the rulerships of all the Teaching Angels, so you see which angel to invoke for your need. The nature of your desired goal will determine the wording of your petition. If, for example, you need a car, do not invoke for *'money to buy a car'*, as that puts limits upon how the universe can manifest the goal in your life. Rather invoke for the goal itself – a car.

But, should money itself be needed – for example: to repay debts – then do invoke for *'the means to earn money'.* In this way you are stating that you are prepared to do your part – to work for the money – and you are invoking the angels to create an opportunity to earn it.

It is *not* true that hard work always results in success! Any farmer will tell you that he may work very hard – sowing seeds, caring for the ripening crop throughout the seasons – only to have it destroyed by flood, drought, or pestilence at the last moment. All that hard work was wasted. With the Sacred Magic of the Angels, we invoke in order

to earn – we will do our part, knowing that the angels, if they consent, will facilitate the opportunities and safeguard the outcome. For help with exclusively financial matters, you would invoke the Angel Sachiel of Jupiter.

In health matters, you cannot just invoke for 'good health'. You must be specific. Petition for the healing of the disease, and you will be made whole. And once asked for, healing may come from any source: doctors, healers, or from a profound change of attitude.

This Magic of the Moon can only be used to invoke healing for yourself and your immediate family (Gabriel rules the family unit, not extended family). Elsewhere in this book, I will teach you other sacred techniques that can be used for invoking healing for other people.

There is a temptation with magic to think of oneself as a 'magic doctor', able to invoke healing for anyone who is ill. But things are not that simple – as many healers have found to their cost. It is a true teaching that, at our present stage of evolution, many of us still learn more through suffering than we do through joy. In times of happiness and contentment, we tend to become complacent, and concerned that our happiness is not taken away. It is in the dark times of pain, anxiety, loss, or loneliness that most of us – through reflective introspection – gain insight into our own created life-patterns. It is then that we recognize our repeated negative emotional patterns that trap us in downward spirals.

So, approach this issue of healing with caution. Because the 'do-gooder' who jumps in with both feet – without anyone's permission – robs the people they thought to help of their own realizations – and subsequent growth. And also the ill person's Higher Self has then to exteriorize yet another dis-eased condition to get their attention. The personal lives of many 'do-gooders' are a mess – a sure indication that they are not on Karma's list of friends.

Using this system will not make you a healer, that is a specialized vocation. But, if you are asked for help by a sick person, that is another matter entirely. Then you may petition the angels on that person's behalf. And the following wording for such a petition of healing is very effective:

'**May the affliction that** [here name the person concerned] **must endure be borne for a good reason, or speedily pass away.**'

My experience over many years is, that using this wording for a petition will often cause the ill person to have a personal realization, that then results in their physical disease being completely healed.

When using these Moon talismans, you are reaching the ruling angel of the matter concerned through the influence of Gabriel and your own Moon Angel. As an example: if you were invoking for healing from the after-effects of surgery (ruled by Angel Samael), the wording of your petition on the Invoking Tablet would begin:

'**To the Angel Samael of Mars, through the Archangel Gabriel, may the...**'

And you could draw color the tablet in red and orange – the colors of the holy Angel Samael.

Each individual request must have a separate tablet made and consecrated for it. After an Invoking Tablet has been made and consecrated, it is then kept for a one lunar cycle (28 days) and burnt the following New Moon.

Although you may make several Tablets at one time, bear in mind that – like cooking, having several pots on the stove at once – it divides concentration and diffuses power, so the results may take longer to manifest. It is far better to do one at a time. Of course, sometimes several serious problems do come up at one and the same time, in which case, I suggest you make an Invoking Tablet for one of those issues, and then use one of the other techniques given in this book for the other problems.

The Banishing Square

This second talisman of the Moon is much simpler in design, but that does not mean that it is less powerful (see figure 2 on page 63). This talisman is used to banish circumstances that restrict you from being fulfilled. Illness, poverty, troubles of any kind – existing now or

threatening to manifest – may all be removed by the correct use of this talisman.

The Banishing Square is made and consecrated on the first night *after* a Full Moon, that is, in the Third Quarter. As the Moon diminishes, so will the adversity that you wish to pass out of your life. This Square can deliver you from any conditions, situations that you have outgrown, but which still clog up your life. It banishes any restrictions that obstruct your progress. It can also be used in cases of people, or relationships that have become dysfunctional, or one-sided.

The Banishing Square is similar to a Native American 'Give away', in which any restrictive influences – whether they be things or individuals – are given back to the Universe with an open heart, and asking for a blessing on their journeys. Even an illness can be transformed, and its inherent energy can be transmuted into life-enhancing power.

The Banishing Square is drawn upon white paper in black ink. First the grid of lines is drawn, then the word **'BUAH'** (which means 'to dispel', 'to avert') is written at the top in the English alphabet, then the same word is written below in the Theban Script (written left to right). In the center of the square, write in Theban what you wish to pass gracefully out your life. Like the Invoking Tablet, one Banishing Square needs to be made for each individual matter; one square cannot be used for multiple issues.

The consecrated square is kept for one lunar cycle, then burned at the following Full Moon. If by then the matter of which you wished to be rid of still persists (some things are stronger than others), make another square to continue the work. But, if the matter has already shown signs of diminishing, you may take this as an indication that the matter is in hand, and leave it to the Celestial Powers to complete.

The Banishing Square is particularly powerful for dispelling sickness, poverty, domestic or emotional problems.

9 In great need, you can use both of the Moon talismans in conjunction. For example: great poverty – a day after a Full Moon make a Banishing Square to banish poverty; and, at the *following* New Moon, make an Invoking Tablet to petition for the opportunity to earn money.

Figure 2 The Banishing Square of the Moon

The Hallowing

This is the ritual used to consecrate and empower the Talismans of the Moon. If you have never performed a sacred ceremony before, I suggest that you do the guided meditation 'Circle of the Moon' before doing this ritual of 'The Hallowing', because that visualization will give your subconscious mind images in which it can 'clothe' the lunar powers (see Practice 2, page 67).

Ensure that you will not be disturbed – it is important to arrange things so that you can work without interruption.

Set up an altar: any table covered with a white or pale-green cloth, facing to the west if possible, with two white candles upon it in candlesticks (white, silver-plate or glass are best), a central light to represent the Divine, and good quality incense (like church frankincense). You can also place these two Tarot cards on the altar if you wish: 'The High-Priestess' for the Moon itself, and 'The Chariot' for the zodiacal sign of Cancer the Crab. Some white flowers in an appropriate vase can make a good centerpiece. Also have your paper, scissors, ruler and colored pencils. And it is advisable to lightly draw out the talisman in pencil before the hallowing, as this makes it easier to ink-in during the ceremony.

Take a bath, holding the intention of purity in mind. You are about to undertake sacred work in the presence of angelic powers and so you should be purified. Wear clean clothes, or a robe; note that in the Sacred Angelic Magic, black is never worn.

Enter your sacred space and light the lamp upon the altar; and from its flame, light the two candles and the charcoal for the incense. Sit in meditation for a while, allowing all thoughts – except from your ritual intention – to just fall away. If there is a persistent worry (it may be related to the matter you are working for), don't try to suppress it, just mentally make an arrangement to give it due attention later; then it will quiet down and leave you free to proceed.

When you are ready, put a little incense onto the hot charcoal, and go to the altar and pray:

Oh Almighty Living ONE, purify and protect this place wherein I stand. And if it be Thy will, send Thy holy Angels of Light to minister unto me in this matter which, holding in my heart, I now raise unto Thee. Selah.

Take the lit lamp from the altar and, holding it before you, walk in a clockwise direction around the room, visualizing as you do so, a circle of white light being formed by the lamp. When the circle is complete, return the lamp to the altar.

Now pass your hands, paper and instruments through the rising incense smoke to purify them all. Now proceed to make the Invoking Tablet or the Banishing Square of the Moon. When the talisman is completed, take it in both hands and stand at the altar again.

Using your own thoughts and words, call upon the Archangel Gabriel. He will formulate behind the altar, facing you across the sacred light (use details from the various meditations in this book). Next invoke your own Moon angel; you will know when this angel has come by a sense of presence just behind your left shoulder. Then, focus on the angel who rules the matter being petitioned for, call that angel – you will find that your Moon Angel will help you with this. When the ruling angel responds, he may be discernible to you as hovering up above the altar itself.

In the presence of these Shining Ones, read your petition aloud with concentrated intent; then lay the talisman upon the altar. There will be a sense of power entering the Invoking Tablet or Banishing Square, it will 'come alive' in a curious way. Then the ruling angel of the matter will withdraw, taking the essence of your petition with him.

Courteously thank your Moon Angel and the Archangel Gabriel, who will also then depart.

Now take up the lamp again and walk the circle, but this time counterclockwise; the circle's radiance will return, via the lamp, to the Heart-of-all-Brightness.

Finally, stand again at the altar:

Oh Almighty Living ONE, I give thanks for Thy graciousness.
May all summoned powers return to their own proper realms,
with Thy blessing. Selah.

Extinguish the candles and dismantle the altar if you need to. Leave the burning lamp and the white flowers on a windowsill as an offering to the Moon powers. Keep the hallowed talisman in a safe place.

When the time comes for the talisman to be destroyed, all you need to do is raise a simple altar – just a cloth, lamp, and receptacle for the ashes.

Invoke the Living Almighty ONE as before, establish the circle of light with the lamp, then, in your own words and with love, thank the angelic powers concerned, then, lighting the corner of the talisman from the altar lamp, place it in the receptacle to burn completely.

Repeat the *'License to Depart'* (the final words of the ceremony), and put the ashes of the talisman into the good earth or running water.

PRACTICE 2
Circle of the Moon

Sit quietly and relax. Let your breathing be deep and even, without strain. Turn inward to the still center of your being, the eternal You.

Around you rises a pale green mist that sparkles with silver motes of light. This mist envelops you; you shiver slightly at the touch of the astral chill, but soon adjust. Now you gently rise, floating like a feather on the evening breeze.

When the mist fades... you are standing on top of a hill. It is dusk, the Sun has just sunk into the west, and the first stars are spangling the sky. There is a valley below, and although it is too dark to see well, you can make out the silver ribbon of a stream that flows through it, and the white bark of willow trees along its banks.

Unexpectedly, a cold muzzle touches your wrist. Startled, you turn to see a great wolfhound seated beside you. Its coat is a soft white, and around its neck is a collar of moonstones linked with silver. The hound gazes up at you with indigo eyes, that contain an intelligence beyond its animal form. Now that the surprise of its arrival has passed, you smile, and reach out a hand for the wolfhound to sniff... then scratch it behind the ear... and smile at the sound of its wagging tail thumping on the ground.

Now that the introductions have been made, the hound rises and descends the hill. You catch up, accompanying your new companion, with your hand resting lightly on his fore-shoulders. Closer to the valley now, you hear the stream's waters. Then, the high warbles of a nightingale singing from the trees, as you come to the valley floor. And, as if this were a signal, the Full Moon rises over the treetops and ensilvers the whole valley with its light. Every blade of grass, every leaf, seems to be spun from silver tissue. The air itself is suffused with a violet radiance. Even a white owl, flying overhead, seems made from the Moon's own essence. You feel at peace in this valley, as if you had always, somehow, known it.

For a while you and the dog walk by the stream, pausing occasionally to admiringly stroke the trunks of the weeping willow trees. Then, getting a little 'moon-drunk', you and the wolfhound play hide-and-seek among the curtains of the trees' branches.

Chasing after the wolfhound, you stumble into a forest glade. In the center stands a circle of nine upright dolmens, each standing stone is twice your height. In the center of this circle is a stone font, filled to the brim with water that shimmers in the moonlight. An atmosphere of power fills this glade; it seems to emanate from the font. You begin to wonder whether you should retrace your steps away from this glade, but the wolfhound looks up at you, wagging his tail to reassure you that all is well. Putting apprehension aside, you follow the hound, who has begun to playfully lope around the circle's perimeter. Misgivings forgotten, you enter into the spirit of the game and try to catch the dog's tail – as all the time the Moon rises in the vault of heaven.

Abruptly, the wolfhound stops in his tracks! You have to quickly swerve aside to avoid colliding with him. The hound looks up to the sky. You follow his gaze, and see that the disc of the Full Moon is almost directly overhead. The wolfhound throws back his head and emits a howl that fills the valley and echoes off the surrounding hills. After the howl, all seems silent. Then, the hound begins to trot again, weaving in and out of the nine sentinel stones. He looks at you over his shoulder, as if to say: **'Follow me'**. You do.

Human and animal, representatives of two kingdoms of Creation, weave between the members of a third – the stones of the mineral kingdom. It becomes a dance. The quartz embedded in the stones glimmer in the moonlight as your dance weaves about them. You loose count of the circuits you've made while dancing in the silver light of this enchanted place. Then, the wolfhound turns inwards, you follow, to both spiral inwards toward the circle's center... coming to a halt by the stone font. Again the wolfhound sounds his mournful howl, as the Moon comes directly overhead... and a moonbeam – an 'arrow of Diana' – shines downward onto the circle, and a perfect image of the Moon is reflected in the waters of the font.

The moon-shaft grows in brightness, becoming a pillar of silver-blue fire that unites the Moon above with her image in the watery mirror below. Now the shaft of moon fire begins to turn, increasing in strength and diameter. The font, filled with lunar flame, now appears as if carved from a great pearl.

And now the moon-fire overflows the font and spills over its rim... pouring onto the ground... and flowing all across the circle. As the silvery fire sweeps past your legs... a thrill of icy power rushes up your spine, and centers at your forehead. The sensation affects your vision... as a curtain of swirling colors – purple, violet and hazy silver – fills your sight.

Adjusting to this higher level of perception, you now see the scene with spiritual sight. Each of the standing stones in the circle appears as a great crystal, receiving and transmitting the Moon's power. Each one sings as it resonates; and each one is linked to its sister stones, each different in tone, the whole forming an arpeggio of sound. This is why the ancients called these circles 'choirs'. And in between each of the crystal monoliths stands an *angel!* Nine monoliths and nine Cherubim making one circle of power.

The Cherubim are beauteous, beyond the duality of gender, yet containing the noblest aspects of both. Their aura-wings are living glories, and a white brilliant flame crowns each one. Strong are the Cherubim – strong beyond the imagining of mortals. Their power is irresistible, yet that power is ensouled by a brooding love.

For the third time the wolfhound howls, and the song of the Circle of Power increases. The huge crystals hum deep bass notes, like a mighty organ. And in response, the Cherubim sing high notes of unimaginable purity, which descant over the deep notes of the crystals.

From across the font, a photon of light appears... it gathers in size and substance... then flares open, to reveal the Archangel Gabriel, high servant of The Almighty ONE! The Archangel of the Moon is nine feet tall, and his violet and silver wings brush the edges of the circle. He is robed in the blues of the ocean. And on his head is set a silver diadem upon which shines the Name of God, written in letters of fire. In one hand, Gabriel wields a rod of power, flowering with white lilies.

The archangel's eyes are green as a storm-tossed sea, and all about him is the sound of mighty waters.

Here, before you, stands the 'Mighty One of God', the Voice of Heaven. And awe has you by the throat, as the green eyes of this celestial being – who existed before the galaxies were born – hold you with their gaze. Yet, despite the awesome power of the archangel, you know that he is veiling his strength, stepping it down, so that you might be able to endure it so that communication can take place. There is a tingling in your mind, an adjustment, like a radio being tuned... then, by the archangel's mind-touch, his voice sounds, bell-like, in your mind:

> **Hail, Child of Earth, offspring of The ONE. Much joy is ours that you seek your heritage and call us for help on the Great Journey to Divinity. Use the sacred knowledge imparted to you and profane it not, thus flowers will adorn your path. Call us when the cycles are propitious – known by the brightening and dimming of your planet's Moon. Now gaze into the Font of Vision.**

You look into the waters of the font, and there appears the image of a strange crown. It has two horns, and between them rests a Crescent Moon and a single Star. Wonderingly you look back up at Gabriel, who continues:

> **By this sigil you may summon me from the Uttermost. Let your mind create it in silver fire, and I will be with you. Since the days of Enoch, now the Prince of the Countenances, have I come to answer humanity's prayers. And you may return to this circle of power whenever you have need. The guide will bring you; but know that he be no true Earth creature, but is a spirit of the Moon. Now receive by me the Blessing of The ONE.**

The archangel's face grows brighter and brighter, until its radiance makes you look down. But the eyes of the archangel remain in your mind, eyes that have looked upon God, face-unto-face.

When you look up again, Gabriel and his attendant Cherubim have gone. You are standing in a circle of nine gray stones, next to a weathered stone font with rainwater caught in it. And seated by the font is a large wolfhound. The Moon has sunk from sight behind the hills that surround this sacred valley.

With the guiding hound you leave the Circle of the Moon... and return along the stream's bank, towards the hill by which you came... as you mount the hill's sloping sides, you hear the hooting of an owl, and wonder if it is the same owl you saw in flight – oh, how long ago?

At the top of the hill, you turn to look back at the valley, now hidden in shadow. A pale green mist that sparkles with silver begins to rise... it is time to thank your guide. The wolfhound rears up placing his front paws upon your shoulders. He licks your cheek with his warm tongue; and as he does so, you hear his voice: **'My name is Atliel. Come and play again'.**

Then the mist covers you, and you experience the same floating sensation as before... then gently settle back into your physical body.

Make sure you are fully aware of the Earth level. Have a good stretch and a warm drink. Then record your interior journey before the details fade from memory.

CHAPTER 4

ANGELIC HEALING

The Sun of Righteousness rises with healing in his wings.[1]

Angels are the servants of Life. And because they oversee the universe – with all of its complex interrelationships – the angels have great powers of healing. We humans are a combination of spirit, psyche, and physicality. And different angels can heal diseased aspects of our totality. For example: one angel heals disorders of the nervous system, while a different angel heals damaged bones, and yet another heals mental problems, and so on. So you do need to know which angel heals which specific disorder. The healing Magic of the Angels is not diagnostic – it does not tell us what is wrong. But once the illness has been diagnosed, it will enable us to invoke for – and receive – healing of specific illnesses.

The angels will usually bring healing about through natural channels. And individuals are often used as agents of the angels. Examples: a person is inspired to go to a different doctor; an acquaintance recommends a healer; a magazine article or television program supplies information that leads to deeper understanding of an illness that leads to healing. All the healing professionals – nurses, surgeons, vets, doctors, dentists, etc. – are linked to the healing ministry of the angels.

Yet sometimes, the healing that comes from the angels is miraculous. But these miraculous healings usually happen when there is no other channel open. I have personally known of hundreds of cases of healing brought about after angelic invocation has been made. The only times I have seen miraculous healings have been with cases

where the medical professions have despaired or pronounced the situation hopeless. If I have learned anything in my years of practicing the angelic magic, it is this: that Heaven is not deaf (though *we* usually are), and that 'hope' is an impulse arising from the human spirit's innate knowledge of its own eternal nature. And that when healing is willed from Above, organs can be regenerated, hereditary or terminal diseases can be healed, and the dead can be raised up.

Disease

To understand healing, we must first look at why sickness, illness, and disease occur at all. It is a complex subject; so what follows is just a generalization of the principles involved, it is not dogmatic or exhaustive.

We come into our first incarnation as naïve, sentient beings, with God-like potential and having free will. We are 'un-finished business' – we are growing, evolving, and learning how to express our God-Self.

But as untried and naïve beings, we are – at first – clumsy and careless. So, our thoughts, words, and actions tend to be inaccurate. The meaning of the word 'transgression' (from which comes the idea of 'sin') means 'to miss the mark', to be 'off target'. A transgression causes an imbalance within the overall Web of energy. And negative thoughts, words and actions create adverse karma. In traditional Western terms the Law of Karma is called 'merit and debt', expressed by the saying: *'As you sow, so shall you reap.'*

Karma is not the fatalistic teaching that many people think it is. The esoteric traditions of East and West view karma as an observable phenomenon. Adverse karma is simply a corrective for misapplied and unbalanced energy. It is not some punishment meted out for bad behavior. Karma is educational. Those areas in our lives where there is adverse karma show us where we need to focus our attention. Illness, for example, is in many cases the result of karma. But the very nature of the illness – its symptoms, the area of the body or mind affected, and the restrictions it brings – all point to what needs to be done to correct the imbalance and so restore health.

For example, many heart diseases are caused by a continual refusal to express emotions; and suppressing the flow of emotional

energy eventual affects the physical organ, and the heart begins to resist the flow of blood through the body.

Disease can also be caused by tensions within a person. To work in a job that is safe and secure is 'common sense', but a person may have powerful creative forces. These forces need to be expressed. But, perhaps because of parental programming or 'education', a person may be too fearful to live in the moment, to 'take risks'. This deep distrust of life chains a person to a way of life that they hate. So the hate, fueled by frustration, builds up over the years – souring their life and warping any capacity for true joy. And finally the hate turns inwards and, without meaning to, the person has literally willed him or herself to death. The only way out of this scenario is to do what Joseph Campbell advised: *'Follow your bliss'.*

Many of the greatest conversations, discoveries, and transformations have occurred when someone is in a sickbed. When a disease comes, don't ask: *'Why is this happening to me?'* Instead, ask *'Why is this happening* for *me?'* *'What are the lessons in this that I need to learn?'* Resist the emotional reaction of 'poor me' and move adventurously forward to see what the universe has in store for you. Go inside yourself, ask your body where it wants you to focus your attention. Go on an imaginary journey, observe and record those scenes, and the characters you meet. These will give you indicators of what is happening deep down. Many people get sick frequently, but not seriously, because it is the *only* time that they reflect on their lives or its direction.

And when you have done all that you can, it is time to call on the relevant angel, saying:

Holy Angel [Name], may the illness I endure be borne for a good reason, or speedily pass away.

The Teaching Angels as Healers

Each of the Teaching Angels can heal certain diseases. Once you know which angel to call on, you can invoke that angel with a Letter-of-Petition (see Table 2, page 77).

Any omens that come after your petition indicate the angel's

consent, the agreement to heal you. But if you do not know which angel to call on to heal a disease, then invoke the Archangel Raphael. Ask Raphael to take your petition to whichever angel will heal it. Archangel Raphael is the head of *all* the Healing Angels – as well as being the angel of communication, so he will take your petition on 'a wing and a prayer'.

Surgery

Before undergoing any surgery, always try to invoke Angel Samael of Mars. Because he will guide the surgeon's hand during the operation and he will also stimulate the physical body's recuperative powers afterwards. General anesthetic is very depleting to the body, because a lot of Etheric energy is lost under anesthesia. And the very vivid dreams that accompany anesthesia reveal just how far the psyche has withdrawn form the physical body.

A Swedish friend of mine who is a surgeon and a healer (he is also a priest), did some interesting experiments. He charged *some* of his post-operation patients with healing energy, but not all of them. He monitored his patients according to scientific observation, and found that all the patients who had been infused with healing energy recovered faster and with less discomfort. And studies in the USA showed that people in hospital, who were being prayed for, recovered better and faster than people who were not.

Hospitals

Every hospital has a major Angel of Healing presiding over it. And many other angels serve in hospitals as well. In a general hospital, one finds Angels of Mars overseeing surgery and revitalizing depleted bodies, Angels of the Moon assisting new souls being born, and the Healing Angels who specialize in various illnesses. And there are the Shepherding Angels (Angels of Saturn) who gently lift souls out of their outworn bodies – and guide them into the Light.

Hospital chapels (or Prayer Rooms) often have charged atmospheres; the experience of suffering strips away smaller concerns, and focuses on the Source of all Life. You don't often find weak prayers

Table 2 Angelic Rulerships of Healing

Michael	Heals all diseases of the heart, or spine; this includes the back and its muscles. Heals cats.
Gabriel	Female health (diseases of the breasts, anything related to childbirth, including recovery). And in both sexes: all stomach complaints, warts, sterility, and edema. And heals dogs.
Samael	All wounds, rashes, infections, eruptive spots, and migraine. Samael is also the patron of surgery.
Raphael	The healing angel par excellence, concerned with general health and all lung and chest complaints. Particularly well disposed to the healing of children, birds, and small animals.
Sachiel	Heals any problems of poor blood circulation, such as varicose veins, or hemorrhoids. And illnesses of ankles and feet.
Anael	Heals diabetes and kidney problems.
Cassiel	Rheumatism, arthritis, all ills caused by cold or damp conditions. Cassiel works well with diseases of the elderly, he brings lasting relief, if not total cure. Cassiel is very slow, so if there is urgency, invoke him through Archangel Raphael.
Uriel	All problems of the nervous system and epilepsy.
Asariel	Insanity, obsessions, and delusions; and problems resulting from 'passive psychism'.

being said in hospital chapels. Much of the angels' healing work is done at night, because the Astral bodies of patients have left their physical sheaths. The temporary absence of the sick person's consciousness allows healing energy from the angels to flow without interference. The hustle and bustle of a busy hospital ward is gone at night; the nurses keep their care-filled vigil till the dawn, while the Angels of Mercy wing their way to the beds of the suffering.

Some of the angels work directly on the physical bodies, focusing the Light's radiance into them, while others take the sleeping souls to Inner plane centers of healing, like the Still Waters (see Practice 1 in Chapter 2).

If you go to visit someone in hospital, try and go to the hospital chapel first. There, silently center yourself, then ask for a blessing upon the work of the presiding angel of the hospital; and then invoke the healing angels, asking them to minister to the person you are going to visit. You could use this invocation:

> **Divine Creator, Endless Fountain of Life, send Raphael and Thy Healing Angels, to bring wholeness and well-being to** [Name of sick person here]. **May** [Name's] **every muscle, every nerve, every organ, and every cell become radiant with Thy Light. May the body, mind and soul of** [Name] **be blessed by Thy amazing grace. And, if it be Thy Will, may** [Name] **flourish. Amen.**
> **Golden Angels of the Healing Sun, bring deepest well-being, happi-ness and joy to** [Name]. **Selah.**

Having done this, go to the person you have come to see. And try to touch him or her, or hold hands while you are visiting. You might be used as a channel for healing from the angels.[2]

And try to remember, whenever you pass a hospital, to direct a blessing to its angel. This doesn't have to be a spoken, just a single thought – swift as an arrow – is enough. We have no real idea of what a tremendous help it is to these Angels of Mercy to have physical beings recognize and bless their unseen labors.

Birth

Every birth, human or animal, is attended by angels. Giving birth is an initiatory experience for a female of any species. Human mothers-to-be risk their lives so a soul can be born. And the incarnating soul is also very vulnerable at this time. The *Jewish Prayer Book* contains a prayer for those souls who *'have drawn near the Earth, and passed by'*.[3]

A mentor of mine (who is now on the side of the angels), told me, that one Sunday morning while walking in North London, his inner attention was drawn to a nearby alley. Following his intuition, he entered the alley and saw with soul-sight the Holy Mother Mary, with an angelic entourage. The vision was glorious, yet utterly tender. When he had recovered enough to approach closer, he found that the physical plane focus of this inner gathering was a cat – lying in the rubbish of the alley – giving birth to her kittens.

The angels who attend births are mostly from the Choir of the Cherubim, who supervise the 'Treasure-house of Souls'. Sometimes at a birth, the presence of Mary, Kwan-Yin, Bridget or Isis, will manifest. These most tender of archetypes are radiant forms of the mother-love of The ONE, come to bless the 'drawing of breath'. A discrete nightlight, lit with the intention of welcoming the Cherubim to a birthing, is a good idea.

Phoebe Payne, a seer of high quality, wrote her psychic observations of a birth which took place in a nursing home in the 1920's:

> It was an area of curiously subdued, soft, effulgent light, and seemed to be created by the Angels attendant upon the birth of the child. Within this space the brilliant coloring of the Angels flashed and shone in alternating hues, creating an exquisite effect of mingling color and sound, which sometimes formed itself into rhythmic patters, sometimes into billowing clouds of glorious coloring.
>
> As far as one could tell, the Angels spoke and worked in terms of consciousness rather then through any more concrete medium of expression. A ceremony seemed to be going on, in which the Angels attendant upon the doctor, the incarnating ego (person), and the presiding Angel were the chief celebrants. They appeared to be enacting

a definite ritual, simple and yet profoundly mystical, which culmi-
nated, after the actual birth, in the giving of the infant into the charge
of another Angel...

The Angel presiding over the whole ceremony was an Angel of
wonderful dignity and power, with a sacerdotal authority which was
felt linked with the innermost heart of the World Mother. Through
this radiant figure poured a flood of sympathy and understanding
towards the mother, at the same time conferring a benediction upon
her sublime function of womanhood, and uniting the highest aspects
of her consciousness with a sense of the presence of the great Lady
Mother... In some deeply mystical way this Angel seemed to be the
direct representative of Our Lady, transmuting Her influence to the
degree in which it could be received by the soul of the mother. He
appeared to be the tabernacle in which the celebration of a mystery
took place, acting as a link with the higher spiritual realms that could
be contacted by the egos of the present...

The Angel himself was a glorious being, some eight or ten feet
in height, with a body like molten gold, gleaming through envelop-
ing draperies of dazzling azure blue... His eyes were unfathomable
pools of deep violet light. Upon his breast lay a scintillating star of
white light, and this remained radiantly white throughout the whole
ceremony... At the moment when the child drew its first breath these
white rays (from the 'star') seemed to shoot out in long shafts and
enfold for a second both mother and child.

Other beings than angels may also attend a birth: astral friends of the
incarnating soul will often come too. It is just the same as when we
accompany friends to an airport when they depart on a long journey.
In ancient Egypt, the seer-priests of Ma'at would watch royal births,
to gauge the spiritual status of an incoming soul, watching who
accompanied the incarnating soul as it approached the Portal-of-Birth.
From the angelic point of view, birth is the mirror image of another
event – death.

Death

In Western culture, most births (though not all) are generally thought of 'happy' events. And most deaths (though not all) are generally considered as 'sad' events. But thanks to the good work of people like Elizabeth Kübler-Ross and Stephen Levine, our culture's view of death is starting to change. Now there are people who are being trained to holistically prepare and assist the dying for their Journey to the Light.

Elizabeth Kübler-Ross spoke of her experiences when she was assisting dying children, and how the presence of the Blessed Mother Mary would come, with the perfume of pink roses. 'Mother' is the name for God upon the lips of all children. This affirmed for Elizabeth the inner reality of the prayer *'Ave Maria',* which ends: *'Holy Mary, Mother of God, pray with us now and at the hour of our death.'*

In spiritual reality, the womb and the tomb are really one gate on a single journey. Our perception of it is simply a matter of which way we are looking. The 'gate' says *Entrance* on one side, and *Exit* on the other – it is just a matter of which side of the gate you are standing on.

At physical death, a prepared soul calmly withdraws from its physical vehicle – and the silver cord connecting the physical and the Etheric bodies together, breaks (like the umbilical cord at birth). The soul is then free upon the Astral level. The disembodied soul then rises to the Spiritual level, where the entire incarnation is assessed by the Higher-Self. What is good is distilled into the Spirit, what is not, is cast out. During the self-judgment, a soul usually passes to a state of purgation – to work out any blemishes, since few of us emerge from incarnation totally spotless. After purification, the soul passes to one of the 'Heavens', there to catch up with old friends, before 'the call to go forth' comes again. In other cases, where evil has been the keynote of an incarnation, the soul passes to one of the hells until atonement has been made. Our dreams and nightmares are the frontiers of heaven and hell.

Deaths by violence, whether accidental or deliberate, or suicides, can cause problems. A soul can get stuck, or earth-bound. 'Earthbound' souls are dead people who either do not believe that they are

dead (quite common for a short period of time, rather like shock), or they are 'unquiet souls' who willfully refuse to leave the Earth plane. Jesus put this very well: *'Where your heart is, there will your treasure be also'* (Matthew 6:21). If a person's main focus in life has been the material realm, they gravitate to the lowest realm and hang around. The films *'Blithe Spirit'*, *'Ghost'* and *'What Dreams May Come'* are all about Earth-bound souls. And the TV series *'Medium'* often has similar cases.

If you personally know of a case like this, and would like to help that soul, you can get a gratis meditation, specially designed to help the Earth-bound, from the Rising Phoenix Foundation's website (go to *www.sacredmagicoftheangels.com/chapelofliberation*).

By her example, Mother Teresa of Calcutta showed us that no one should die alone. And on the inner side, it is a fact that no one passes over without angels to help. Most dying people are also met by their friends and loved ones who have already made their own transitions.

Azrael is the Angel of Death. And the angels who minister to the dying are known as the 'Shepherding Angels'. Like Angel Cassiel of Saturn, the 'Shepherds' serve under the great Archangel Tzaphkiel.

But not all deaths bring rest. The deaths of individuals who lived evil lives – who deliberately inflicted pain and suffering upon others – are darkened by great fear. They are met by loathsome shadow-creatures, which they unknowingly 'fed' by their cruel actions. Such creatures wait to feed upon their disintegrating psyches, like astral hyenas or vultures. And also waiting for them, are those of their dead victims, who have decided not to 'turn the other cheek' for the evil done to them. Free will and self-determination do not cease with death, nor does hate or revenge, and neither does redemption or love.

Other cultures than our own found wise ways to assist discarnating souls: the priests of Anubis and Osiris in ancient Egypt, the priestesses of Persephone in Greece; and Tibetan Buddhist lamas still attend the dying to guide them – not only up to the moment of separation from the physical, but afterwards too, guiding them telepathically upon the inner realms. The Jewish *mitzvah* to 'accompany the dead' esoterically refers to guiding the newly departed through the lower astral plane

and back to the Spirit. Spiritualist Rescue Circles and Christian Requiem Masses also do much good in guiding wandering souls to havens of light, from where the Shepherding Angels can take them onward. I have been told that there is a loose-knit society of Catholic priests who, despite their church's theology, offer Requiem Masses with the intention of releasing souls from hell, from the Dark Dimensions.

Sudden deaths – resulting from violence, accident, or a natural disaster – are traumatic for the newly dead. They are shocked and bewildered. So the Shepherding Angels will manipulate astral forms to help newly dead people adjust. I remember on one occasion – after a plane crash with many fatalities – the Shepherding Angels arrived on the astral scene wearing the appearance of emergency helpers, doctors and nurses. They helped distressed and shocked victims, rebuild the astral double of the airplane, and then transported the newly dead to the astral simulacrum of an airport. This 'airport' was really one of the Places of Peace, where people are helped to adjust to the new condition.

Angels who minister to the dying, rarely turn up in their own forms, except in the case of an advanced soul. They usually wear forms that comfort the dying. When there are multiple fatalities – earthquakes, bombings, etc. – living people who have the compassion and are able to astrally project, go to the site of the disaster, where they work alongside the Shepherding Angels. This is the meaning of a phrase in Scripture: 'to serve the Most Holy ONE by night and by day'. And it is one of the ways in which angels and humans cooperate in the service of God.

If you are with a dying person, do not be fearful or sorrowful, but try to radiate assurance and confidence based upon knowledge of human immortality. Remember, the dying person is not going to oblivion. (S)he is only changing worlds, shedding a costume, and will put on another one at some future time. Those drawing near the portal of death tend to become very psychic toward the end. It is very reassuring for them to have someone nearby for whom the unseen holds little fear.

Mentally send a call to Angel Cassiel and the Shepherding Angels. Build up in your imagination Cassiel's call-sign: the Ladder of Jacob – a vast ladder of light that spans the realms – with beautiful angels ascending and descending on it. Then quietly speak the invitation:

> **Come forth to meet [Name], you Angels of the Lord.**
> **Receive [him/her] into your company, you Holy Ones of God.**
> **In the name of the Most Gracious ONE, may you, [Name], be encompassed by the high Princes of Heaven. May Raphael be at your right hand; Gabriel at your left hand; Michael guards you behind; and before you Uriel leads the way. Above your head, [Name], shines the lamp of the Most High, before whose Light all darkness flees away. May choirs of Angels take you, [Name], into their tender care, and guide you into everlasting Light.**
> **Amen.**

Welcome the Shepherding Angels as they come to guide the dying person into peace. Then shall the chamber of death become a doorway into Heaven, lit by a Light as the Earth has never seen.

PRACTICE 3
Litany of Raphael the Archangel

This sacred Litany invokes the assistance of the Archangel Raphael. It is used for healing intercessions. You speak the name of the person you are interceding for, where it is indicated by 'Name'. If you are doing it for your own needs, then simply use 'me' where it says 'Name'.

In the name of the All-Holy One, and invoking the help of the holy Archangel Raphael, I offer this Litany for the wholeness of Name; may (s)he/me have Deepest Well-Being, Happiness and Joy. Selah.

Oh holy Raphael of the Glorious Seven, you who stand before the Throne of Grace, and gaze upon the Unveiled Face of the All-Holy One who is the Life of Worlds. Oh Raphael, archangel of health, wholeness and well-being; the Lord has filled your hand with balm from Heaven to soothe or cure our pains. If it is willed, please heal Name of what dis-eases him/her, and guide his/her steps on the way to wholeness. Amen.

Source of all Being,
 pour forth Thy Love upon Name.
Eternal Word,
 pour forth Thy Love upon Name.
Whole Spirit of Life,
 pour forth Thy Love upon Name.
Shekinah, Queen of the angels,
 pray for Name.
Celestial Raphael, the archangel,
 pray for Name.
Holy Raphael, whose name means 'God has healed',
 pray for Name.
Splendid Raphael, exalted among the Spirits of Light,
 pray for Name.

Archangel Raphael, one of the Seven who stand before the Most High,
 pray for Name.
Celestial Raphael, ministering at the Divine Throne in Heaven,
 pray for Name.
Holy Raphael, noble and mighty messenger of God,
 pray for Name.
Splendid Raphael, devoted to the Holy Will of God,
 pray for Name.
Archangel Raphael, who offered to God the prayers of Tobit,
 pray for Name.
Celestial Raphael, traveling-companion of Tobias,
 pray for Name.
Holy Raphael, who guarded your companions from danger,
 pray for Name.
Splendid Raphael, who healed Sarah from evil spirits,
 pray for Name.
Archangel Raphael, who healed Tobit of his blindness,
 pray for Name.
Celestial Raphael, guide of our journey through life,
 pray for Name.
Holy Raphael, strong helper in time of need,
 pray for Name.
Splendid Raphael, dispeller of evil,
 pray for Name.
Archangel Raphael, guide and counselor of humanity,
 pray for Name.
Celestial Raphael, protector of pure souls,
 pray for Name.
Holy Raphael, patron of youthfulness,
 pray for Name.
Splendid Raphael, angel of wholeness,
 pray for Name.
Archangel Raphael, angel of auspicious meetings,
 pray for Name.

Celestial Raphael, angel of education,
 pray for Name.
Holy Raphael, guardian of animals,
 pray for Name.
Splendid Raphael, protector of travelers,
 pray for Name.
Archangel Raphael, bringer of health,
 pray for Name.
Celestial Raphael, heavenly physician,
 pray for Name.
Holy Raphael, helper of the blind,
 pray for Name.
Splendid Raphael, healer of the sick,
 pray for Name.
Archangel Raphael, patron of physicians,
 pray for Name.
Celestial Raphael, consoler of the afflicted,
 pray for Name.
Holy Raphael, support of the suffering,
 pray for Name.
Splendid Raphael, herald of blessings,
 pray for Name.
Archangel Raphael, messenger between the hosts,
 pray for Name.
 Kyrie Eleison
 Kyrie Eleison
 Kyrie Eleison
 Kyrie Eleison
 May all wounds heal and blessings flow!
 Kyrie Eleison
 Kyrie Eleison
 Kyrie Eleison
 Kyrie Eleison
 AUUUMMMMEEEEN

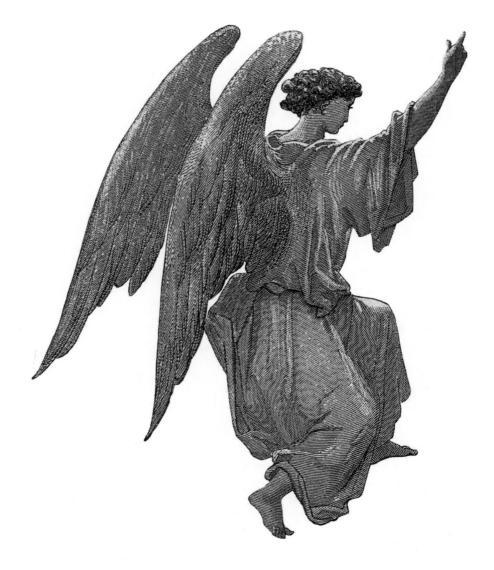

Illustration by Gustave Doré

CHAPTER 5

BY THEIR SIGNS
YE SHALL KNOW THEM

For He shall give His angels charge over thee,
to keep thee in all thy ways.[1]

In this chapter you will learn how to communicate with each of the angels for their help in any of the matters they rule over (see Chapter 2). Once you get the hang of this, it is very simple – deceptively so – yet it brings amazing results. This method of angelic magic is used more than any other. It is known as 'Letters-of-Petition'. It is the method of invoking any particular angel directly (unlike Moon magic, where the angels are invoked through Archangel Gabriel). So, to do this I will teach you: the days of rulership, the colors, and the personal 'call-signs' of each one of the angels. You will also learn the 'Language of Omens', so that you will know when the angels are replying to your requests, by sending you messages.

The Language of Omens
The angels communicate with most people through the subconscious mind. Only people specially trained, or gifted by Grace, can communicate with angels face-to-face (see *www.sacredmagicoftheangels.com/higherworlds*). We humans share subconsciousness with *all* other life forms – vegetable and animal, and with those of the Subtle levels: Nature-spirits and angels. Because we all have subconsciousness, we are all able to communicate. The basis for this amazing fact is the all-pervading Mind of The ONE, which permeates and ensouls everything. But, communication between the life-forms does *not* mean that it is by language, by words. It is by images, emotions and impressions in these empathic types of communication. It is empathy between two

beings that makes communication possible. True recognition of the Divine within another being – whether animal, tree, crystal or rock – makes us sensitive to those different chords in the 'Song of Creation'.

A person who practices sacred magic, begins to attune to the vibration rate of the angels and, in many cases, direct communication will gradually unfold. The practices in this book (the guided meditations and the rituals), have all been specifically designed to make this so.

To communicate with humanity, the angels use the Langue of Omens. They use the various animals, birds, and trees to act as messages to us. An omen must be synchronistic and spontaneous, and it must occur within the specific time-span of each angel. For example: oranges are sacred to the Archangel Michael, and a gift of them is an omen from him if they are received within seven days of invoking him. But, if you had invoked this archangel and then asked someone to buy you some oranges, that would *not* be an omen at all.

But, if someone, without your knowledge, had posted oranges to you *before* you invoked the archangel – and then the oranges arrived as a surprise gift *after* the invocation – would this be a omen? Yes it would, because it was not pre-planned by you, and it arrived within the correct time-span.

With the angels there is no such thing as coincidence, and their omens just materialize from the most unlikely sources. The angels cause these synchronistic coincidences to occur unexpectedly. And when you do receive a true omen, deep down you will *know* it, because momentarily it makes your heart shine.

Most people think of omens as mere coincidence, as meaningless events – because they do not understand the nature of Creation. But these same events have great significance for those-who-know. Because they understand that omens are loving messages from the Unseen, from the Powers-that-Be. And thus, their reactions to omens surprise others. Here is an illustration that I remember: the Angel Sachiel rules monetary and financial help. And one of his omens-of-consent to helping with financial problems is to find a foreign coin in your change. Now most people, if they find a foreign coin in their

change do not exactly 'bless the Lord'. But I have seen a fellow-practitioner of angelic magic 'whoop for joy' and leap up in the air – in a crowded supermarket – on discovering a foreign coin, thus shocking everybody else in the vicinity! You can imagine my difficulty explaining to the onlookers the reason for my colleague's exuberant behavior!

For an omen from the angels to be genuine, it must be:
◆ a sign specifically mentioned in the tradition;
◆ it must come within the specific time-span of each angel;
◆ and it must be 'out of the blue' – spontaneous and unexpected.

But, what is the purpose behind waiting for an omen? Why? There is one supreme reason – because, by receiving an omen, you then know that it is the will of The ONE that your need be fulfilled. The angels are the messengers of the Will *(Ratzon Kether)*,[2] they carry your petition to The ONE, and their omens are the 'reply' of The ONE, through them. And the All–wise and All-loving ONE grants everything that is required for your deepest well-being, and your deepest happiness and joy – at precisely the right time, and in the right place.

There is a good example of asking for omens in the Old Testament of The Bible, in the *Book of Judges,* chapter 7, verses: 36-40. The hero of that book, Gideon, asks for an omen twice, to ascertain whether a planned undertaking is truly willed by Heaven, and will therefore be successful, or not.

All Letters-of-Petition to the Angels are written in the plural; you do not write *'please help me',* always write *'please help us'.* This is because of our oneness with all. And because the Universe is evolving through you, your problems are the Universe's problems! Therefore the Universal resources can be invoked to overcome your obstacles and challenges.

A Letter-of-Petition is written on a square of paper using either a pen or pencil. The color of the paper and the color of the ink depend on which angel is being petitioned. At the top of the petition, a grid is drawn (see figure 3), in which are placed the symbols of the particular angel and its personal 'call-sign'.

FIRST ZODIACAL SIGN	SECOND ZODIACAL SIGN	PLANETARY SYMBOL	ANGEL'S CALL SIGN

HERE WRITE THE NAME AND TITLE OF THE ANGEL

FOLLOWED BY YOUR PETITION

AND END WITH YOUR NAME

Figure 3 Template for a Letter-of-Petition

The request is then written in the appropriate sacred script (or scripts). Only white candles are burned while writing a petition; colored candles are only used for talismans-of-power (see Chapter 6). The petition is kept for a specified number of days, during which – *if the petition is going to be granted* – a sign of the angel's consent will come to you, in the form of an omen or omens. When the specified number of days has elapsed – regardless of whether you have received omens or not – the Letter-of-Petition must be burnt by fire.

If your petition does not receive an omen of consent, it may just be that the time is inappropriate. It does not automatically mean a 'no' for all time. Angels have an overview of Creation, they see how the various pieces of the mosaic of Life will come together.

So, if a petition is refused, leave it for three months, and then petition again.

You need to be able distinguish between *wanting* something, and *needing* it – there is a great difference. Angelic assistance will not take the place of what you can achieve by your own efforts. The angels will empower your own efforts – and do what you cannot.

When a petition has been consented to by an angel, you can be certain that the result will come about, within the span of that angel's time-orbit (see page 112). The ONE appointed these particular angels to care for human well-being – and each one of them is all-powerful in their own sphere. So, if an angel consents to your petition, it is then in the best hands in the universe. And the results of angelic petitions are sometimes even more than magical – they can be miraculous!

Let us now look at each of the angels in turn, and learn how you can obtain their help in the matters that they look after.

Archangel Gabriel

The Archangel Gabriel rules the Moon and its powers. There is a charming Arabic legend that at the beginning of Creation the Sun and Moon were of equal brightness, both mirroring the luminosity of the Divine Throne. They were like two suns. But as a consequence, the creatures of Earth could not distinguish day from night, when to labor and when to rest. So The ONE, Allah, in compassion, commanded the Archangel Gabriel (*Jibril* in Arabic) to dim the light of the Moon. Gabriel did this by touching the lunar orb with his wings. The Moon's light, once as bright as the Sun's, became gentle, cool, and silvery. The markings seen upon the Moon's face are said to be the traces left by the touch of the feathers of the archangel's wings.

The Archangel Gabriel may be petitioned on nights of the New and Full Moon, and on any Monday. The petition should be written on white paper in either blue or silver ink. It should be written completely in the *Theban Script*; beginning with the words: **'To Archangel Gabriel of the Moon'**, then followed by the request (**'please help us to... etc.'**), and ended with **'thank you'** and your name. The three symbols to be drawn upon petitions to the Archangel Gabriel are shown in figure 4.

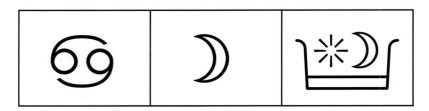

Figure 4 The signs of Archangel Gabriel:
the symbol of the zodiacal sign of Cancer the Crab; the Crescent,
signifying the waxing Moon; and Gabriel's personal call-sign:
the 'Stella-Luna Corona'.

The Letter-of-Petition should be kept for 28 days, an entire lunar cycle.
It is during this time that Gabriel's omens of consent will come.

The omens that tell you that Archangel Gabriel has consented are:

◆ an unexpected gift in the form of shellfish, or an invitation to
a meal at which shellfish are served;

◆ a gift of melons, lychees, or pears;

◆ a visit to a place where you find a pear tree in blossom or in fruit;

◆ a gift of silver;

◆ or a surprise invitation to a birth-related ceremony (e.g. infant
baptism);

◆ to hear of a baby being born, or for a baby to visit your home for
the first time;

◆ a strange dog honoring you with its affection, or a dog's persistent
barking outside your home;

◆ acquiring a new puppy;

◆ seeing a Weeping-willow tree (genus *Salix*) for the first time,
or having your attention attracted to one unexpectedly;

◆ moths entering your home;

◆ a spider taking up residence there, or the sight of a spider
spinning its web;

◆ a moonbeam shining upon you or any place in your home;

◆ a gift of white flowers or a white flower suddenly blooming in
your garden.

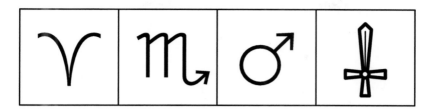

Figure 5 The signs of Angel Samael:
the glyph of Aries the Ram; the sign of Scorpio the Scorpion;
the symbol of the planet Mars; and Samael's personal call-sign:
the drawn, upright Sword.

Receiving any one of these omens indicates that the Archangel Gabriel
will grant and bless your request.

Angel Samael

Angel Samael is petitioned on any Tuesday. A petition to him should
be written on white paper with red ink. The whole petition should be
written in the *Passing of the Rivers Script*. It is addressed: **'To Angel
Samael of Mars, the great protective angel',** then the request itself,
a **'thank you'** of gratitude, and finally your name.

Petitions to Angel Samael are kept for seven days – from the
Tuesday of writing to the next Tuesday – and then burned. During the
seven days his omen(s) will come if he consents to assist you. The four
symbols to put at the top of petitions to the Angel Samael are shown
in figure 5.

Samael's omens-of-consent are:
- the gift of a knife, sword, or any sharp instrument;
- knives falling onto the ground for any reason;
- the spilling of pepper or spices;
- sparks jumping from a fire, or anything catching fire;
- to suddenly see red light;
- to be stung by a wasp or any other insect;
- or the appearance of a red spot;

- the gift of Horse-chestnuts *(Aesculus hippocastanum)*;
- the unexpected sight of a Monkey-Puzzle tree *(Araucaria araucana)* or pepper tree (trees in the *Schinus* genus);
- a dream of sheep or rams;
- or a gift of sheepskin or any ornament in the form of a sheep;
- if you have asked for healing in a particular part of your body, Angel Samael may signal his consent by generating heat there.

Any single one of these omens manifesting within seven days after the petition tells you that the Protective Angel will help you.

Archangel Raphael

Letters of petition to Archangel Raphael of Mercury are made upon any Wednesday. They are written in black ink on yellow paper. In addition to the rulerships already mentioned, Raphael may also be asked to help recover things that have been lost, to capture thieves, and for general protection from theft. You can write petitions to this archangel in either of the two sacred scripts. The three symbols for the top of the petition are shown in figure 6. Letters to Raphael are kept for seven days and it is during this time that his omen(s) will manifest.

Raphael signals his consent by these omens:

- a bird entering your home or nesting near your house or garden;
- the gift of a bird;
- a talking bird giving you a message;
- a gift or the sudden blooming of yellow flowers;
- the sudden appearance of a fern or weed (especially in a wall, roof, or between flagstones);
- a dream of monkeys or hearing a story about them;
- a plague of flies or any gift ornamented with a design incorporating birds, monkeys, or flies, are signs of Raphael's consent;
- to see an Aspen tree *(Salicaceae)* or a Silver birch tree *(Betula pendula)*, or to hear a strange sound in those trees;
- to have many visitors unexpectedly;
- to have an increase of your incoming mail;
- to go on a surprise journey;

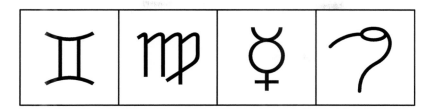

Figure 6 The signs of Archangel Raphael:
the sign of Gemini the Twins; the glyph of Virgo; the symbol of the planet Mercury; and Raphael's own personal call-sign: the head of a Bird.

- or to see quick, darting lights;
- the gift of a mirror or the accidental breaking of one.

Any of these omens, appearing within seven days, assures you of Archangel Raphael's speedy help.

Angel Sachiel

The Angel Sachiel of Jupiter is invoked on Thursdays and the petition kept for seven days, waiting for any one of his omens of consent. Petitions to Sachiel are written with blue ink on lavender paper, or alternatively, you can use purple ink upon white paper. The entire petition should be written in the *Passing of the Rivers Script*. The four symbols to head petitions to the Angel Sachiel are shown in figure 7.

Sachiel can show his consent through a variety of omens, they are:

- to find a foreign coin in your change, or to find money on the street, is a sign of financial increase;
- to see purple light or haze, or golden motes dancing in the air;
- to take a surprise trip to the sea or a voyage by boat;
- to receive unexpected news about a sailor or fisherman;
- to receive any gift from the sea or ornamented with designs of fish, elephants or whales, or to see any of these creatures unexpectedly, indicate Sachiel's consent;
- to be given purple flowers or grapes;
- to see an oak tree for the first time, or to find or be given acorns, oak apples, or oak leaves;

Figure 7 The signs of Angel Sachiel:
the Arrow of Sagittarius the Centaur; the symbol of Pisces the Fishes; the glyph of the planet Jupiter; and Sachiel's personal call-sign: the 'Part of Fortune'.

- ◆ to receive or dream of ships;
- ◆ to receive a gift of money or a raise in salary;
- ◆ to see, in person (not on TV), a member of any royal family, especially a sovereign, is also a favorable sign;
- ◆ for a bee to enter your home or hover about you (for bees make honey, which is 'Nature's gold') is a blessed omen;
- ◆ to see a queen bee, whether in swarm or not, is the most fortunate sign of all.

Any one of these omens, coming within seven days, tells you that the Angel Sachiel will grant your petition.

Angel Anael

Rose-Angel Anael of Venus, the great angel of love and affection, may be petitioned upon any Friday. These letters are kept for twenty-eight days, being burned on the fourth Friday after writing. All of the petition should be written in the *Passing of the Rivers Script*, except for your name at the very end, which should be written in the *Theban Script*.

Petitions to Anael can be written on either blue or pink paper, using either blue or red ink. The four signs for Anael's petitions are shown in figure 8.

It is important to understand that if you petitioned Anael to bless you with the love of another person and got omens, *you* could still sabotage the outcome. Because, if having received the promise of the

Figure 8 The signs of Rose-Angel Anael:
the symbol of Taurus the Bull; the sign of Libra the Scales;
the glyph of the planet Venus; and Anael's personal call-sign:
'the Cup of Happiness'.

Rose-Angel's help, you then start to behave towards that person without integrity – it will fail. In other words, if you then act on the advice of certain magazines, or your worldly-wise 'friends' – advice like: *'Oh, make him jealous!',* or *'Create a drama; try some emotional blackmail'* – then you will sabotage the results – even if you had received omens of consent. Because your own free will is saying to the universe, *'I'm not courageous enough to love yet.'*

Neither may you petition to acquire the love of a person who is already in a committed relationship with somebody else. There is a saying in Angel Magic: *'If you try to take away someone else's Cup of Happiness, you will knock over your own in the process.'* This angelic system is White Magic. The angels do not condone theft, and adultery *is* stealing, for which there will be karmic consequences. Instead, learn to love nobly and courageously. The ONE is Love – and The ONE is infinite and omnipotent, so have no fear of being alone.

The omens of Angel Anael's consent are:
- to receive a gift of apples;
- to see apple trees unexpectedly or to gather windfall apples;
- to hear the cooing of doves;
- to see or be given a blue budgerigar;
- for a dove or blue tit *(Cyanistes caeruleus)* to enter your garden or home;

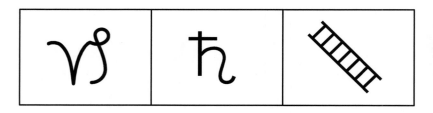

Figure 9 The signs of Angel Cassiel:
the sign of Capricorn the Sea-Goat; the planetary symbol of Saturn; and Cassiel's personal call-sign: 'Jacob's Ladder'.

- ◆ a gift of roses, or Love-in-the-mist *(Nigella damascena)*, or Delphiniums;
- ◆ a surprise gift of pink or blue clothing, are also favorable signs;
- ◆ if your petition concerns love between you and another, to have any kind of ring given to you, or to find one – even a curtain ring – is an omen of consent.

Any one of these omens coming within the twenty-eight days is a sure indication of Rose-Angel Anael granting your petition.

Angel Cassiel
The Angel Cassiel of Saturn may be petitioned on any Saturday. Petitions to him are written on white paper, using either black ink or a lead pencil. The *Passing of the Rivers Script* is used throughout the letter. Cassiel works slowly but surely, so the petition must be kept for *three* complete calendar months, and during this time Cassiel will send his omens, if he consents to help you in the matter laid before him. The three symbols to be placed at the top of petitions to the Angel of Saturn are shown in figure 9.

Angel Cassiel shows his consent by any of these omens:
- ◆ unexpectedly receiving branches of evergreen trees;
- ◆ encountering a tortoise;
- ◆ encountering a parrot (listen to what the bird may say!);
- ◆ to find a worm in your path;

- ◆ to find the metal lead in any form;
- ◆ to receive a gift of coal or find it by chance;
- ◆ to bite into something bitter unexpectedly;
- ◆ to receive a sudden invitation to a funeral or a memorial service;
- ◆ or a surprise visit from an elderly person;
- ◆ to receive a present of dried flowers.

Any one of these omens, occurring within three months of your petition, assures you of Cassiel's help.

Angel Cassiel has a long time-orbit of four years, in which he brings about results. But there is an omen which indicates that he will speedily help you: a sudden fall of soot down a chimney. If you do receive this omen, say: **'May the Angel Cassiel bless me by this sign he has given me'.**

And, if you *do* need speedy help in any matter ruled by Angel Cassiel, then you can petition him through Archangel Raphael (on a Wednesday), or through Archangel Gabriel using a New Moon Invoking Tablet.

Archangel Uriel

This mighty archangel shares Saturday with Cassiel as his day of invocation and petitioning. Letters to Archangel Uriel are written upon white paper in green ink; they are written throughout in the *Passing of the Rivers Script* – the addressing, the petition, and your name. All petitions to this archangel are addressed: **'To Uriel Throne-Angel of God and Magical Force'.** The letter is kept for fourteen days and then burned. If Uriel has consented to bestow his potent help, the signs of consent will appear within the fourteen days of the letters' physical existence. Never ask for Uriel's help in any matter you can perform yourself. The three magical symbols that head all Letters-of-Petition to Uriel are shown in figure 10.

The planet Earth is especially magnetic and one of the ways it receives force (which is electrical in nature) is through the lightning that occurs in thunderstorms. As mentioned before, Uriel often manifests in storms.

Electricity and electrical appliances are affected by the presence

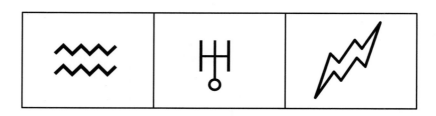

Figure 10 The signs of Archangel Uriel:
the zodiacal sign of Aquarius the Water-Bearer; the sign of the planet
Uranus; and the call-sign of Uriel: 'the Lightning Flash'.

of Uriel. His personal call-sign, the lightning flash, refers to the poten-
tially devastating force for which Uriel is the lens. The lightning flash
also indicates the speed with which this archangel traditionally brings
about his results when invoked. Uriel's help may be asked in all mat-
ters of illnesses of the nervous system (which operates through elec-
trical impulses).

Archangel Uriel's favorable omens are:
- ◆ ornaments or pictures showing unicorns, either seen unexpect-
 edly or received as a gift;
- ◆ to see a pool of glistening oil, or for a rainbow to enter your home
 by means of light refraction;
- ◆ to see a lizard or chameleon;
- ◆ to be presented with a gift of bananas, mangos or multicolored
 flowers;
- ◆ to be given a Hydrangea plant, or for one you already have to
 suddenly change color;
- ◆ to see a dragonfly or receive a gift with a dragonfly motif;
- ◆ to see a rainbow in the sky is a most beautiful omen of Uriel.

Any of these omens occurring within fourteen days indicates Archan-
gel Uriel's powerful help.

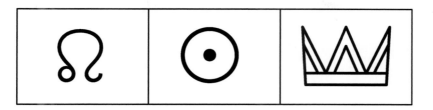

Figure 11 The signs of Archangel Michael:
the zodiacal sign of Leo the Lion; the hieroglyph of the Sun;
and Michael's own call-sign: a royal gold Crown.

Archangel Michael

Sunday is the day sacred to the Archangel Michael and should be used to invoke his help in the matters he rules (see Chapter 2). Letters to Michael should be written on white paper in either orange or gold colored ink. The addressing of the letter (**'To the Archangel Michael'**) is written in the *Passing of the Rivers Script,* the petition itself is written in *Theban Script,* and your own name is signed in the *Passing of the Rivers Script.*

Petitions to Michael are kept from Sunday to the following Sunday, and during the intervening seven days, signs of consent will come if Michael is favorable. The three symbols placed upon the letters to this archangel are shown in figure 11.

Archangel Michael will show consent to your petition by any of these omens:

◆ a gift of oranges, Marigolds *(Tagetes),* Sunflowers *(Helianthus annuus),* or pomegranates;
◆ any gift ornamented with a crown;
◆ to be unexpectedly bathed in a sunbeam;
◆ for a stray cat to enter your home or garden, or 'adopt' you (give it food, for it is a messenger of the archangel);
◆ to be given anything that has a lion shown on it;
◆ for your pet cat to give birth to kittens;

- ◆ to hear a stringed instrument been played unexpectedly (live music only) near your home;
- ◆ if your piano makes sounds;
- ◆ to be invited to a wedding or a golden anniversary;
- ◆ or to be invited unexpectedly to ride in a wheeled vehicle, is a sign of consent because it symbolizes the *Gammadion*, the chariot of the Sun;
- ◆ to see a golden butterfly in your garden or home;
- ◆ for a 'Daddy Long-legs' (Crane Flies of the *Tipulidae* family) to enter your home;
- ◆ to visit any place where there is a laurel tree (*Lauraceae* family) growing, or for a laurel tree to rustle in a way to attract your attention.

Any one of these omens occurring within seven days, are a message of consent from the Archangel Michael.

Sometimes while you are awaiting a sign from an angel whose help you have invoked, you may receive what *appears* to be an omen, but which doesn't appear in the list given. It might even be quite spectacular. I remember on one occasion receiving many pictures of the Archangel Michael – but they were *not* omens – they were 'signs'.

A sign is an indication that your petition has been heard, has gotten through, but is not to be granted. (But, it may be a case of timing – so you can petition again, three months later.) If you do get signs, but not any of the listed omens, it means that the angel has not consented. It means that it is not Willed at this time. The only omens that you can put trust in, those that do indicate that your petition will be granted, are those mentioned above. If you ignore this teaching, you will run the danger of 'wish fulfillment', of your unconscious mind manufacturing 'signs' to appear. Neither should you count lyrics of songs heard on the radio, or things seen on TV, as omens of consent – they are not. Fooling yourself in this way will just lead to bitter disappointment.

However, if you have petitioned an angel and received one or more omens, you may put your mind at rest that your problem is now being dealt with by a supernatural being of irresistible power, and

so all shall be well. In the 12th chapter of the *Book of Tobit* Archangel Raphael says:

> *... for I am Raphael, one of the seven holy angels which present the prayers... and go in and out before the Glory of the Holy One. ... Not of any favor of mine, but of the will of our God I came; therefore praise Him... for I go up to Him who sent me.*

This quote is important because it gives an important Qabalistic teaching – that The ONE has appointed certain angels to answer prayers (petitions). You can now see why it is important to know the rulerships of the various angels, because each one has a *precise* and *unique* funtion. It is by having this 'occult'[6] knowledge that we know to whom to make our petitions – and we also know what omens to expect – and in what time-frame the request will come about – if our petition is to be granted.

Realize what a tremendous blessing this is – to actually be able to make a written 'prayer of petition' with the confidence that it will be heard. And that – if what you ask for is Willed to come about – then you will be told so through tried-and-tested omens within a certain number of days. What a relief! No more need to worry! What a blessing! To personally experience the care of these mighty Spirits of Light – who are the embodiments of the all-accomplishing Power of The ONE. And so, you know that all shall be well – because God has sent His angel to minister unto you.

The Sacred Scripts

There are two scripts that are used in the Sacred Magic of Angels. These sacred scripts have been used for centuries to invoke the Angels of Light and so they deeply resonate with the angelic kingdom. The two scripts are: the *Theban Script* and the *Passing of the Rivers Script*. These scripts empower any petitions written with them, because the added concentration needed to use them creates a beam of mental energy into the petition. Using the sacred scripts makes the mind one-pointed and undistracted.

All Letters-of-Petition must be written in one of these two scripts, and sometimes in a combination. But this is *not* difficult – in fact it is child's play. These scripts are *not* foreign languages, they are crypto-grams.[4] And to use them, you simply transpose the letters of your own native language into these symbols – just like writing a letter in code. For example, the proper noun 'David' is written with the symbols in the scripts that represent: **D,A,V,I,D.**

A question I am often asked is, *'Why do I have to use these scripts? Can't the angels read English? Can't they just understand my intention?'* And some people decide not to even try a petition because they feel 'intellectually insulted'. In other words, their 'pride' stops them from getting Heaven's help. But as one of my students said, *'If all you have to do to get the angels to help you, is cut out a piece of colored paper, and write your request in a script – that's marvelous.'* There is no fasting necessary, no complicated rituals, or obscure languages.

But why use a sacred script at all? The answer is simple. The truth is that our attention span and concentration is not very strong. (That is why High Magic requires mental training.) But, the effort of changing letters into script focuses our concentration and brings our mental powers to bear. As many of my students have reported, when you start to write an angelic petition using a script, it is as if a bright spotlight were shining down onto you. There is a sense of intensity as each symbol is drawn, a 'now-ness'. Yet, the moment when you have written the very last character of your petition, there is an immediate sense of relief – the pressure is gone – to be followed by a sense of ela-tion and completion.

The Theban Script
This magical script is named after Honorius of Thebes. This script is strongly related to the Moon and to the Astral plane. It is used in some petitions to certain angels, in the Moon tablets and some other angelic talismans. It is very easy to use (see Table 3 on page 108).

The table shows the alphabet of the *Theban Script* equated to the English alphabet. As with many ancient scripts, there are no equiva-lents for the modern letters **J**, **U**, and **W**. So, when you need to use those

letters, use the Theban symbol for **I** as the substitute for the letter **J**; the Theban symbol for **V** is also used for the English **U**, and the **V** is written *twice* for the letter **W**.

The Passing of the Rivers Script

The second script is called the *Passing of the Rivers Script*. Traditionally it is an early form of liturgical Hebrew, and its letters are living energies. The name of this script comes from the *Book of Genesis* where it describes the four rivers which flowed through the Garden of Eden. The rivers – *Pison, Euphrates, Gihon* and *Hiddekel* – flow from the roots of the Tree of Life and flow to the four cardinal points. This makes a symbolic mandala with the Tree as the *Axis Mundi* in the center, and the rivers flowing to the four pillars that uphold the universe. In this there is the idea of the passage of time, and of the stream of consciousness, moving away from the stillness of the 'Now' at the center.

The *Passing of the Rivers Script* is more demanding to use than the Theban, because it requires more than just simple transliteration. The values of the *Passing of the Rivers Script* symbols are phonetic. When using this script, you must spell out the words phonetically.[5] So, the words are written as they *sound* not as they are usually *spelt*. For example: the word 'please' would be written as 'plez' – using the symbols **P,L,E** and **Z**. And the word 'cat' is written as 'kat', using the **K,A,T** symbols (see Table 4 on page 109).

This script has one symbol for **Sh** and another for **S**, and similarly one character for **T** and another for **Th**. It has no character for **F**, so you use the two symbols for the letters **P** and **H**. Two **V** characters are used to write a **W**. The same character is used for **J** as for **Y**. There is also one symbol that can be used for an **L** or for the syllable **EL** (this is used for the last syllable of the word 'angel', and for the names of the Teaching Angels). This may all sound complicated, but it is really quite easy to do.

When writing in the *Passing of the Rivers Script*, you have to speak the word as you write it, so that the power of this script comes into full manifestation by sound and sign. This script is a strong magic in its own right because it is based upon the universal law of vibration.

Table 3 The Theban Script

A	𝓾	N	𝓾𝓶
B	𝓠	O	𝓶
C	𝓶	P	𝓶
D	𝓶	Q	𝓶
E	𝓩	R	𝓶
F	𝓶	S	𝓷
G	𝓾	T	𝓾𝓩
H	𝓟	V	𝓥
I	𝓿	X	𝓾𝓾𝓶
K	𝓶	Y	𝓶𝓶
L	𝓾	Z	𝓶
M	𝔂	there are no symbols for J, U and W	

Table 4 The Passing of the Rivers Script

A	broad sounding as in **ay**		N	= en	
B	= **be** or **bee**		Sh	as in **show** = **sh**	
G	hard sounding as in **get**		O	as in **cold** = **o** and **oh**	
D	= **de** or **dee**		P	= **pe** or **pea**	
E	as in **where** **e** or **er**		J,Y	all **j**'s and **y**'s soft sound as in **ye**	
V	use **v v** for **w** **u** and **oo**-sound		Q	or **qu** = **ku** or **queue**	
Z	= **zee**		R	= **ar** or **r**	
H	hard as in **his**		K	hard sound as in **cat**	
Th	as in **there** = **th**		L	= **el**	
I	all **i**'s and **ee** **ee**-sound		S	**s** as in **stay**	
M	= **em**		T	= **te** or **tea**	

When used, this script creates a vortex of energy, whirling from the mental level, down through the Astral level, and into the physical. By speaking the words as you write them, you give them breath – the Sacred Wind of Life.[6] In this way, the words of your petition do not just exist on the mental level, they are manifested through the physical power of speech. Diligence and ingenuity are needed to use this script, but the results more than make up for any effort involved.

Time Orbits
Table 5 (page 112) shows a simple 'Table of Correspondences'[7] for each of the Teaching Angels of Humanity. In the columns next to the angel's name are shown:
◆ that angel's day of the week;
◆ the angel's color-vibrations;
◆ the number of days to await omens after petitioning that angel;
◆ and finally, that angel's time-orbit.
The time-orbit is the length of time in which the angel will bring about the results to the petition. A time-orbit is the longest time that it takes – but the angel can (and often does) bring the result at any time *during* the time-orbit.

Looking at the orbit column in the Table of Correspondences you will see that:
◆ Archangel Michael brings his beautiful results within one year. That is, *anytime* within 365 days. His omens and results are characteristically clear and strong.
◆ Archangel Gabriel brings results within three or nine (3x3) months – but very occasionally within twelve months. He is very strong, and usually his results will manifest in three months.
◆ Angel Samael usually works quickly; he often destroys old patterns, removing 'dead wood' to make room for the new circumstances. Sometimes his blessings come 'in disguise' (change often seems daunting), but he will not keep the petitioner waiting for long.
◆ The results of Archangel Raphael are fast – he brings his results at the earliest opportunity – but, sometimes it is left to you to sort out their order. Letters, advertisements and documents often play a big

part in Raphael's granting of petitions. If, after petitioning the Arch-angel Raphael, something in a newspaper or magazine attracts your attention, do follow it up.

◆ Angel Sachiel of Jupiter may bring his results at any time. He is a benevolent angel who takes the first opportunity to bring about his results. Often joyful surprises come with his results, like unexpected money.

◆ Rose-Angel Anael's results usually come within six months. A wonderful sense of tenderness often accompanies Anael's omens.

◆ Angel Cassiel, the 'Angel of the Temple', can be very slow to bring results – anytime within four years. But his results are thorough and long-lasting. If you do need Angel Cassiel's help within a speedier time-frame, then petition him through Archangel Raphael[8] – in cases like that you would look for omens from Raphael.

◆ The Archangel Uriel brings his results in peculiar and unusual ways – electrical equipment and light-bulbs are often affected by his presence. Uriel's results often come when least expected.

Table 5 Correspondences of the Teaching Angels

ANGEL	DAY	COLORS	OMENS	ORBIT
Michael	Sunday	gold orange	7 days	1 year
Gabriel	Monday New Moon Full Moon	silver dark blue pale green	28 days	3, 9, or 12 months
Samael	Tuesday	scarlet red orange	7 days	usually works quickly
Raphael	Wednesday	yellow black	7 days	very fast
Sachiel	Thursday	purple lavender	7 days	any time
Anael	Friday	pink pale blue	28 days	6 months
Cassiel	Saturday	dark blues dark greens	3 months	4 years
Uriel	Saturday	electric blue rainbow	14 days	suddenly

THE ANGELS OF NATURE

God placed Adam in Eden to grow roses.[1]

Approximately fifteen billion years ago, the physical universe came into being with the Big Bang – a vibration that can still be measured. Billions of galaxies were created. Some of these galaxies are still traveling away from the cosmic center at a speed faster than light. From this Creative Fiat[2] came all physical Creation. And so everything is related and shares a common source.

We live on a beautiful planet that is our island-home among the stars. It is the nursery in which we can grow into our Divine nature. Our planet is a living being, a conscious entity with its own unique destiny. Our planet revolves about the Sun; the Sun in turn orbits about the center of this galaxy (somewhere near the constellation of Virgo); and our galaxy orbits around something greater. With each spiraling turn of this great dance, the relationships between the various heavenly bodies reconfigure. These cosmic energies weave together in a great network of vibrating force – one living web of communicating light – whose collective vibrations are the Music of the Spheres.

Some cultures have imaged planet Earth as 'mother' – Gaia, Demeter, Turtle-Mother. But for other cultures the Earth is 'father'.[3] Perhaps, at this time, the idea of Earth Mother speaks more deeply to us, but this does not make the other images wrong. Images are only signposts; the reality to which they point, is that the Earth is a living being, a planetary entity, in which we live and move and have our physical being. The Earth has its own guiding intelligence. This planetary guardian is the Archangel Sandalphon of Malkuth.[4] Sandalphon

holds the template of the Earth's destiny, its completed perfection. Every being upon the Earth is linked at a deep level to the Archangel Sandalphon. And this great archangel can be called upon to assist you with your Earth-walk, to help you find your reason for incarnation at this time, and to help you develop to fulfill your destiny for the good of all. You can also invoke Sandalphon to help any injured animal or plant.

Watching the news reports on television can be distressing, until you realize that, because your attention is focused upon a news item (a person, place, or situation), you can be a link between that situation and the angels. You can invoke angelic assistance for those you see on the TV screen – and the angels will follow your beam of attention to that person or place. Any angels you have worked with are linked with you in a special way.[5] You can call upon them and commend other people and situations to their ministry. But *always* make sure to begin your request with *'If it be the Divine Will'*, so that you do not interfere the workings of Providence that oversees everything to its ultimate good (even if we can not understand it yet).

The Devas
There are hosts of angels who minister to the planet Earth. They oversee the planet's eco-system, and relay the complex range of energies throughout all living forms. These Angels of Nature are the *Devas* (Sanskrit for 'Shining Ones'). It is these angels who maintain, support and vitalize the interdependent Web of Life.

The Devas are ruled by Archangel Haniel of *Netzach*. 'Haniel' means 'Grace of God'. The sphere of this archangel is the Divine activity through which The ONE becomes the Many, as primal unity clothes Itself in 'name' and 'form', in an infinite number of apparently separate beings. So, Haniel reveals the spiritual vision of God made manifest in nature. Archangel Haniel also presides over the path of the nature-mystic, the shaman, the Druid, and the Celtic Christian. These seekers often go on Vision-quests (alone in the wilderness), to experience the sacredness of all living things in nature.

'If you have the courage to walk with me through the forest ways at night, I will show you the very face of God himself.'[6]

It is the Devas, serving under Archangel Haniel, who give nature its *numen*, its sense of the Divine. Our perception of nature's inherent beauty – seeing a majestic mountain range, or a golden dawn over the sea, each unique snow-flake on a window, or a stag poised in a forest glade – is our soul's recognition of the work of the Devas.

The Hosts of Faerie: Elementals, Fairies & Elves

The Devas oversee the activities of the 'elementals', units of consciousness responsible for the life-force in all physical substances. The Western tradition names them after the four elements: *Sylphs,* who are the sprites of Air (all gases); *Salamanders,* the denizens of fire (all combustion); *Undines,* the spirits of water (all fluids); and *Gnomes,* the elementals of earth (all inert substances). Because of this fourfold classification, these beings are called 'elementals'.

Elementals are not physical, but Etheric beings. The Etheric level is the interface between physical matter and the Astral plane. Elementals stand in the same relation to angels as cattle do to humans. I am not saying the angels treat elementals the same way that humans treat cattle; I mean their level of consciousness. Elementals are the simplest life-forms in the angelic kingdom. But, under certain conditions, an elemental can evolve into an angel.

Fairies, or Nature-spirits, work with the vegetable kingdom. And they serve under Rose-Angel Anael. Anael is the principal 'lieutenant' of Archangel Haniel and has responsibility for the vegetable kingdom. Every single plant is connected to a fairy, who channels *prana*[7] or *chi,* into the plant. Fairies often appear as vortices of spinning green light. Sick plants can be helped by directing energy to its attendant fairy. The folk-lore of the work of the fairies portrays them attending flowers and flitting from bloom to bloom (Shakespeare's *Midsummer Night's Dream,* or Walt Disney's *Fantasia*).

Elves are more complex than elementals or Nature-spirits. They too, reside in the Etheric interface, just between full physicality and the Astral level of existence. Elves (Celtic: *the Sidhe*) live in areas of

great natural beauty and power. Unlike elementals and fairies, elves cannot abide in modern cities or places of high industrialization. And not all of the elven folk are good, there are dark elves too, who do not wish humans well. In fact, even the good ones tend to be aloof. All elves are creatures of great beauty – *'How beautiful they are, How beautiful, The Lordly Ones In the hollow hills.'*[8] – and it is their beauty which often glamours the unwary.

Elves can live for great periods of time, even for many centuries, but after they have lived their span, they dissolve back into the universal primal matter. They have no existence in the higher worlds of spirit. This can make dealing with them hazardous; indeed, it is best left to those who have been trained by an experienced teacher. These invisible spirits of nature have no morality. They are not evil, but they are amoral, like a young human child, who, wanting something, will do anything to obtain it. Any dealings with elementals or the elven folk, should only be conducted through the angels who have rulership over them.

The Work of the Devas

The life-force of this planet rises up from its molten center, the titanic energy field held in the heart of the globe. Our planet originated from the Sun, and has solar force at its core. This terrestrial fire at the planet's heart sustains all physical life.[9] From it, life-giving energy radiates throughout the globe through etheric canals, or Moon-paths. (These were mentioned in Chapter 3, *'Moon Magic'*.) And these same pathways are channels for the terrestrial energy welling up from the planetary center.

The Devas look after specific locations on the planet's surface, to ensure a smooth flow of these energies through those areas. The Devas receive the energy, they add their own special vibration to it, and then they direct energy through the rest of the web. There are Devas over mountains and hills, rivers, lakes and seas, forests, plains and fields. In fact, every place has a specific Angel of Nature. Our ancestors acknowledged this by honoring the 'gods' of specific mountains, trees, rivers, etc.

The Deva of a mountain contains the entire mountain within its energy-field: every boulder, pebble, shrub and tree upon the mountain, is held within the angel's consciousness. And each animal and bird which makes its home in the mountain is also known to the Deva; and, in turn, those creatures are aware of the Deva. The Deva overshadows the whole subtle eco-system of the mountain. The relationship of the mountain to its environment, to the landmass of which it is a part, its effect on wind paths and the precipitation of rain, its erosion (that feeds the valleys through the rivers), and its mental and emotional effect upon other life-forms – are all part of the presiding Deva's role.

Seen with soul-eyes, a mountain Deva is a majestic sight.[10] Its 'body' begins deep down in the continental plate from which the mountain emerges, and towers hundreds of feet above the mountain's highest peak. Through the vortices of its body, the Deva draws energy up from the planetary center, to cascade like a living fountain over the mountain, permeating every part of it. The immense aura of the Deva encompasses the mountain. At times the Deva's aura flares out like wings, as energy is directed outward, and at other times the wings mantle the mountain, like a tower of color and light, as energy is directed into the mountain. The head of the Deva sometimes resembles a crown of golden rays, which flow and vibrate, resembling a radiant Native American headdress. The colors of the Deva's body and aura vary according to the energies being focused at the time – which can be solar, lunar, or seasonal. A tree-clad mountain Deva is an amazing sight in springtime. If you have ever stayed in a village at the foot of a large mountain, you will know how easy it is to tune into the 'presence' of the mountain, that vast, serene strength that broods over all within its sway. That presence is the mind-touch of a Deva of the mountains of God.

Findhorn is a spiritual community in north-west Scotland, which works with the Devas. It was founded by Eileen Caddy (1917-2006). By opening themselves to the angelic influences in nature, the Findhorn Community were able to receive communication, teaching and advice from the Devas. The soil of the land of Findhorn was no good for the cultivation of plants and crops. But by welcoming the

Devas, the angelic consciousness stimulated alterations in the soil's composition, and now Findhorn grows its own food. This knowledge of how to cooperate with the Devas was once held by the ancients, and from it grew the various religious rites of blessing fields and crops. In Scotland small plots of land are left to grow wild, for the 'Gentry' (an old name for the Elves); and contracts of sale still contain a clause that these small plots will be left undisturbed.

A good friend of mine, who worked at Findhorn in its early days, told me that one of the instructions the Devas gave, was to leave a certain area of land in their vegetable gardens uncultivated. This untilled area gave the Devas a 'foothold' in the gardens, from which they could radiate their life-giving energies. It is interesting to observe, in this connection, the increase of wild gardens being established by British gardeners; the purpose of these gardens is to provide natural habitat for wild species of flowers, grasses, and butterflies. Anybody who is fortunate enough to have a garden, can leave a portion of it wild, and invite the Devas to use it. The invited presence of the angels of nature can do much to help our gardens; but more importantly, it can assist our towns, our cities, and us. With the growing awareness of ecology, of 'green' lifestyles, and the interconnectedness of all life-forms on our planet, the Devas can teach us how to make the Earth a garden – a paradise.

The Animal Lords

The followers of the shamanic way work with Nature-powers as their teachers. The shaman makes right relationship with all life-forms, and tries to co-operate with the Devas of nature. The Nature-mystic seeks union through experiencing The ONE clothed in the garment of matter. For the followers of these paths, separation between the Creator and Creation is unknown. As the Mohawks, a Native American nation in the Iroquois Confederacy, say:

> *We believe that when The Mystery, or God, created the universe, He placed His hand on the whole thing, so everything is spiritual. As far as I know, God never told us Mohawks to separate anything, but just*

to look upon everything that He made as holy and sacred, and act
accordingly with respect.

I wrote in Chapter 1 about those angels who are the Higher Selves of
an entire animal species. Those angels – the Sacred Animal Powers –
are the Divine proto-animals. For the shaman, the totem creature is
the 'ray', the earthly likeness, through which the angel instructs and
guides. And in Chapter 5, I shared how the Teaching Angels use ani-
mals as omens of consent to petitions. In shamanic journeys into the
Astral plane, the spirit-creatures that are met are the collective entity,
the angel who is the Oversoul of that species. The teaching received
is based upon the entire experience of a species that has existed on
Earth for millennia. But that is not all: the angel of the species is an
embodiment of the 'idea', the archetype of the species in the Divine
Mind. So the angel embodies the ultimate perfection of the species
that it guides.

In his book *Battalions of Heaven*, the Reverend Vale Owen re-
corded the messages he received from his friends who had passed over.
This communication describes those angels who are Oversouls for the
animal kingdoms and it gives us a sense of those beings:

The animal entities had fully sensation in themselves, and also a
modicum of personality. And their Lords were very splendid in their
array... I cannot limn their aspect to you because you have nothing
for comparison on earth, albeit they are very busy in your midst,
nevertheless.

I will be content with saying that as we looked upon each we
knew, from the aspect of him, that department of nature of which he
was Ruler. Whether it was... oak or tiger, his dominion was writ upon
him plainly, and in all its beauty.

Form, and the substance of his body, and countenance, and
raiment all expressed his kingdom. Some had raiment, some had
none. But the grandeur of these great Lords is very majestic in
strength and comeliness. All had their retinue who were ordered in
their degrees. These had charge of the subdivisions of their kingdoms

and linked up their Lords with the animals or forces which those Lords controlled."

Through the Devas we can experience the Divine Presence in nature, what Qabalah calls *Shekinah,* the Immanence. And we can come to know for ourselves that The ONE outpours Its goodness through all the elements, plants, animals and spirits, through the ministries of angels everywhere, in Heaven and Earth. This hidden knowledge is expressed in Psalm 24: *'The Earth is the Lord's, and the fullness thereof'.*

Illustration by Gustave Doré

PRACTICE 5
Rite of Archangel Sandalphon

This group ceremony invokes the Archangel Sandalphon to help endangered species of animals and plants. I wrote it in 2010 for the Angel Sanctums. An 'Angel Sanctum' is a group of people who gather together (usually monthly) to perform the angelic ceremonies that broadcast peace and blessings on the world. There are Sanctums worldwide now. I personally train the leader of a Sanctum in preparation for this work.
For further details go to www.sacredmagicofthe angels.com/trainer

For this ceremony, the ritual-team consists of a Leader, plus four others to represent the cardinal points: East, South, West and North. But it is the rest of the group who really make the ceremony work, by the power of their visualization and chanting.

Set up a central altar, and on it place:
- *the Presence Lamp;*
- *a candle for each endangered species being commemorated;*
- *pictures, too, can be used.*

Leader **Oh El-Elyon, You mantle Yourself in light, and stretch out the skies as a curtain, and the clouds as Your chariot; You exhale the ways of the wind, making them Your messengers, and make Your servants to be as sacred fire.**
On a firm foundation You established the Earth, on a foundation that forever abides.
Have regard for this planet, may it be the footstool of Your presence. Amen.

Now create-with-thought (visualize) four great crystalline mountains at the fours points of the horizon – where sky and land meet:

'See' at the eastern horizon a glorious yellow mountain: '*the Mountain of the Omnipotent Will*'.

Now image at the southern horizon a glowing scarlet mountain: '*the Mountain of Radiant Love*'.

Then picture at the western horizon a luminous blue mountain: '*the Mountain of All-accomplishing Power*'.

And last of all, visualize in the north a powerful jet-black mountain: '*the Mountain of Transformation*'.

From the peak of each of the four mountains a beam of light arcs up into the sky... and they converge at the center of the sky, directly above the place where you are working this sacred ceremony. And now the ritual words are spoken:

Leader **In the name of the All-Healing, we send our voice to the eastern horizon, and call unto us Paralda, the Air-King.**
We feel the fragrant breezes that herald his advent.
Surrounded by dawning light, he comes!
And winds blow from him and vitalize our auras.

South **In the name of the All-Radiant, we send our voice to the southern horizon, and call unto us Djinn, the Fire-King. We sense the heat that heralds his approach. He comes, radiant with dancing flames! And waves of heat radiate from him and energize our auras.**

West **In the name of the All-Merciful, we send our voice to the western horizon, and call unto us Nixsa, the Water-King. We hear the murmuring sea that precedes him. He comes, robed with foaming waves all about him! And the rains flow from his aura into the atmosphere.**

North **In the name of the All-Sustaining, we send our voice to the northern horizon, and call unto us Ghob, the Earth-King. We smell the freshly turned soil, as he comes to us; clothed with jewels and dragon-gold! And the earth beneath us stirs as he blesses it with his presence.**

Leader **Let us call upon the Source of Life –
Oh God of Glory, You outpour Your own Divine Life to uphold and sustain the world; we intercede for healing of the Earth. May Your blessing descend upon all creatures and plants on this planet, empowering them with life, health and strength. Oh God made manifest in nature, may humanity venerate You in all beings, and so respect, honor and care for them.
We name before You the** (here name an endangered species of plant or animal. Different people do this for different species.)
We name before You the [name].
We name before You the [name].
(As many are named as is deemed suitable.)

Leader **Therefore, for the sake of every creature under Heaven let us turn the Wheel of Life, the chakra of planet Earth.**

The group circles around the altar while chanting the response to the 'LITANY OF BEINGNESS':

Leader **All you works of the great mystery, praise Adonai:**
Response *Praise The ONE and receive His Grace.*

All you archangels of God, praise Adonai:
Praise The ONE and receive His Grace.

All you angels of His light, praise Adonai:
Praise The ONE and receive His Grace.

All you Heavens, praise Adonai:
Praise The ONE and receive His Grace.

All you Powers-that-be, praise Adonai:
Praise The ONE and receive His Grace.

Oh, you Sun and Moon, praise Adonai:
Praise The ONE and receive His Grace.

All you stars of Heaven, praise Adonai:
Praise The ONE and receive His Grace.

All you showers and rain, praise Adonai:
Praise The ONE and receive His Grace.

All you winds of God, praise Adonai:
Praise The ONE and receive His Grace.

All you fires and heat, praise Adonai:
Praise The ONE and receive His Grace.

All you winters and summers, praise Adonai:
Praise The ONE and receive His Grace.

All you springs and autumns, praise Adonai:
Praise The ONE and receive His Grace.

All you dews and rains, praise Adonai:
Praise The ONE and receive His Grace.

All you frosts and cold, praise Adonai:
Praise The ONE and receive His Grace.

All you ice and snows, praise Adonai:
Praise The ONE and receive His Grace.

All you nights and days, praise Adonai:
Praise The ONE and receive His Grace.

Oh, you light and darkness, praise Adonai:
Praise The ONE and receive His Grace.

All you lightnings and clouds, praise Adonai:
Praise The ONE and receive His Grace.

Oh, let the whole Earth, praise Adonai:
Praise The ONE and receive His Grace.

All you mountains and hills, praise Adonai:
Praise The ONE and receive His Grace.

All you lakes and rivers, praise Adonai:
Praise The ONE and receive His Grace.

All you seas and oceans, praise Adonai:
Praise The ONE and receive His Grace.

All you plants and trees, praise Adonai:
Praise The ONE and receive His Grace.

All you forests and plains, praise Adonai:
Praise The ONE and receive His Grace.

All you Hosts of Faerie, praise Adonai:
Praise The ONE and receive His Grace.

All you whales and those that swim, praise Adonai:
Praise The ONE and receive His Grace.

All you birds and those that fly, praise Adonai:
Praise The ONE and receive His Grace.

All you mammals and reptiles, praise Adonai:
Praise The ONE and receive His Grace.

All you children of Adam, praise Adonai:
Praise The ONE and receive His Grace.

All you humans of good heart, praise Adonai:
Praise The ONE and receive His Grace.

All you Works of the Great Mystery, praise Adonai:
Praise The ONE and receive His Grace.

Leader **Praise to the Creator, the Renewer, the Whole Spirit of Life; now and forever.**

Response **Amen. Amen. Amen. Amen.**

Leader **Archangel Sandalphon, you are this planet's Holy Guardian Angel, carry on high this our intercession for all our relations. Bear it unto the Fountain of Life, even unto our loving Father-Mother. For we acknowledge the sublime truth: that our lives and thine, oh Sandalphon, are one in God.**

May the blessing of the Great Mystery, even Adonai,
be upon you forever. Selah.

East **Our gracious thanks be unto thee, Paralda, oh king of
breeze and wind. May the blessing of the Great Mystery,
even Adonai, be upon you forever.
Selah.**

South **Our gracious thanks be unto thee, Djinn, oh king of fire and
flame. May the blessing of the Great Mystery, even Adonai,
be upon you forever.
Selah.**

West **Our gracious thanks be unto thee, Nixsa, oh king of sea and
rain. May the blessing of the Great Mystery, even Adonai,
be upon you forever.
Selah.**

North **Our gracious thanks be unto thee, Ghob, oh king of earth
and stone. May the blessing of the Great Mystery, even
Adonai, be upon you forever.
Selah.**

Leader **Peace to all beings.**

*After the ritual, participants should take the candles home – lighting
them for a while each day – to continue this Earth-healing magic.*

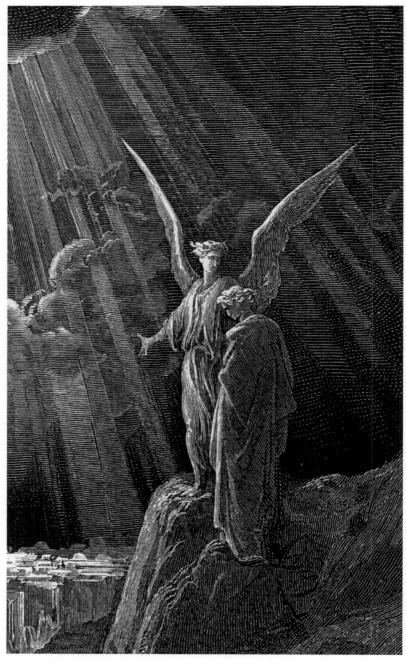

Detail of *'The New Jerusalem'* by Gustave Doré

CHAPTER 7

THE TALISMANS OF POWER

Because Thou hast been my help,
therefore beneath the shadow of Thy wings will I rejoice.[1]

It is good for anyone practicing this Sacred Magic to strengthen their link with the angels at each New Moon. The best way is to go into your sacred space, and there spend some time communing with The ONE (I recommend Practice 8, *Temple of the Heart*). Then, call your personal Sun and Moon Angels; and then Archangel Gabriel of the Moon. Make this dedication before the Powers-that-Be:

At this renewing of the Moon's face, I dedicate anew my work with the sacred angels, to the glory of the Almighty ONE of All Life (Shaddai-El-Chai).[2] **In this Lunar cycle may my magic flourish for my own well-being, and for that of all Creation. Selah.**

The Crown of Resplendence
This magic can be performed on any Sunday of the year (unless there is a solar or lunar eclipse), and best during the hours of sunlight. This magic is sacred to the Archangel Michael. And this talisman's signs-of-power are his.

The purpose of this talisman is to crown any legitimate undertaking with success – to help you bring abundance and improvement into your life. This talisman is particularly effective for any matter that involves the influence of 'people in authority', i.e. managers, employers or government officials.

This solar magic can be used to help in anything where you can gain through your own efforts; for example: having your worth

Figure 12 The Crown of Resplendence

recognized by your employers and getting promoted. The ritual needs to be repeated every Sunday until your goal has manifested.

For this working, you need an orange or gold-colored candle, a square sheet of yellow paper, a ruler and a pair of compasses, an orange or gold pen and some quality incense (frankincense is best for angelic workings). When you are ready to begin, take the unlit candle and dedicate it to your intention by the following invocation:

> **With the Divine permission, and invoking the help of Archangel Michael of the Sun, I bring fire to earth** [now light the candle] **– so that sun-bright grace may empower my own efforts in attaining success in the following petition** [state your intention simply].

Next, upon the square of paper write your petition in the *Passing of the Rivers Script,* using orange or gold ink. Light the incense and pass the lit candle three times through the fragrant smoke. Then pass the paper upon which you have written your petition through the fragrant smoke too.

Now, on the reverse side of the yellow paper, draw the talisman-of-power as it is shown in figure 12. Draw the circle first, and then the words and the symbols in a clockwise direction.[3] The Hebrew words in the circle are the names of four Solar Angels: Shemeshiel, Paimoniah, Rekhodiah and Malkhiel. Then, fold the completed talisman into a triangle. Extinguish the candle. Carry the solar talisman on your person until the following Sunday. And before you make another one, make sure that first of all you burn the one made on the previous Sunday.

Bringing a Blessing to the Home

This sacred magic is under the rulership of the Archangel Gabriel. This working may only be done on the night of a New Moon. It is used for obtaining furniture or any domestic appliance that you cannot afford. Remember, in magic you always invoke for what is needed, *never* for the money to buy it – why limit the universe to a single way of helping you? But, if money itself is desperately needed to pay rent or mortgage, then this talisman can be used for that; and it will help you to earn or receive the necessary amount.

The talisman is Gabriel's lunar square-of-power. Its symbols are lunar crescents, interspersed with the numbers of the lunar cycle. The vibration of the Moon's waxing and waning tides, in the Four Quarters, are woven into the talisman.

To work this magic, you need one white candle, a ruler, a blue or silver pen, incense, and a square of white paper.

On the first night of a New Moon, light the white candle and the frankincense. Consecrate the candle by passing it four times (once for each phase of the Moon) through the perfumed smoke.

Then draw the grid of the talisman on the paper: four lines down by seven lines across. Next, draw the symbols in the squares of the grid, starting at the top, and writing across from left to right;

7	🌙	14	🌙	21	🌙	28
🌙	14	🌙	21	🌙	28	🌙
7	🌙	14	🌙	21	🌙	28
🌙	14	🌙	21	🌙	28	🌙

Figure 13 Bringing a Blessing to the Home

then the second, third, and fourth lines – thus completing the talisman (see figure 13).

On the reverse side of the talisman, draw the 'invoking sign' (the trident fork shown in figure 14), which represents the New, Full and Old phases of the Moon. Then write the name of **'Gabriel'**, with the *Passing of the Rivers Script*, and follow it with a second invoking sign. Underneath this, in *Theban Script*, write whatever is needed, e.g. 'beds', or 'curtains', or 'refrigerator'.

Then pass the completed talisman through the incense smoke four times while you say:

> **Holy Archangel Gabriel, I invoke you to aid me in this matter, over which the Almighty Living ONE gave you rule. Selah.**

Then extinguish the candle.

This talisman must be kept in the same room that it was made in until the following New Moon (it may be hidden from sight if necessary). If what is needed has not come by the following New Moon, then burn the talisman and repeat the ritual working.

Figure 14 Bringing a Blessing to the Home *(reverse side)*

The Lamp of Discovery

This magic reveals the truth about any person, situation, or received information. For example: if you hear a rumor being spread that hurts your good-standing, this talisman can reveal to you the truth of *who* originated the rumor and for *what* purpose. You will be given evidence that reveals the facts clearly. The information usually comes in a perfectly natural way. And this talisman can only be used in matters that concern you – not others. The ruler of this magic is Angel Asariel of Neptune, which is the planet of psychism and hidden things. This working can be performed on any day of the week, and it only has to be performed just once – but it can only be used for one matter at a time.

You need a white candle and a black candle (or, if you can't obtain a black one, use a white candle with some black ribbon or wool tied around it), a ruler, a black pen, frankincense, and a square of white paper.

To perform this magic, place the candles about eight inches apart from each other. The white candle represents truth, while the black candle signifies falsehoods and lies. Begin by saying:

May Light shine into the darkness of doubt.

4	9	3	6	5
9	9	1	7	6
3	1	4	1	3
6	7	1	9	9
5	6	3	9	4

Figure 15 The Lamp of Discovery

Light the white candle, and invoke:

> **May Asariel, the Revealer of Mysteries, shine the Light of Truth upon this matter of confusion, so that I may see clearly, like unto the Eye of Heaven.**

On the paper draw in black ink the grid, as shown in figure 15. Next, from left to right, draw the numbers,[4] and fill the rows in descending order.

After completing the square, pass it once through the incense smoke. Next, on the reverse side of the square write, in the *Passing of the Rivers Script*, **'Asariel Reveal'**.

Next – while holding in your mind the matter you need to know the truth about – light the black candle, and then allow it to burn completely.

Keep the square until the truth of the matter has been revealed; then thank the invoked powers and burn the square completely.

Ritual for Obtaining Justice or Financial Increase

This is a powerful magic of the Angel Sachiel of Jupiter, and it is performed on his sacred day, Thursday. It can be used to invoke for assistance in legal matters where it will bring about a *just verdict*, and may also help with costs incurred. The justice will be in proportion to the righteousness of the cause – in other words – Divine Justice.[5] This talisman may also be used for increase of finances. But it cannot be used for these two intentions at once.

You will need a purple candle, a ruler, compasses, a purple or blue pen, frankincense, and a square of white or lavender paper. Light the candle and incense, then invoke:

Great Angel Sachiel, Servant of El, as this light shines and this incense ascends, so lift thou my petition before The ONE. Selah.

Next, on the paper, draw the outer, and then the inner circles (see figure 16). Then draw the six-pointed Star at the top, write the three Hebrew words in the left-hand semi-circle. And then, in the right-hand semi-circle write the other three Hebrew words. (Do make sure that the letters of the Hebrew words themselves are written from right to left.) Next, draw the horizontal line and its symbols; then the vertical line and its symbols; followed by the diagonal line and symbols (top left to bottom right); and finally, the diagonal one from top right to bottom left. On the reverse side of the paper, write the name **'Sachiel'** in the *Theban Script*.[6]

If this talisman has been made for justice, then fold the talisman around a feather (representing Ma'at, the Egyptian goddess of justice). Then keep the folded talisman inside your pillowcase or beneath your mattress.

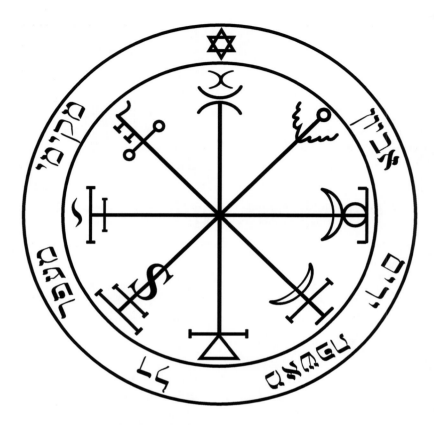

Figure 16 Ritual for Obtaining Justice or Monetary Increase

If your intention is for monetary increase, then fold the talisman around a gold or silver coin,[7] and keep it in your wallet or purse. Allow the purple candle to burn out completely.

This working has to be repeated each subsequent Thursday, after burning the talisman made the previous Thursday. But, if there is any progress at all, it indicates that the magic has begun to operate and so keep the most recent talisman until the final result. When it is accomplished, burn the final talisman giving thanks.

Shield of the Warrior-Angel

This talisman is empowered by the Great Protective Angel, Samael of Mars. It is used to overcome enemies – known or unknown. It is also

M	E	B	H	A	E	R
E	L	I	A	I	L	E
B	I	K	O	S	I	A
H	A	O	R	O	A	H
A	I	S	O	K	I	B
E	L	I	A	I	L	E
R	E	A	H	B	E	M

Figure 17 Shield of the Warrior-Angel

used for protection from enemies. But we must first understand just what an *enemy* is. An enemy should not be confused with a *rival*. A rival is a person who spurs us on to excel – like the necessary grit in an oyster, whose irritation forms a pearl. A rival helps us develop our strengths and recognize our talents. But enemies are those people who would diminish us, who hurt us willfully.

To distinguish whether a person is an enemy or not, the following test is helpful: Ask yourself, *'Is the person damaging me and mine, or is it only my feelings that are being hurt?'* And having enemies does not mean that you are a bad person. The Buddha, Gandhi and Jesus had enemies.

All beings have the right to self-defense. And the Shield of the

Warrior-Angel talisman defends us from enemies. Once invoked, the angels will neutralize the enemy's thoughts, words and actions towards us. The enemy will either have a change-of-heart towards us, or be removed from our ambit altogether.

However, to receive the protection of the Angel Samael through his talisman, we must refrain from all retaliation against the enemy. Of course, we are entitled to act in self-defense and to speak one's truth; but not to repay hate for hate, or cruelty for cruelty. The very reason why Angel Samael will consent to protect us, is so that we can remain clear lamps and not cast any unholy shadows.

Creating the Shield of the Warrior-Angel is done on a Tuesday. You need a red candle, a red pen, a ruler, a square of white paper, and a glass of water.

First light the candle, then draw the grid of the talisman, changing the English letters into the *Passing of the Rivers Script*, writing it from left to right, in descending order (see figure 17). Immediately after you have finished writing, plunge the lit candle into the water, to instantly extinguish it as you declare:

Beneath Thy wings, All-powerful ONE, I will rest safe and secure. Therefore no evil shall touch me, nor enter my dwelling. Selah.

Keep the talisman near a source of heat: a boiler, radiator, oven, or fireplace. And when you receive proof that the angel has dealt with your enemy, burn the talisman on the next Tuesday.

Mirror of the Mind

This talisman brings fluency of thought, speech, and writing. It improves the mental faculties of concentration and memory. Using it 'polishes' the mind, making it clear and bright. This talisman is very useful when preparing for examinations, but should be made before starting to prepare for the exam – not be made just a few days before sitting the exam. This talisman also helps with creative writing and public speaking.

The angel who this magic invokes is Archangel Raphael of

Figure 18 Mirror of the Mind

Mercury. This working is performed upon a Wednesday and repeated each following Wednesday, until proficiency is achieved.

The magic only requires a square of yellow paper, a ruler, and a black pen. There is no ritual – no candles, spoken invocations, or incense – the square is just drawn each Wednesday and kept within your pillowcase or under the mattress (see figure 18). But, on the day of the exam, you must wear it on your person, and briefly touch it to your forehead.

The Thunderbolt

This is a talisman of great magical force; it is very powerful and effective. But, people who do not want sudden changes or great upheavals

Figure 19 The Thunderbolt

in their lives should not use it. The talisman removes unwanted obstacles in sudden and unexpected ways. So devastating are the effects of this talisman, that it should not be used more than once a year.

The working removes obstacles that are preventing you from enjoying happiness and life. To legitimately use this talisman, it must be to remove a burden that is ruining your life – a burden that was *imposed* on you, that was *foisted* upon you. And you must be prepared to accept the upheavals that using this talisman-of-power may bring.

Because the Thunderbolt often works by disintegrating the obstacle, it must *never* be used against any living being. Nor can it be used to remove ill health, or poverty, or to influence loved ones. This is a talisman of Archangel Uriel, who is a Throne Angel of the highest degree, and whose results are dramatic and devastating. If you were to use this talisman inappropriately, the invoked power may well turn against you – for this archangel, named the 'Light of God', will not permit any unjust or corrupt intentions.

The method is extremely simple, because the symbol on the talisman is so very potent – it is the thunderbolt that is pictured in the sixteenth Tarot card, 'The Blasted Tower'. There is a legend which says that it was the Archangel Uriel who was sent to destroy Atlantis and its peoples, to bring to an end their abuse of science and magic.

This working is done on a Saturday and all that is required is a sheet of black paper, a piece of white chalk, and a clear conscience! Begin by naming aloud the obstacle you wish to be removed, then speak the invocation:

Holy Uriel, Light of God and Angel of Magical Force, remove from my path [name the obstacle again] **which unjustly afflicts me.**

If at this point you receive *any* intuition or sign to stop, do *not* proceed with this working – abandon it. Any misgivings you feel may be an indication from Uriel not to proceed.

But if all is well, then write your request in the *Passing of the Rivers Script* with the white chalk on the black paper. Then on the reverse side, draw the symbol of the Thunderbolt (see figure 19), and write the name 'Uriel' in the same script. As soon as you have completed the talisman, fold it into a square and then immediately bury it in some wasteland or in common ground.

The Wheel of Anael

This talisman and ritual belongs to the Rose-Angel Anael of Venus, and is used on a Friday. Its purpose is to increase love and deepen affection between friends, partners, or relatives. It is a powerful healing of arguments or separation between loved ones. It can restore fondness in failing friendships, and reunite quarreling relatives. No matter what pain or hurt loved ones may have caused one another, if the 'spark of affection' still exists, then Angel Anael can fan it back into a healthy flame. 'Love', in the romantic sense, is like a greenhouse-plant: it requires all the right conditions to blossom. The Wheel of Anael can generate the conditions needed for love to flower. The results of this ritual manifest within six weeks.

But this working will *not* compel another person's love if they have no initial affection. The Wheel of Anael cannot be used to force love. (There are dark magics that can force the illusion of love by compulsion and glamour; but always, these methods end in ashes, because the worker of such dark magic knows that the other person never entered into the relationship of their own free will.) Love, to truly be love, must be freely given and honored; it must prefer the greater good of the loved one, to any personal gratification.

And the Wheel of Anael can be used to ascertain whether someone is meant to become a 'loved' one. If you are attracted to someone,

Figure 20 The Wheel of Anael

13

but unsure whether your feelings are reciprocated, you may use the Wheel; and if, by the end of the six weeks, there has been no indication of growing affection, you will know that there is no future in the relationship. In that case, say **'thank you'**, and move on. But if affection *has* manifested, then the Wheel will continue to encourage it to flower and ripen.

To perform this ritual of the Wheel of Anael you will need: three pink candles, three pale blue candles, one stick of red sealing-wax, and some Venusian incense (just add rose oil to frankincense), a six-inch square of pink or pale blue card stock (not paper), compasses, a ruler, a red pen, and a fresh rose flower. All of these items are used for all the six Fridays – except the rose, which must be bought fresh each time.

On Friday, set up an altar for this ritual. Place the six candles in a row along the back – placing the rose flower in the middle – three candles, the rose, then the other three candles. In front of this row place the incense burner, ready for use. In the center of the tabletop place the card, drawing implements, and sealing-wax.

Before starting this ritual, put some perfume or scented oil on the palms of your hands. Then, light the candles and incense. Next, write the name 'Anael' in the *Passing of the Rivers Script* with red ink on each of the four corners of the card. Then, pass the card through the fragrant incense smoke – so that the written name is briefly held over the incense. Then, having incensed the four corners of the card, draw the diagram of the Wheel of Anael in the center, as shown in figure 20.

Turn over the card and write, in the *Passing of the Rivers Script,* the name of the person whose affection you wish to receive. Then roll the completed talisman from left to right into a tube, and put along its edge six seals using the red sealing-wax.

Now extinguish the six candles, speaking this invocation as you put out *each* candle:

In the name of Anael may the Wheel revolve.

Leave the incense to burn as an offering to the angel, and place the Wheel under the mattress of your bed.

On the subsequent five Fridays: buy a fresh rose, and set up the altar as before. Light the candles and incense. Then, break the six seals on the Wheel and unroll it. Incense the four corners of the Wheel as before. Then, roll the Wheel, from left to right, into a cylinder again, and seal it again with six seals. Extinguish the six candles, speaking the invocation (**'In the name of...'**) with each one; and then return the Wheel to its place under your mattress.

This ritual must be performed for six *consecutive* Fridays. If for any reason a Friday is missed – then the entire working must be started all over again – with new candles, paper, etc.

By the sixth Friday, if no signs of *increased* affection from the

other person have come – then the Wheel must be burned. But, if affection has perceptibly grown, then after the sixth performance of the ritual, tear the Wheel into small fragments and scatter them to the night wind.

The Square of Lumiel

This is an angelic talisman of protection. It protects the soul from fear and disempowerment; it protects the mind from damage; and it protects the body from harm and degeneration of health. This talisman is sacred to the Angel Lumiel,[8] one of the Angels of the Earth. A person who possesses a Square of Lumiel is protected from harm in body, mind, and soul.

The talisman is made on *thick* white card – it has to last a lifetime! And it should be made on the day sacred to either your personal Moon or Sun Angels.

If you are making it for someone else, then do it on the day of his or her angels. There is no ritual for this talisman, because the drawing and coloring of its symbols will empower it.

The grid of the square is drawn in red. The symbols are drawn in different colors: the *Physical Heart*[9] in red, the *Star-of-Glory*[10] in silver, the *Eye of Heaven*[11] in sky blue, the *Djed-pillar of Osiris*[12] in gold, and the *Symbol of Fortune*[13] in purple.

The letters of the name 'Lumiel' are written in green, using the regular English alphabet (see figure 21). On the reverse side of the talisman, write in green the name of the person for whom the square is intended, in the *Passing of the Rivers Script*.

The Square of Lumiel is only made once – unless it is lost and needs replacing. You can keep it in a wallet or purse, or even in a picture frame at home. Some practitioners of Angel Magic keep theirs under the mattress, unless traveling, when they take it with them. This talisman-of-power has a truly wonderful ability to protect and safeguard its possessor.

18

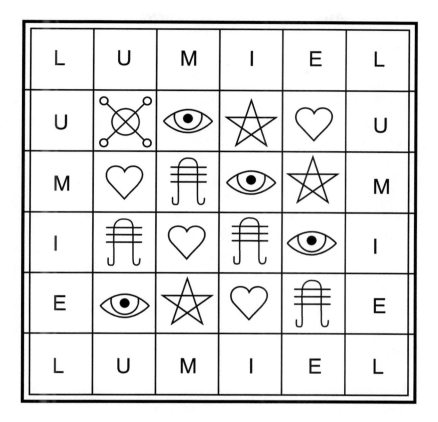

Figure 21 The Square of Lumiel

PRACTICE 6
The Moon Tree

A *Moon Tree* acts as a focus for lunar energies, and is of great help in workings with the talismans of the Archangel Gabriel. A Moon Tree is charged with the lunar energy and empowers all workings done in its presence. And because most angelic energy comes through the sphere of the Moon (the Astro-etheric plane), a Moon Tree is helpful for all angelic workings. And so, many practitioners of the Sacred Magic have a Moon Tree in their gardens or shrines. A Moon Tree is linked to the archetype of the Burning Bush upon the Mountain of the Moon, and it represents the Tree of Life of the Astral plane.[14] You can either have a Moon Tree in your garden, or make one for your altar or sacred space.

A Living Moon Tree

If you are going to establish a living Moon Tree in your garden, you can either choose one of the trees that are already in it, or you can buy a new sapling especially for the purpose. The best trees to use are willow, silver birch, or pear trees. But you can use any tree if necessary. If you do buy a new tree, then plant it at a New Moon, and consecrate it at a Full Moon. If possible plant the tree where moonlight will often shine on it. Place into the hole, in which the tree will be put, a few silver coins and some strands of your own hair. Plant the tree and water it with pure water. Then leave it to settle until the Full Moon, fourteen days later.

Decorate the tree with a few ornaments (not too many). Many items can be used to ornament a Moon Tree: small bells, prisms, and pearls (real or artificial). But keep back one of the ornaments, and save it for the consecration itself.

On a night of Full Moon, consecrate your living Moon Tree. When the Moon has risen in the sky, go to the garden and light three lamps at the base of the chosen tree – you can use candles, hurricane lamps, or the like. When you light the first one say: **'Shaddai-El-Chai'**; for the second say: **'Gabriel'**; and as you light the third one say: **'Levannah'**.

Now call upon your personal Moon Angel by name, until you feel the angel formulate behind your left shoulder. And then place the final ornament on the branches of the tree. Then consecrate your living Moon Tree, saying:

> **Oh Living Almighty ONE, place Thy hand upon this tree and fill it with the lunar fire of silver flame. Let the spirit-breath of Gabriel blow through its branches, and may Thy mighty Cherubim shine as lamps hereon.**
>
> **As the Moon above mirrors Thy power, so I hereby consecrate this Moon Tree to the Glory of Shaddai-El-Chai and the Archangel Gabriel, to the joy of the angels and in honor of the holy Angel** [name your personal Moon Angel]. **As it has been spoken, so let it be done, by the power of The ONE. Selah.**

Now pour an offering of milk over the roots of the Moon Tree, as a libation. And just spend some time sitting with the tree, just being with it.

In the days to come, you can use the living Moon Tree to anchor your prayers and intercessions. Take a ribbon, in the appropriate angelic color, and tie it to the Moon Tree as you state your intention. These prayer-ribbons can be used for your own needs, and for those of others. You can also tie on ribbons with the intention that — as the wind blows though the branches of the Moon Tree — it will then carry the blessings to wherever it blows. You should try and make a libation of milk every Full Moon. You may also notice that the Nature-spirits of the garden are attracted to the Moon Tree, especially just before dawn or after sunset. And at Full Moons the tree may become the center of fairy dances.

A Symbolic Moon Tree

To make a symbolic Moon Tree you need a branch from, preferably, a willow, silver birch, or pear tree. Start your search after a New Moon. Look for a branch that has a good fan spread of twigs. Choose the branch according to what size you want. Place a silver coin and a few hairs from your head at the roots of the tree from which the branch came. It is a thank-you. Take the branch home and seal the place where the branch

was separated from the tree with molten wax from a candle; this will hold the life-force inside the branch. Place the branch somewhere safe and warm until three days before a Full Moon.

While waiting for the Full Moon, get a suitable pot or vase for the Moon Tree. The pot should be strong enough to hold concrete or plaster. Remember that the pot will become a fixture within your sacred space, and a tool for the angels, so it should be beautiful. You will need many ornaments for an indoor Moon Tree; anything colored white, silver, or transparent (crystal or glass). You can add further ornaments in the future, but it is better to have as many of them as possible ready for the consecration of your Moon Tree at Full Moon.

Three days before Full Moon, paint the entire branch white. Then the next day (two before the Moon's fullness), paint the branch with silver paint and, when it is dry, place it in the pot or vase, set in with concrete or plaster to hold it. Then one day before Full Moon, place all the ornaments you have collected on the branch – except one. Spend as much time as you need, it should be a beautiful arrangement. Some practitioners place an image of something related to their Moon Angel at the foot of their Moon Tree. For example, if your Moon Angel is Angel Sachiel, a white or glass image of a whale, or an elephant. Your personal Moon Angel is the lens through which you receive the lunar influences.

To consecrate your Moon Tree you will need:

◆ nine white candles in holders;
◆ frankincense (add a little camphor);
◆ water;
◆ salt.

Arrange the candles in a triangle around the Moon Tree – three candles forming each line of the triangle – with the triangle's base in front of you, and the apex pointing away.

On the night of a Full Moon, purify yourself, and go to your sacred space. Light the altar lamp and the incense. Lightly sprinkle the Moon Tree with the mixed water and salt, holding the intent to purify it. Next pass the incense smoke three times around the Moon Tree.

Then, light the row of three candles to your right-hand side, saying with each one: **'Shaddai-El-Chai'**. Then, light the three candles of the next side, saying three times: **'Gabriel'**. Then light the three candles in front of you, saying as you light each one: **'Levannah'**. The Moon Tree is now enclosed in a 'Triangle of the Art'.

Now call upon your personal Moon Angel by name, until you feel the angel formulate behind your left shoulder. Next, place the last ornament upon the Moon Tree, thus completing it. Spend some time in contemplating your finished Moon Tree.

Now visualize above it the Full Moon. Build up the image until it becomes strong; see it shining with power and vitality. When the image has taken on a certain 'independent' quality in your mind, envision a shaft of moonlight shining down and bathing the Moon Tree with its influence. Now invoke:

> **Oh Living Almighty ONE, place Thy Hand upon this tree and fill it with the lunar fire of silver flame. Let the spirit-breath of Gabriel blow through its branches, and may Thy mighty Cherubim shine as lamps thereon.**
>
> **As the Moon above mirrors Thy power, so I hereby consecrate this Moon Tree to the Glory of Shaddai-El-Chai and the Archangel Gabriel, to the joy of the Angels and in honor of the holy Angel** [name your personal Moon Angel]. **As it has been spoken, so let it be done, by the power of The ONE. Selah.**

Now open your inner hearing, and hear a musical chord in your mind. As you hear it, hum it – sound it forth – repeating it over and over. Sound it louder, until it vibrates through your consciousness and begins to lift you into an altered state.

Now, allow your body to move and sway to the 'Angel Song'. You will begin to hear other voices singing the chord with you – voices of purity and power. You are singing with the choir of the Cherubim.

When this happens, you will 'see' that the Moon Tree is outlined with silvery-white glow. And it begins to gently vibrate (if there are bells on the Moon Tree, they will tinkle). When this happens you know that

your Moon Tree has been accepted from Above, and that the Moon Tree is now awake in the angelic World. Now gently bring the song to an end, but do not be surprised if the 'invisible singers' continue for a while.

Memorize the chant, because you can use it in future as an aid to enter higher levels of consciousness, and to communicate with your own Moon Angel. This gifted chant is a spiritual treasure, honor it as such.

Keep your awakened Moon Tree safe. You may move it to another place in your home. If someone ever asks you, *'What is it?'* you can truthfully answer that it is a piece of art you made for some 'Friends'.

CHAPTER 8

ANGELS IN OUR LIVES

... And with the dawn, those Angel faces smile;
Which I have known, long since, and lost awhile.[1]

Angels have supervised all evolution upon this planet. As we have learnt, their oversight of the mineral, vegetable, and animal kingdoms resulted in this beautiful planet, ecologically balanced, and able to support human life. With the coming of humanity, a new factor was brought into evolution: free will. Up until then all modifications of bodies were accomplished by whichever angel is the Oversoul of a species. Creatures such as the dinosaurs passed away when their function for this planet was fulfilled. Each new development in a species was the result of its presiding angel bringing about, on the physical plane, the complete archetypal idea in the Mind of The ONE. The angelic labor of love lies in the tension between beholding the timeless 'dream' of the Creator, and its successful manifestation on Earth.

Humans have deliberately changed other creatures' bodies – the cultivation of plants and the domestication of animals. This is one of the occult meanings behind the story in the *Book of Genesis*, with Adam naming the creatures. Humans also have the ability to alter their own physical bodies. (This is the specialized work of high adepts, those men and women who are the flowers of human evolution.) With the coming of humanity, more complex laws and relationships were introduced into the planetary scheme. And, in response, Orders of angels that had not previously been involved with this planet, then became active. The work of these Orders is intimately linked with humans.

Of all creatures on Earth, human beings alone have the ability to access all the levels: physical, astral, mental, and spiritual. This is

one of the meanings of 'free will'. A human is not only free to make moral decisions between good and evil, a human is free to function on the various levels of consciousness. The Upper Worlds have their own inhabitants, just as the Earth has its own flora and fauna. The principal inhabitants of these Higher Worlds are the angelic hosts. So it was inevitable that the human and angelic evolutions should meet and interact.

Hunters and scouts in early societies explored their physical terrain, and the lifestyles of animals found there. And at the same time, the dreamers and seers of those cultures were exploring the Upper Worlds and their inhabitants. While the physical scouts learnt about plants, medicines and foodstuffs from observing animals, the shamans (the first priests) were learning from their astral encounters. The scouts mapped out the physical world, the seers signposted the Invisible.

The principal angels encountered by these early seers were the Teaching Angels of Humanity. And these bright spirits are still the ones most involved with human unfoldment and growth. And it is how to interact with those celestial beings of love and wisdom that this sacred magic is all about. Early shamans also encountered the Devas of nature and angelic Oversouls of animal species. Some of these angels became the earliest gods, tribal patrons. Often the Devas came to be venerated in particular places, which became sites of power and pilgrimage.

Out of the communication between humans and angels arose the possibility for cooperation. Although this cooperation is rare, there is evidence that it is increasing. We hope that, in this Aquarian Age, there may be a spiritual renaissance – perhaps even a golden age (if we will make the effort). Most of the interaction between the angels and humanity tends to be unconscious on our part; this is mainly due to ignorance of Higher World activity. To dispel this, let us examine some of the areas of cooperation between the angels and us.

Princes of the Nations

Consciousness is dormant in the mineral, sleeps in the plant, dreams in the animal, and awakens in humanity. But these are not different consciousnesses; they are phases of consciousness. Each higher life-form builds on top of previous experience. And humans, although individual, also form groups. A human embryo, gestating in the womb, undergoes all the previous life expressions. A human embryo lives in water and undergoes changes similar to those of a tadpole in its course of development. The human body contains mineral salts and metallic traces from the mineral kingdom. Its digestive system and reproductive instinct is inherited from the vegetable kingdom. Humanity gets both its fight-or-flight instinct and the herd instinct from the animal kingdom.

The herd instinct is the basis of our social divisions of family, clan, tribe, nation, culture, and civilization. And these divisions form 'group-souls' of various degrees of strength. The group-souls of nations are huge, they include everyone who has been a part of that nation, past or present. These national group-souls are ensouled by mighty angelics, whose purpose is to mediate spiritual energy into the group-soul. In the Old Testament's *Book of Daniel*[2] the Angels of the Nations are called the 'Princes' (plural: the Principalities). These angelic Oversouls are not concerned with the fleeting ripples of news or fashion that surface in the national consciousness. They are concerned with the spiritual vitality and the underlying 'vision' of the nation; for example, the philosophy of 'liberty under God' enshrined in true Americanism, and its influence on the family of nations.

A head-of-state is linked with the presiding Angel of the Nation during their term of office. The magical purpose of a sovereign's coronation ceremony is to make those inner links, and to consecrate the new king or queen as a channel for grace, to benefit the land and the people. A selfless head-of-state can receive the benevolent influence of the Angel of the Nation for the performance of their duty towards the nation entrusted to them.

There are events in a nation's life that stir this angelic consciousness: an anniversary of some event in the national history (for example,

Thanksgiving in the USA), or when a nation fought against an aggressor, or the coronation of a monarch. At times like these, sensitive people can detect the presence of a great intelligence brooding over the national mind, a feeling of encouragement towards what is uplifting and noble.

In some old books the angels of national group-souls are called 'racial angels'. Personally I think this term is misleading, and can give rise to a kind of intellectual racism that has no part in true spiritual work. The angels of national group-souls deal with nations. And a modern nation is usually made up of several races. The Angel of a Nation holds the *dharma,* the ultimate destiny for which Providence brought each nation into existence. These angelic Princes of the Nations are also involved in the work of the spiritual council that exists to serve all humanity on its upward journey to at-one-ment.

You can help in this work too. There is a special meditation that many of us do at each Full Moon to bring peace and blessings upon the family of nations. You can download this gratis meditation from: *www.sacredmagicoftheangels.com/peacemeditation*

An Angel of a Nation often appears in a form from the mythic or historical memory of the nation concerned. The presiding Angel of the United States often uses a transfigured form of the Statue of Liberty – titanic in stature, built of translucent colors, with rays of light as a corona, and holding aloft a beacon of dazzling brilliance – the Light of Freedom. At other times the same national angel may use an idealized form of the Native American Great Spirit, vast as the sky, strong as the plains, wearing feathers of the sacred eagle.

The Angel of England sometimes uses the form of St. George, and at other times that of Britannia. An idealized representation of a nation's patron saint is a powerful channel for the nation's angel. The thought-form of the saint has been empowered by centuries of devotion and hallowed by the essential idea of a life given to God. So it is consistent with the role of the angel.

But the only nation to officially recognize its own angel is Portugal. King Manoel I petitioned the Pope to authorize a *Feast of the Guardian Angel of Portugal* – it is the third Sunday in July. The most

recent apparition of the Angel of Portugal occurred in 1916 at Fatima, where it appeared to three children as a forerunner to their later visions of the Holy Lady Mary. The children described the form of the Angel of Portugal as a young man, brilliant as crystal when it is lit by the Sun, and carrying a Host that dripped the sacred blood into a chalice.

There are also angels set over each city; and these 'civic' angels come under the rulership of the national angel.

At a deeper level still there is the great group-soul of all humanity, what Jung called the Collective Unconscious. And there are 'men and women of good will' who work day and night to bring about the realization of our shared humanity, and the care and compassion that comes from that realization.

Music

Another interface between the angelic and human kingdoms is music. In the Orient, Angels of Music are called the *Gandharvas*. Many composers receive their inspiration through these angels, the singing of the angelic choirs is sometimes heard by composers in their dreams. It is the haunting memory of the angels' song, the Music of the Spheres, which inspires many compositions. Some great composers develop a particular type of 'clairaudience' that enables them to tune into the *Gandharvas* while awake.

Because Creation is composed of vibration, every single being, every piece of matter, every wave of energy, sounds a unique note in the Great Symphony of Existence. The 'song' of the *Gandharvas* is the angelic vibration that holds the unity of all things. This song is exceedingly harmonious and pure.[3] And the performance of great music, particularly sacred music, calls the *Gandharvas* to attend. This is one of the reasons why a religious service that contains music, chanting, or singing has a different atmosphere from a service with none.

All music that is rhythmic or harmonious builds various shapes and colors in the Astral plane. And certain seers can perceive these 'music-forms'. And these music-forms, built by the vibrations of the music, are made even stronger by the emotional response of the listeners. Musical concerts produce beautiful forms which attract the

Gandharvas. But the *Gandharvas* are not just passive attendees, they *use* the music. The Astral music-forms are like cups filled with the emotional energy of the audience. This energy is usually of fine quality, since certain types of music stimulate the higher emotional range. The *Gandharvas* empower this energy with their own, and so increase its vibration rate and strength. Then they radiate that influence upon the area where the concert is taking place. Other angels, working in the same area, receive some of this outpouring and use it in their own areas of work.

If a concert is held for a particular cause, the *Gandharvas* can perceive this and direct the cumulative energy along that intention – but this is helped if at least one human tells them the intention. Notice how improved relations between nations are cultivated as the result of cultural exchanges. Orchestras, ballet companies, and choirs who visit and perform in foreign lands are agents used by the *Gandharvas* to promote goodwill between the nations.

A mentor of mine was a church organist and a 'priest with knowledge'. He could invoke the *Gandharvas* at will – in fact, they were so close to him that I sometimes thought of them as his 'invisible choir'. I would watch him heal groups of people by playing sacred music on more than one level. He could also magnetize jewelry for healing through the magic of music. And on those rare occasions when he sang a high Mass, the windows of the building would vibrate.

The *Gandharvas* are fond of sweet-toned bells and great gongs, and using such instruments in a sacred ceremony always summons their assistance. Church bells receive a special blessing, which can only be performed by a bishop, in which the bells are anointed, incensed, and dedicated to a particular saint. Some bishops, who are also mages, call on Archangel Raphael, so that whenever the bell is rung, healing influence can spread outwards to wherever the sound travels. The *Gandharvas* carry the healing energy to any sick beings who hear the bell.

Tibetan sacred music is very powerful; it is pure sound energy. But you need to know which Beings it is invoking before using its awesome force.

Other beings are attracted by different sounds and music. The sound of a *shofar* (a ram's horn trumpet) alerts the great Archangel Sandalphon. The Seraphim enjoy trumpets and marching music.[4] Elves are particularly fond of the melody of *'Greensleeves'* (so be careful where you sing it). And they also like Irish jigs, Scottish reels, the sound of a harp, and doleful laments. The Devas and the elementals respond well to music with a strong rhythm – particularly drumming. In a forest at Full Moon, one can 'drum-up' some very interesting visitors: a circle of dancing Nature-spirits is a sight not to be forgotten.

Inner plane beings are not music-critics; for them it is all about vibration, not taste. If a certain type of music works, they will use it to bring about certain effects. What interests them is the form that the music builds and the emotions that charge it. But dissonant music is of no use, since it promotes chaotic vibrations. In fact, under adverse conditions, discordant music can stimulate deep psychic unrest and even stir up demons.

Places of Worship

True worship encourages a renewal of our connection with Spirit; it re-directs our consciousness to the Source of existence. As one prayer puts it: '... *may we ever perceive within ourselves Your indwelling Life; and know ourselves to be one with You, and through You, with* all *that lives.*'[5] At a profound level what one individual does affects all beings. The 'magic' of worship occurs when we are drawn beyond ourselves into awareness of a stupendous Reality that underlies everything at a hidden, yet perceptible, level.

During worship we are focused on something other than ourselves – our consciousness is expanded and receptive – and so the angels become accessible. Most people's first encounter with angels happens during worship of some kind. The heightened sensitivity, the power of devotion, and the receptivity to the invisible, make the ideal conditions for such encounters. A Russian Orthodox bishop told that when he entered the sanctuary for the first time, he was awed by the presence of the angels. Millions of people are aware that when they worship The ONE (by whatever name) otherworldly Beings of Light worship with them.

Mystics of all traditions give accounts, based on their visions, of the angels offering worship to The ONE. There are many descriptions of the celestial rituals done by the angels to facilitate the flow of grace to sustain the world. Qabalah teaches that an aware human can enter the Upper Worlds to participate in the heavenly worship. It is probable that the use of elaborate ceremony in religious practice arose from a desire to mirror on Earth the celestial worship of the angels. The splendid rituals of the Temple of Solomon in Jerusalem reflected the process of creation and evolution. The magnificent ritual of a Byzantine Eucharist is far removed from the simple Last Supper; but there are clairvoyant accounts of how the Last Supper appeared in the spiritual realms.[6] The Christian Eucharist – regardless of denomination – facilitates the continual outpouring of Divine life into time and space.

In a shamanic Medicine-Wheel ceremony, the powers of Creation, the Devas, are invited to share sacred space with the human participants, and to exchange energy in recognition of their underlying unity in The ONE. The group-souls of the animal, vegetable, and mineral realms attend as respected guests and friends. And rising from the center of the sacred hoop is the flowering tree. Life, in all its variety and complexity, is celebrated as a complete, cosmic event. The planet Earth is honored as the living altar of embodied Spirit. Such a circle of power and wisdom is held in the sacred hands of the Great Mystery, The ONE.

Any place that is regularly used for worship attracts an 'Angel of Praise'. That angel will act as the principal guardian of the place and channel the adoration of the worshippers to The ONE. The Angel of Praise also acts as the lens for the response of Grace that answers all true prayer. Every place of worship has an Angel of Praise attached to it, whether it is a synagogue, church, sacred circle, household altar, mosque or temple. Whenever we enter a sacred place, we should 'salute' its angel, and ask for the blessing of The ONE upon its angelic servant.

A wise practitioner will get to know the various places of worship in their residential area and visit them to introduce themselves to

the local Angels of Praise. A good greeting is: **'I too am in the service of God'.**

Sharing information with an Angel of Praise about your own sacred place, has great benefits for both parties. You may ask the angel of that place to direct some of the grace it facilitates toward your own sacred place and work. And in return, you offer that some of the heavenly dew that flows into your sacred place will go towards that angel and its charge. In this way a beautiful local network can be made linking all the sacred places and their angels.

Each religion is a Way of the Spirit and every sacred building is a potential gateway to Heaven. Through mutual respect and spiritual cooperation, a neighborhood could receive grace from on high that would benefit the community as a whole. Wonderful blessings could be received, as each place of worship in turn strengthens the others through their daily, weekly and annual cycles of worship. Spiritual light would flow between the places of worship as the various high and holy days were celebrated. And our own angelic shrines too can be living links in such a network of grace, contributing to the spiritual health of the communities we live in.

Over the Earth there is a canopy of light, an umbrella of energy that shelters the planet. This canopy shields the psychic consciousness of humanity from darkest evil that tries to sabotage human evolution by dragging it back down into barbarism and savagery. The energy that maintains this canopy of light comes from the hearts of all people of goodwill. They are people from all religions and traditions, but each one of them, in their way, has deep communion with The ONE – regardless of the external form of their religious observance. Allegiance to the Light of the Most High goes far beyond any sectarian boundaries. Organized religion is meant to encourage young and developing souls into awareness of the spiritual dimension. Every place of worship creates a vortex of energy that replenishes the canopy of light. With spiritual vision, a radiant dome can be seen over any place of worship and holy site. The Angel of Praise uses this dome to direct energy into the canopy of light, and also uses the dome like a lens to focus descending grace into the place of worship.

But it is the great canopy of light that is most important, particularly in these times of growing planetary awareness. Organizations such as Freemasonry and other mesoteric groups do much to contribute power to the overall canopy, filling in the 'gaps' left between the various organized religions. There are also individuals who, working under the supervision of the 'Lords of Compassion', take up their watch as guardians about the canopy of light that shields the Earth from evils too great to be faced by collective humanity.[7]

The Archangel Sandalphon, the angelic guide of our planet, is also called the Prince of Prayer. When a 'Great Prayer' is offered, Sandalphon himself is then the 'Angel of Praise', who carries it to the altar on high. A Great Prayer is when thousands, or even millions of people (right across national or racial boundaries), unite with the same intent. Examples of Great Prayers are: Christmas, Yom Kippur, Wesak, Divali, or Id al-Fitr. But perhaps even more significant – in this time of growing global consciousness – are those occasions when people from all faiths and nations come together to make intercession against injustice, greed, or exploitation, or when people unite and pray for a cure for HIV, or on *Earth Healing Day* for global healing. These are also Great Prayers. And when people all over the world pray with the same intention, Sandalphon weaves those soul-energies into one Great Prayer and presents it to the Heart-of-all-Brightness. Surely, it is on such occasions that the angels sing: *'Glory to God in the highest, and on Earth peace to all people of goodwill.'*

Partnerships

We have seen how human collectives form as group-minds; that it can be a football-fan club, a political party, or a nation. Wherever a shared bond of ideals and emotions exists, a group-mind is born. Some group-minds last a few years, while others endure for thousands of years. World religions form the largest group-minds of all, because they extend beyond geographical boundaries and down through the generations. Since the purpose of religion is to focus on the things of the Spirit, religious group-minds penetrate deep into the Upper Worlds and, consequently, their group-minds also produce a 'group-soul'.

This explains why, although a religion may go through periods of dryness, or even evil (like crusades, inquisitions, etc), its members can still have access to grace, revelation and union with the Divine. Because it is of a higher order, the group-soul is not defiled by the group-mind. Consequently, each religion has a reservoir of grace that flows through its appointed channels, and particular angels who facilitate the flow of grace.

When individuals in a religion are given authority by the group-mind, then they have access to its reservoir of grace. Those chosen individuals receive a 'formal initiation'. Such formal initiations vary according to tradition: ordination of Christian priests or Buddhist monks, transmission of Rabbinic authority, the 'raising' of a Master-Mason, the *barakah* of the Sufi orders, etc. The recipients of these formal initiations often receive angelic assistance; this will vary according to the provisions made with Heaven by the different traditions.

Ordained Christian priests have a 'sacerdotal angel' who assists with the functions of that office. A Grand Inspector-General is the thirty-third degree of the Rite of Scottish Freemasonry. At the ceremony conferring that degree, two great white angels of the rite become attached to the new 'prince of Masonry'. Those angels become co-workers who assist the new ruler of the craft in his future work. The 'Apostolic Angels' who are attached to a bishop function in a similar way. While a bishop may be personally unaware of the inner levels, yet when (s)he 'opens' up for a sacramental function, the 'Apostolic Angels' will direct grace upon those present.

These Angels of Ceremony who work with those who hold various degrees of authority within a religion's group-soul, facilitate the flow of higher energy through the human instrument. This 'joint ministry' between the angelic kingdom and humans with sacred office is one of the reasons why there can be a dramatic difference between when a minister functions in office, and when they are in their everyday personality. Nor does this mean that a recipient of formal initiation goes through life attended by various angels twenty-four hours a day. The angelic connection appears as a tiny 'star' of light within the person's aura. When the human makes an act of will to function in his or

her entrusted office, then the angels instantly flash into appearance and perform their duty. Sadly, most people who receive these formal initiations are not consciously aware of these 'angelic partnerships'. But, after all, they are not given for the personal benefit of the religious officer. Yet, how much more effective their ministry would be if they were to consciously cooperate with the Angels of Light.

But a person can forge an angel-human partnership without ever having received a formal initiation. These partnerships tend to occur spontaneously when human beings follow their vocation, their true destiny. It seems that unselfish dedication attracts angels. Angels who specialize in the same field of service do attend some nurses, teachers, midwives, doctors, vets, healers and social workers. In fact, from what I have observed to date, it seems that every aspect of human work that serves the well-being of Creation, attracts angelic cooperation, both at the intuitional level and by those synchronistic events that so often adorn the life of a dedicated person.

PRACTICE 11
Daily Angelic Ritual

This is a daily ceremony for calling the angels to come into your life. It requires a bell, some incense, a lamp to represent the Divine Light, plus nine extra candles. The ceremony changes slightly for each of the days of the week — because the Angel of the Day is invoked to bring special blessings that are unique to that Angel.

First light the lamp and the incense. Then, standing before the altar raise up the Lamp of the Divine Presence, and say:

> **Holy art Thou, oh Eternal ONE,**
> **Holy art Thou, oh Mighty ONE,**
> **Holy art Thou, oh Immortal ONE,**
> **Outpour Thy Power, Wisdom and Love, upon us.**

Replace the lamp on the altar.

> **Oh Most Holy ONE, before Whose glory even the angels veil their faces; grant us knowledge of all Thy worlds; so that – assisted by Thy holy angels – we may ever work joyfully in thy service; oh Thou the everlasting and eternal Light of All. Amen.**

With a taper lit from the lamp, light the nine candles as you name each of the '*nine angelic orders*':

> **May the blessing of the Celestial Hosts descend upon this place and fill it with divine radiance:**
> **the benediction of the Angels and Archangels,**
> **of the Thrones, Dominations and Princedoms,**
> **of the Virtues, and Powers,**
> **and of the Cherubim and Seraphim, descend upon us:**
> **for thy life and ours, are one in God!**

Bless the incense:

> **May Michael the Archangel – who stands by the celestial altar – bless this Earthly incense and carry it on high as a spiritual sacrifice – to make all Divine.**

Cense the altar and temple.

Then invoke the 'Angel of the Day' according to which day you are doing this ceremony:

SUNDAY
ring Bell x 6

trace Michael's call-sign:
the gold Crown

**Eternal Yod-Heh-Vav-Heh,[8]
Thou who art the One Reality,
send to all beings Thy Angels of Light;
and unto us send Michael-ha'Gadul,
archangel of true Beauty.
Amen.**

MONDAY
ring Bell x 9

trace Gabriel's call-sign:
the Stella-Luna Corona

**Oh living Almighty ONE, Thou Life of All Worlds, send to all beings Thy Angels of Light; and unto us send Gabriel-ha'Gadul, messenger of Thy unending goodness.
Amen.**

TUESDAY
ring Bell x 5

trace Samael's call-sign:
the upright Sword

**Oh vast and mighty ONE, our refuge and shield – send to all beings Thy Angels of Light; and unto to us appoint holy Samael, angel of Thy protective strength.
Amen.**

WEDNESDAY
ring Bell x 8

trace Raphael's call-sign:
the Bird head

**Oh Creator of Hosts, the One-in-All – send to all beings Thy Angels of Light; and upon us bestow Raphael-ha'Gadul, Thy Healing Hand.
Amen.**

THURSDAY *ring Bell x 4* *trace Sachiel's call-sign:* *the Part of Fortune*	Merciful El,[9] the all-compassionate ONE – send to all beings Thy Angels of Light; and unto us send holy Sachiel, Thy angel of prosperity and abundance. Amen.
FRIDAY *ring Bell x 7* *trace Anael's call-sign:* *the Cup of Happiness*	Oh Eternal of Hosts, the All-in-One – send to all beings Thy Angels of Light; and unto us appoint holy Anael, Rose-Angel of Thy Love. Amen.
SATURDAY *ring Bell x 3* *trace Cassiel's call-sign:* *the Ladder of Light*	Thou Great Mystery, ineffable and wonderful – send to all beings Thy Angels of Light; and unto us bestow holy Cassiel, angel of completion and rest. Amen.

Rest for a while in the presence of the angels, then – when you are ready – say:

Oh Eternal ONE, we praise Thee for the celestial glory of Thy holy angels. We thank Thee for their wonderful wisdom, their supreme strength, and their radiant beauty. And as their irresistible power is always used in Thy service, so may we follow their resplendent example and devote ourselves to Thy all-loving will.
Hear our voice, oh Lord of All: let there be Light!
Amen, Amen, Amen and Amen.

Allow the candles to burn for a while, and extinguish them later.

Using this ritual will help you to do the best thing that you ever can do – to focus Light upon the world and all its beings. Every time you perform it, a beam of grace-filled Light shines out to dispel the darkness.

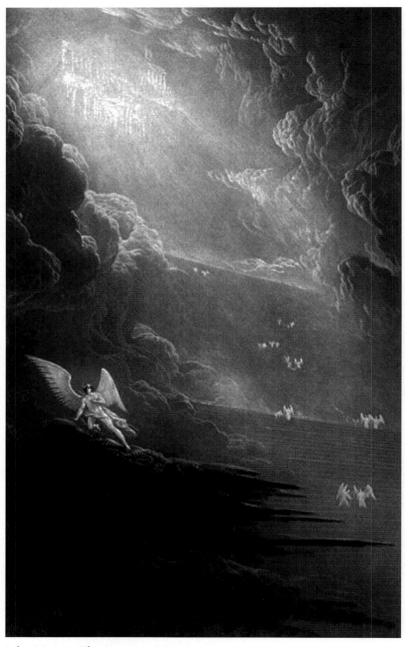

John Martin, *The Ascent to Heaven,*
illustration for *Paradise Lost* by John Milton

CHAPTER 9

INTERCESSION

I am Raphael, one of the seven holy angels who present the prayers of the saints before the glory of the Holy ONE.[1]

In Chapter 5, '*By their signs ye shall know them*', you learnt how to make petitions through the angels. I stressed there that it is *essential* for you to have permission from another person, *before* you do a Letter-of-Petition *on their behalf*. I also pointed out that one of the reasons for this is, so that you don't interfere with their development. But there is another reason, a reason with very serious consequences, and it is called *Kor*.

Kor

'Kor' is a Tibetan word, that translates as 'adverse karma acquired through good intention'. What does that mean? There are several ways it can happen. In traditional societies people go to magical practitioners for help. They explain their problem to the practitioner, who then works magic to assist them. But, because we are not all-knowing, a practitioner can cause harm without realizing it.

One of the many examples I know of, was where a man went to a practitioner for help, because his wife had left him. He cried a lot, and he spoke of his undying love for his wife. The practitioner was very traditional (*'a wife's place is in the home'* kind-of-mentality)[2] and agreed to bring them back together. The practitioner worked a 'magic of compulsion' and brought the wife back. But what the husband had omitted to tell the practitioner was that he regularly beat his wife. So, now that practitioner had a heavy karmic debt for compelling the wife, against her will, back into a violent situation. That is Kor – getting bad karma,

even though your intention was well meant. Religious ministers – clergy, rabbis, immans, lamas, etc. – are very prone to Kor. Human insight is limited. But when it comes to magic, the potential for Kor is magnified a thousand-fold. To stir up the Powers-that-Be, seeking to cause a certain result on a person or a situation, just because you think it is right, will have grave consequences over many incarnations.

The Zohar[3] warns about this: 'It is not fitting for a commoner to touch the scepter of the King'. This time-fettered phrase means that Magic is holy – and to use it (however well intentioned), because of the short-sightedness of the personality, is unholy. And any excuses like: 'But I did it for their highest good', or 'But I want my grown children to be happy', or 'My "true" religion knows what people should have', are unacceptable in the Courts of Karma – nor will it shorten the centuries of suffering atonement.

The great beauty of the Sacred Magic of the Angels is that, by using it, we do not generate any Kor. This is why I made it available to the public. One makes a petition for help with a need, and then waits for the Will of Heaven to reveal itself through omens and results. In this sacred magic there are no compulsions – no human-based judgments or opinions – just trust in the immense goodness of the All-loving ONE.

Intercession

So, in a world where we are often bombarded with news of cruelty, suffering, and pain – are we just to be spectators? And – as our sensitivities increase, and we detect distress in others – on public transport, in the work place, or amongst our friends – are we helpless? No, not at all.

The only reason why we must have prior permission for petitions is because otherwise we violate the free will of others and interfere with their growth. Yet another person's permission does not have to be a formal, 'Please write an angelic petition for me'. It can be a: 'Please hold me in your thoughts', or a 'Please remember me in your prayers'.

If you use the 'Temple-of-the Heart' meditation[4] to connect to the Divine Indwelling, you can also use it to help distressed people,

without generating Kor. If you see someone in pain – physical or emotional – you quickly recall the Presence within you – then you envision the Divine Spark in their heart and then mentally say something like:

All-Loving ONE, have regard for this your son or daughter. Amen.

That's all – simple, yet often surprisingly effective.[5]

With a more serious case, you can make a formal intercession. The difference between a *petition* and an *intercession* is this:

◆ In a petition we state our need, and ask for it to be met by a *specific result*.

◆ With an intercession we lift the problem on high, and bring it to the attention of Heaven, giving it over *without* asking for a specific outcome.

The following intercessory meditation can be done anywhere, but is most effective when done before your own altar, or in a sacred place.

PRACTICE 7
The Fount of Mercy

Having decided upon your intercession (whether for an individual, for more than one person, or a situation), whatever it is that has moved you to do this – set time apart when you will be undisturbed.

Go before your altar and kindle the lights and some frankincense.

Then call upon the two angels who are your closest companions (your Moon and Sun Angels), invoke them... and sense their arrival, with the presence of your Moon Angel on your left, and your Sun Angel on your right.

They outstretch their wings around you, mantling you with their pinions... as if you were throned upon the Mercy-seat of the Ark and sheltered by the overshadowing wings of the Cherubim.

Now you call upon Archangel Sandalphon with words like these:

Holy Sandalphon, Prince of Prayer, Archangel of the Kingdom, lift up my intercession to the Fount of Mercy so that all wounds may heal and blessings flow.

Archangel Sandalphon now appears, vast in size. He is robed in the colors of a ripe apple, with a garland of purple grapes on his head; he regards you with his grey eyes. Then, Sandalphon stoops and gathers you up in his hands. Sandalphon lifts you up above his head... and from within his cupped hands, you look higher yet... and then you call upon the Moon Lord in words like these:

Holy Gabriel, Might of God, Prince of the Foundation, add your silver strength to my intercession and elevate it to the Fount of Mercy.

Now it seems as if a full moon has been unveiled overhead... and a mighty celestial being reaches down and lifts you from Sandalphon's hands.

You now are held by Gabriel, Lord of the Astral plane. He is clad in the silver of the Moon and has vast violet wings. His eyes are green as a storm-tossed sea, and all around him is the sound of many waters. Gabriel, the Messenger of the Light, lifts you and holds you to his heart, adjusting your energies... and adding his power to your intercession. Then he lifts you up above his head as you look into the heights and call upon the Archangel of the Sun in words like these:

Oh Michael, sun-bright Champion of The ONE, Captain of the heavenly hosts, enlighten my intercession, and raise my prayer to the Fount of Grace.

In the sky is the midday Sun... and a winged spirit appears, so bright that at first you cannot bear to look upon him... then Gabriel passes you into the hands of Great Michael. His face is like the Sun, he wears the armor of light, and his wings are covered with the iridescent peacock eye-feathers. Michael of the Sun, fills you with light – dispelling all shadows – then raises you on high. And once more you send your voice to the Uttermost:

Holy Uriel, Light of God, Prince of Gnosis, oh Wonderworker of the Divine, empower my prayer, and exalt my intercession to the Fount of Mercy.

There is a flash of lightning! And in the dazzled afterglow appears an incandescent being, bright as the heart of a star. Archangel Uriel, the 'Lamp of God' receives you into his luminous hands... and you are raised up amongst the stars. And then you are lifted 'through' them into a place where the stars are now the floor of a vast chamber that is filled with angels without number! And above all shines an effulgent sphere of White Brilliance, a light that has never shone on land or sea. And beyond this dazzling orb is a backdrop of shimmering darkness. You gaze upon this light of *Ratzon*, the Will of the Most High – at the Crown of Creation.[6]

As Uriel holds you up towards the Primal Will-to-Good, you make your intercession before God...

> **Oh eternal Love, Wisdom and Power, have regard for** [here name who or what you are interceding for]. **If it be Thy will, please bless them** [or him or her or the situation]. **Not my will, but Thy Will, oh Most Holy ONE, be done on Earth as it is here in Heaven. Amen.**

and with a trusting heart you cast your prayer into the infinite mercy of The ONE:

Archangel Uriel draws you down from the stars... and passes you back into the sun-bright hands of Michael...

... and Archangel Michael strengthens your own radiant essence... before he passes you down into the moon-cool hands of Gabriel...

... and there your soul is washed with the Waters of the Moon and your subtle body is made whole. Then Gabriel passes you down into the steadfast hands of Sandalphon...

... and you are held awhile in the hands of the Great Angel of planet Earth... before being gently returned into your physical body, that is still guarded by your Moon and Sun Angels.

Take some time to readjust, feel the welcoming embrace of your physical body. Then arise and, in your own words, give thanks to the All-accomplishing Power, the All-pervading Wisdom, to the All-embracing Love that is ONE.

And be of good heart because your intercession has been heard on high – and since it shall be as The ONE wills – the outcome can only be ultimately good.

CHAPTER 10

DESTINY

Speak of the Qabalah and the angels draw nigh.[1]

Angels inhabit the Astral plane, and it is from there that they affect the physical level. This means that their forces are the same energies that humans experience as emotions, although the angels do not have the same range of emotions as we do. They do not have the lower emotions of hate, greed, jealousy, fear, or depression. But angels do have the higher emotions range: love, joy, trust, selflessness, hope and compassion. If we did not also have the higher emotions, there could not be any communication between the angels and us. And yet, the angelic emotional range extends even higher, beyond the range of most of us. Angels continually experience sublime rapture because of their beatific communion with The ONE. The bliss of a yogi, the ecstasy of a contemplative, or the exaltation of a mage wrapped in invocation – all of these states are continually enjoyed by the angels.

The ONE is the Source of all life-energy and the angels act as 'transformers' to step down the Divine glory, so that we can experience it, and grow towards it. At the moment, only the most evolved members of humanity have transcended even the angels, by becoming totally God-conscious. These enlightened ones attain a perfect union with The ONE, and become the 'Friends of God'. No angel or archangel has ever achieved such a degree of intimacy with The ONE.

But this is the secret: the angels remain on their own level to maintain Creation, so that sentient life can evolve. They remain 'outside' of full union to enable us to attain it! Imagine it – the angels forego the great bliss of at-one-ment with The ONE, so that you and I can go there first!

Then, afterwards, the angels will follow us into the eternal splendor of the Limitless Light. This is from a vision that I was given...

> *Metatron ushers you from the chapel of Kether... and the archangels rise. You are almost embarrassed by the unspeakable kindness that the archangels have shown you, to bring you to all of this, to the very Crown of Creation itself.*
>
> *And now – in a moment of insight – you can see that this is their greatest joy – it was for this that the archangels were created: to bring sentient life onto the Path leading to fullness.*
>
> *The archangels now sing a triumphal anthem, as together we pass over the bridge... and even the darkness shrinks back before the joy of the archangels as you and your companions are escorted back down through the levels of the Tree of the Living Ones.*[2]

Humans affect everything with which we come into contact, for good or ill. Every level of our planet has been explored and examined. The depths of the Earth have been mined; the summits of its highest mountains have been climbed; submarines have swum deeper and longer than any whale; 'metal birds' (airplanes) daily carry thousands of people above the clouds; and men have walked upon the Moon. The human eye has seen the 'invisible' microscopic level, the interior workings of living bodies, the ocean chasms, the planets of our solar system, and galaxies far beyond our own. Humans affect the four elements, bringing them into new combinations and new relationships. Plants and animals are changed by our husbandry, or exterminated by our persecution. As individuals and as a species, we humans are catalysts; we initiate change, stimulate adaptation, and provoke transformation. Everything around us is imprinted by our thoughts and saturated by our feelings.

And this is true of the invisible realms too. Elementals, fairies, and elves have all been affected by humanity's presence; and so too has the angelic kingdom. We have seen how the angelic ministry has adapted with us. The angels were with us as nature gods and clan totems; they have taught our wise ones; they have helped heal our sick

and attend our births and our deaths. Angels brood over our cities, bless our hospitals, guard our holy places, and pray with us. They seek ever to inspire the nations in the ways of The ONE. And they assist evolved humans to ascend through the Heavens and to unite with the Heart-of-all-Brightness.

Those of us whose knowledge of the angelic ministry is no longer based on faith but on personal experience, are sometimes faced with a problem. The problem is 'gratitude'. The human soul has a need to give delight to others. And when an angel has been instrumental in helping or blessing you, it is very natural to want to do more than just say *'Thank you'.* But what can we give to an incorporeal being?

Gifting

We can 'gift' an angel by sharing our memories of those experiences that an angel has never known. We *can* share them as a 'thank-you' to the angel.

To do this, recall an experience of sheer beauty which filled the cup of your soul. Make sure it is a completely positive memory, containing no negativity (for example: relief from fear when a dear one recovered from illness). It might be the memory of your first kiss, the sight of a dawn over a mountain lake, or the pleasure of being reunited with an old friend. It might be the memory of the first time you heard Rachmaninov's *Second Piano Concerto*, or when you held a newborn baby. Of course the memories will be different for different people, that is part of the wonder of being human. And do not worry that you will lose the memory by gifting it, you will not. But, you will gain the joy of sharing it. By seeking to bless and empower the holy angels, you forge a reciprocal relationship with them, giving and receiving.

Having selected your memory, relive it in your mind. Build it up, recall the details and sensations, and waken it with your imagination. Now, by a gentle act of will, shift up a level, and in your cupped hands see a glittering, geometric shape. It will probably be multifaceted, glowing with lovely colors; no two are ever identical. This is how your memory looks on the Astral plane.

Now send a mental call to the angel whom you wish to gift.

Having already worked with this angel, the response will be fast. When the angel has come, speak by mind-touch and inform the angel that you wish to offer as a love-gift the memory in your hands, in gratitude. Do not be surprised if the angel's own colors change and ripple in appearance – this is the angel's display of pleasure. It is still a very rare thing for an embodied human to even think of gifting an angelic spirit.

When the Angel has accepted your gift, it will draw the geometric shape into its being. And the resulting 'firework display' that you will see in the angel's aura is the assimilation of your gift – a starburst of purest delight. And the vicarious joy that you will feel is the result of a sharing between two lines of evolution – human and angel – united for an eternal moment outside of time. By blessing the angels you are greatly blessed.

Metatron

In the *Book of Genesis* there is brief mention of a person called Enoch,[3] who *'walked with God, and was not'*. The Qabalah teaches that Enoch was the first fully enlightened human being – and that he was physically transported into the Upper Worlds, as others have been since.[4] Having ascended in body, soul, and spirit, Enoch entered the presence of The ONE and supernal fire filled every atom of his being, transforming him into an archangel. He was also given a new name: *Metatron*.[5]

The Archangel Metatron is Prince of the Countenances, and the chief of *all* the angels and archangels ('Master of the Winged Ones'). So glorious is Metatron, that to the angelic hosts he is the embodiment of the Divine. His title is 'The Lesser Yahveh', and because his God-Self is fully realized, he mirrors The ONE. Metatron is a perfected human and the greatest of the archangels. Standing at the head of the celestial hosts, Archangel Metatron oversees all Creation, and human evolution in particular.

The Archangel Metatron is the 'template' of human destiny. We are all destined to become fully realized beings. Only God and human beings have the ability to consciously experience the mineral, vegetable and animal kingdoms, as well as the visible and invisible worlds – and

all they contain. When a human being has learnt all that embodiment can teach, and has transfigured their soul into an unspotted mirror of the Light – by remembering 'Who' they have always been – that person is then ready to transcend Creation and even the angels themselves.[6] This is *The Day of Be With Us*, when a human triumphantly returns to The ONE-in-All. As it is written: *'Unto which of the angels said He: "Thou art My Son, this day have I begotten Thee".'*[7]

It was to help us achieve this high destiny, that the Teaching Angels of Humanity taught their sacred magic to our ancestors. And it was for this same reason that the initiated, down the millennia, have so carefully preserved this sacred magic, which now rests in your hands.

It is my sincere hope that this book will quicken the time when you enter the presence of the Most Holy ONE – before Whose glory even the angels veil their faces.

PRACTICE 8
Temple of the Heart

> *The Lord is in His holy temple –*
> *let all the worlds fall silent before Him.*[8]

This meditation helps you to go within, and begin your personal relationship, your courtship, with the Loving Eternal ONE. You can use this meditation to access your deepest identity, the Divine 'I Am'. The heart mirrors the essence of That which is both Most High and Inmost – both Above and the Within – Who is the Divine Indwelling.

Make sure that you will be undisturbed. Sit comfortably, but not so comfortable that you become sleepy; sit with a straight back, uncrossed legs, and with hands resting on your thighs. Close your eyes. And breathe rhythmically, deeply, but without any strain.

Now put aside any thoughts you may have, simply acknowledge them, and realize them for what they are – just images on the screen of your mind, but not actually you.

Now let go of any emotions, recognize them for what they are – just feelings that you are having, not you yourself.

Now visualize the call-sign of your personal Moon Angel in silver light. When it begins to gently glow, you will feel a presence by your left shoulder, so you will know that your Moon Angel has come.

Welcome the angel with words like

**Holy [Name], my God-given Moon Angel, in The ONE's Name
I give greetings.**

Allow the angel's aura-wings to gently enfold you.

Now build with golden light, the call-sign of your personal Sun Angel. When it begins to gleam, you will feel a presence at your right shoulder, indicating that your mental call has been answered.

Again give welcome:

Holy [Name], my God-given Sun Angel, in The ONE's Name I give greetings.

Now both of the angels are holding you in their auras – mantling you with their wings – so that you are filled with silvery gold light. Your male and female energies are thus awakened, harmonized, and vibrant. Your Sun and Moon Angels now move forward, lifting you between them.

Before you floats a great, red rosebud. As you watch, the petals of the Mystic Rose begin to unfold, revealing in its center a soft radiance. The angels bring you within this place of holy wholeness, into the Temple of the Heart.

Within stands a small altar of white marble, upon which stands a shining chalice. The chalice is simple in design, beautiful in its purity, and glows with an inner light, like a lamp. Allow the stillness of this place to fill you, to permeate your being. Allow the Peace that flows from the Cup-of-cups to fill the empty places in your soul. Allow its influence to heal your habitual thought-patterns, your emotional reactions, making them new creations of beauty, hope, and trust.

Not even the archangels can know what happens here, between you and The ONE. For this is your heritage as a child of the Divine, to know that you are forever loved, forever protected, and forever guided every step of the way.

Lift up the chalice – symbol of the unbreakable bond of love between you and the Creator – now take the Grail, drink deeply, and be refreshed.

Having drained the Grail, at the bottom of the chalice-bowl is a pure, clear flame (like that of a candle). And if all the winds of Earth were to gather their forces and blow upon this flame, still would it burn serene and undisturbed.

The flame draws you into itself, into another level of being where there is no past or future – no up or down – just a luminous kind of darkness filled with pure presence, that is God.

From the heart of all existence, the Voice of Silence speaks to you:

Be still and know that I AM God.[9]

Now let go... melt into the Infinite... and simply **BE**.

When your communion with The ONE is over, place the chalice back onto the altar. The waiting angels will come and draw you back from the Temple of the Heart. The petals of the Mystic Rose fold once more and veil the Divine Indwelling.

Become aware of being in your body. But before you re-engage with the physical plane, ask for a blessing upon your Sun and Moon Angels. Then, gently open your eyes, and become aware of your identity within the physical aspect of reality. Now stand up, and go forth to bless the world with the Presence shining within you.

You may use this meditation whenever you have need. Whenever the stresses of outer life seem too much, return to the Heart-temple and drink of the Presence that creates and sustains everything. If you feel burdened beyond your strength, follow the advice of the Psalmist and 'cast thy burden upon The ONE, He shall sustain thee.'[10] If healing is needed, then take that intention with you into the Temple of the Heart and there surrender it unreservedly to the Inner Light.

Also enter this place of God-nourished silence to give thanks for all the ongoing blessings of your life. Ever return back to this, back into the presence of the Most Loving ONE in the place of miracles.

APPENDIX I

THE TREE OF
THE LIVING ONES

Speak of the Qabalah and the angels draw nigh.[1]

Some of you may have heard about the Qabalah,[2] others may not. It was the Qabalah that brought the Ageless Wisdom to medieval Europe, and it has been the foundation of the Western Mystery Tradition ever since. The Qabalah uses the symbol of the Tree of Life from the *Book of Genesis* as a map, a model, of all Existence.[3] Tradition says that the Qabalah was originally given to humanity by the angels.

The Tree of Life has ten Spheres[4] that are the range of frequencies in the Universal Radiant Energy of The ONE. Each Sphere has an archangel, and an angelic host, who are assigned to it; the Teaching Angels of Humanity are included among them. There is also a Divine Name of The ONE which is set over each of these Hosts of Light (see figure 22 on page 182).

The Host of Eheyeh in Kether
Archangel Metatron of Kether, and the angels known as the 'Four Living Creatures'[5]: the Eagle, the Winged Lion, Winged Bull, and Winged Human. They are the messengers of the Primal Will-to-Good, which eternally creates and sustains the universe. They teach the highest mysteries of sanctification, and reveal what is Willed.

The Host of Tetragrammaton in Chokmah
Archangel Ratziel, Prince of Wisdom, and the *Auphanim,* the Angels of Chokmah. These celestial spirits control the movements of the galaxies and stars. They hold the Starry Wisdom, of which Astrology is a part. The Auphanim are the Star Lords.

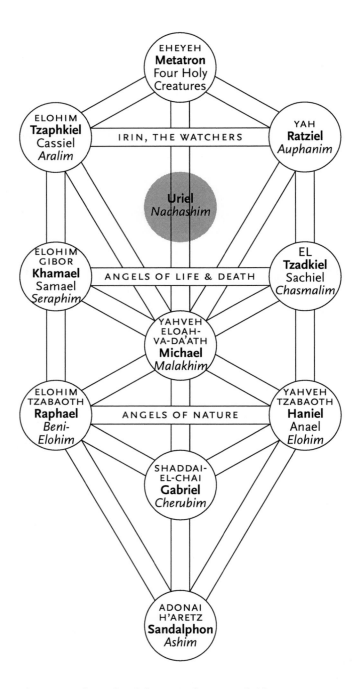

Figure 22 The Celestials upon the Tree of Life

The Host of Elohim[6] in Binah

Archangel Tzaphquiel ('the Contemplation of God'), the Angel Cassiel of *Shabbathai*,[7] and the *Aralim*, the Angels of Binah. They teach the mysteries of Form and transformation. 'Aralim' means 'the Thrones'. Every consecrated altar is a throne of The ONE, so every altar of Light is presided over by an Angel of Binah. The burning Lamp on the altar symbolizes the holy *Shekinah*.[8]

The Host of El in Chesed

Archangel Tzadkiel, the Angel Sachiel of *Tzedek*,[9] and the *Chasmalim* of Chesed. These Brilliant Ones are the angels who open and close the Gates of Mercy. They teach manifestation magic through accessing the infinite supply. And they also hold the secret of the true nature of The ONE.

The Host of Elohim-Gibor in Geburah

Archangel Khamael, the 'Fire of God', the Protective Angel Samael, and the *Seraphim*, the Warrior-angels, who are charged with keeping evil within its appointed bounds. They are the wrathful face of The ONE, and their power is the fire of purification. The *Geburahim* work with this host too. They are the 'Occult Police' who monitor black magic and corruption in esoteric groups, and bring to an end when the decree is given from Above.

The Host of YHVH-Eloah in Tiphareth

Archangel Michael and the *Malakhim* are angels of the Christ-force, which is the redemptive tendency inherent in all beings and communities. The Malakhim are our Holy Guardian Angels, those radiant spirits who are appointed to each one of us.

The Host of YHVH-Tzabaoth in Netzach

Archangel Haniel, Prince of Victory, the Rose-Angel Anael of *Nogah*,[10] and all the Deva-angels of Nature. They teach the ways of the Sacred Animal Powers and how to heal the Earth.

The Host of Elohim-Tzabaoth in Hod

Archangel Raphael, the 'Healing Hand of God', and the *Beni-Elohim*. They are the messengers between the hosts and between the Worlds. If invoked, they carry messages across distances, and they also guard and guide us on journeys.

The Host of Shaddai-El-Chai in Yesod

Archangel Gabriel and the *Cherubim* guide souls into and out of incarnation. They teach Astral creation, and can help to heal family illnesses and abuses from previous generations.

The Host of Adonai-Malekh in Malkuth

Archangel Sandalphon and the *Ashim*, the Angels of the Kingdom. They maintain and heal physical substances. They can teach the physical manifestation of things that presently reside in the Upper Worlds. The Ashim have a deep involvement in Alchemical transmutations. And they are very close to those people who walk the Worlds."

PRACTICE 9
Within the Temple of Solomon

The Sacred Magic of the Angels was the esoteric method of the Temple in Jerusalem, that was built by the great mage, Solomon the King. What is now called 'Qabalah' was originally the hidden teaching practiced in the Jerusalem Temple. In the Temple, the Angelology of the Qabalah was a daily experience, a sacred lifestyle. Working in the Temple, surrounded by the radiant archangels and the Hosts of Light – one's consciousness was lifted into the pure realms of undying beauty. This is what inspired me to facilitate five-day Angelic Retreats ('Graceful Gatherings of Angels"[12]), so that modern people could have the same elevating experience.

This guided meditation gives some sense of the spiritual force of sacred ritual.

Allow yourself to sink into mediation. Ease yourself into the nurturing darkness of no form. And cease to be aware of time or space – just rest.

You feel the morning light upon your eyelids as you awaken in a chamber that has sunlight streaming through an open window. You get up from the simple bed... and walk over to the bronze mirror that hangs upon the wall. See in the mirror the body you are wearing in this meditation. You are a man in his prime. The body is not athletic but it is refined through self-discipline. A full, white beard flows to your chest – and like the snowy shoulder-length hair – it has a vital, electric quality. The face is one of strength, with a hawk-like nose, a broad forehead and deep-set bright eyes that look out at you from under white eyebrows.

As your mind merges with this form, you become aware of its identity – in this 'vision' you are Zadok, the High Priest of the Temple of Yahveh within the city of Jerusalem, and an adept of the holy Qabalah. And you know that today is the high and holy day on which you must exercise your most awesome office – to enter into the Holy-of-Holies, and there whisper the ineffable Name of God.

On this day, some of the heavy burden of sin and suffering will be lifted from the world, for this is *Yom Kippur*, the Day of Atonement –

when you must lift your heart into at-one-ment with the Light.

Now you go to a basin of consecrated water and perform your morning ablutions – while meditating upon Binah, the life-giving waters of the Cosmic Womb. Then, you vest yourself in a white linen robe signifying your light-filled essence. Going to open the door of your chamber... where there are priests awaiting you. They bow to receive your blessing: **'Shalom Adonai alichem – the Peace of the Lord be unto you'**, and they escort you through the corridors of the Great Temple.

The Sun has reached mid-morning as you emerge into the Outer Court. Great walls enclose this vast open courtyard and upon their ramparts stand the Levites blowing the ram-horn trumpets. Members of all the tribes of Israel are gathered here – their twelve standards gleaming in the sunlight. They wait in silence, robed in dark cloaks of mourning, for this is the Day of Repentance, a time of introspection before turning again to the Divine Source.

In front of the people stands King Solomon, surrounded by his court. By his side is the sacred Queen Balkis of Sheba, she upon whom you invoked the blessing of the Elohim in a secret rite of the Temple, to call an *Ibbur* (a high soul),[13] into her womb. For Balkis is a 'garment of Shekinah', and is destined to give birth to Menelik, the Lion of Judah and king of Ethiopia – the land which will become a resting-place of the holy Ark in the centuries to come.

You walk through the assembled people, till you come to the gates that separate the Outer Court from the Inner one. You stand between the black and white Pillars of *Jakin* and *Boaz*. And nearby is the 'brazen sea', a big vessel of sacred waters supported by the statues of twelve oxen – the image of Aleph. Here, before the multitude, you are unrobed... till you stand naked, so that all may see that you are whole and without blemish. The Levites pour the lustral waters over you, and then anoint you with precious oil.

Now the priests bring the Robes of Glory – that are worn by the High Priest alone – and, as they put each vestment on you, you meditate upon their inner significance. First a new, white linen robe envelops you from throat to ankle, symbol of *Atziluth*, of your innermost Divine nature. Then a tunic of blue and purple for Soul and Spirit – it has golden

bells at the hem representing the vibrations of the Word. A girdle – the circle of Time and Space – binds this. Then, over your heart is placed the jeweled breastplate[14] – one jewel for each of the twelve spiritual types of humanity. The oracular *Urim* and *Thurim,* used to divine the Will of the Ancient-of-Days, is put on your shoulders. And finally, a miter is placed on your head, bearing a gold plate on which is inscribed: '*Holy to the Lord*' – the crown of a Lord of Light. Thus arrayed, you turn your face towards the Holy Place and prepare yourself to walk from the world of men into the Realms Above.

You enter the Sanctuary. There are black and white tiles underfoot, and along the walls there are ten gold seven-branched candlesticks – ten images of the Tree of Life – because there is a Tree within each Sephirah. The entire chamber is charged with the energies of *Briah.*

You reflect on your ascension thus far through the levels. In the Outer Court you walked in *Assiah* – the World of Manifestation – as a man amongst men. Yet you know – in a real way – that each person there is a part of you. King, merchant or slave, man, woman or child, each is an aspect of your totality. Then, within the Inner Court you stood in *Yetzirah,* in the Astral World of the Soul. And there you were purified and balanced – your subtle currents were harmonized and brought into alignment. And now, in *Briah,* you breathe in the cosmic breath of the Spirit.

At the end of the sanctuary, just before the veil, stands the Altar of Incense. You sprinkle incense onto the burning coals... and the perfumed smoke fills the temple. And as the smoke rises so too do your thoughts. Then, there is a burst of brilliant colors – as your inner sight opens – and you see that each of the ten candlesticks is surrounded by the colors of the Sephiroth, the 'fruit' of the Tree of Life. And you can hear the singing of the 'birds of paradise', the Archangels of Light praising The ONE. You are standing upon galaxies of stars. While vast rainbows of fire form the walls of this universal temple. Mighty presences sweep near and through you – the touch of their great wings ravishing your soul.

And, facing you across the altar, there is a beautiful being of pure sunlight; with eyes like stars that hold wisdom and sorrow, joy and

tenderness. United in this being is the strength and nobility of the finest type of man, and the nurturing love and refinement of ideal womanhood. You stand enraptured before your Holy Guardian Angel, your Higher Self. Then this 'Indweller-in-Light' (which is your true Self) opens its radiant arms and wings and embraces you. You are now at one with your eternal Self. In this exalted state all is known, understood and accepted – the purpose of transgression and forgiveness; the need for error, and attainment; the right to make mistakes, and to triumph.

And all the while you are gazing at the *Pargod*, the embroidered veil which separates the Sanctuary from the Holy-of-Holies. Each thread of this curtain is a human destiny – from its first emergence from the Light, until the final day of 'Be-with-Us'. You remember all the people whom you represent, and to whom you are bound at the deepest level. Some are ignorant of their destiny as yet, in some the light is kindled but not yet strong, and a few (like Balkis or Solomon) are souls of millions-of-years in whom the Light is radiant. But all are moving to make the perfect design of the Creator. To form the great crystal cup, in which God shall behold God. Thus, holding all beings in your mind, you part the veil... and pass into *Atziluth,* into the Divine!

Black ceiling, walls, and floor – all is dark. Only the gold Ark relieves the thick darkness. The Holy-of-Holies is a perfect cube and at its center rests the Ark, formed of gold, and covered by the outstretched wings of the Cherubim. Standing before the Ark, you whisper the secret Name of God: **'Eheyeh'**[15]... and are transported. You are nowhere and everywhere, floating in boundless No-thing.

Then, you hear, softly at first, then growing until it seems to fill all existence, the endless mantra of the angels:

Qadosh, Qadosh, Qadosh Adonai-Tzabaoth...
Qadosh, Qadosh, Qadosh Adonai-Tzabaoth...
Qadosh, Qadosh...

All about you is that song of the Four Holy Creatures, their praise, which is the heartbeat of the universe.

Now, the All-Seeing Eye opens – its pupil a starry nebula – and

it regards you with a love that permeates every atom of your being. It thrills through you till you feel you are about to ignite, to burst forth into a new form of being, into a splendor beyond comprehension. A light shines from the Divine Eye and descends upon you, draws you in, and... you are with God.

What is said and given is for you alone. Allow it to pour into you... heal you... and fill you to overflowing. Rest... be loved... love – for a thousand years are but a moment in that Presence.

[pause]

Somehow you have moved without moving. Somehow your innermost being has shifted from perfection to something not quite perfect. And as your vision adjusts, it reveals that you are riding through the dimensions upon the back of the Great Eagle. The head of the bird is blazing white, and its outstretched wings are sapphire blue. The eagle carries you back from the Endless Day of eternity, back for a little while into time and space.

And when the eyes of your soul open, your hands are resting on the Mercy Seat of the Ark in the Holy-of-Holies, and you are full of light. Your aura is incandescent – for you have been with the Creator – you have been invested with the power to make things whole. A voice calls you from behind: **'Zadok'**, and you step back through the veil, until the embroidered curtain falls in front of your face again, concealing the *Sanctum-Sanctorum*.

From the gold table you take some *Manna* (the Bread of Angels) and eat of the presence-bread. And then, escorted by the Angels of the Presence, you go to the entrance, to the courts of the people. As you emerge into the sight of the Children of Israel, your aura outstretches like wings of glory, and the letters of the Holy Name burn like fire in your mind's eye. A sigh of awe escapes from a thousand throats, because you stand before them as a *Baal-Shem* – a 'Master of the Holy Name' – and they bow like wheat before the wind.

You raise your hands in blessing. And through you pours the benediction of the Most Holy ONE. That grace spreads like a great fan

encompassing all assembled, and it also pours on the buildings, the rocks, the trees and the holy mountain itself. Green colored Nature-spirits gather and bath in this supernal Light, and the Deva of Mount Zion itself shines like a star. Because for this moment in time, *Malkuth* is fully realized as the Kingdom of the Crown – and the light within every living thing shines out in response as the *Shekinah* (the glory of Adonai) fills the Earth. For a moment, *Kallah,* the Bride, enters into the embrace of her Lord.

You begin to withdraw from this mind-meld with Zadok, returning to your familiar body, feeling its warmth and weight... but just before you return to normal awareness, you hear the mental voice of Zadok proclaim:

> **Hear ye peoples of this world.**
> **The One Reality is our God.**
> **'I Am' is ONE.**
> **In at-one-ment let us live.**

Because of free will, only humanity can choose to consciously love, serve, and unite with the Divine. The Qabalah teaches that when all human-kind has done this, then The ONE-in-All will shine out from every human heart. And the Earth shall be filled with the Glory of God, as the waters cover the sea, each 'wave' of individual consciousness mirroring the Fire of Illumination – an ocean ablaze with Love.

May it be so!

APPENDIX II

THE DARK MIRROR

In your reading about angels, you may have come across, what is called 'Enochian Magick'.[1] The Enochian system is *not,* and has *never* been, a part of the Sacred Angelic Magic. Enochian Magick is a 'twilight' system, that makes claims to calling angels, but it actually summons unclean spirits. Here is its history.

It began with a brilliant man called Dr. John Dee (1527–1609). John Dee was a noted mathematician, astronomer, geographer, and astrologer. He was a consultant to Queen Elizabeth i, and a leading intellectual light in Elizabethan England. And Dee was also an occultist who devoted much of his time to practicing Renaissance magic.

Dr. John Dee grew increasingly dissatisfied with his attempts to learn the secrets of the Universe. He was a great intellectual, but had no psychic ability. So, he tried to gain more knowledge through the use of a 'scryer' (a crystal-gazer) who could act as an intermediary between Dee and the Invisible. His first attempts were not satisfactory, but in 1582 he met a man called Edward Kelly.

Kelly was a convicted criminal: his ears had been cut off as punishment for forgery. He was, what nowadays we would call a 'conman'. Edward Kelly was a spirit-medium, a psychic. This reveals a very important fact – that psychism and spirituality are *not* the same thing at all. Since all psychic impressions come through the subconscious mind of the person sensitized to them, it is vitally important that the person receiving them has integrity – honesty. If a person is untrustworthy on the material level, how can what they psychically 'receive' be trusted?

Dee and Kelly were a fatal combination: a magical practitioner who was hungry for knowledge (but had little interior development), and a natural psychic who had no moral fiber. Of the two, it was Dee who really fell into the trap (Kelly was already in it). Dee had developed a 'lust for higher knowledge' – in the same way that some researchers

in science sacrifice their integrity – he convinced himself that the end justified the means.

Dee, through Kelly's mediumship, came to believe that they were in touch with heavenly angels. They believed that they were being taught the 'language of the angels', the language of Enoch – which is why it became known as the 'Enochian' system. They became so wrapped up in this, that Kelly would spend nearly 10 hours a day in trance. They received an entire language and talismans. Modern scholars have examined this Enochian language and have said that it is a 'genuine language'– in the sense that it has all that a functioning language needs: vocabulary, syntax, and grammar. Their conclusion was that the 'Enochian language' is too complex for someone to 'invent' without spending years on it.

From these facts, please understand that I am not saying that Kelly was a fake medium. What I am stressing is, that it was a matter of 'like-calling-to-like'. Kelly was an immoral character, and so psychically he attracted entities of similar vibrations. You cannot get clean water from a dirty pipe! Edward Kelly was a con-man, who was incidentally psychic, and he attracted, and communed with, lying spirits. He used as his 'lens' for communicating with the spirits, an obsidian mirror from the New World. This black mirror had been a tool of the Aztec priests of Tezcatlipoca (the 'Smoking Mirror'), who used blood and pain to gain visions. This mirror can still be seen at the British Museum in London, UK.

But, John Dee was so fascinated by the 'information' that Kelly was bringing through, that he stopped exercising any discernment. He justified it to himself that he would use it one day 'to help mankind'. And he forgot that this kind of work has a 'handle with care' label on it. Lying or evil spirits can and do impersonate other beings, even pretending to be Angels of Light. Just because an entity looks radiant, beautiful and has wings, it does not automatically mean that the being is 'of God'.

Consider, have you never met a beautiful, well-dressed person, who had wicked intentions? Have you never watched some lawyers, insurance-salesman, fashion-dolls or actors? Should you give your

well-being over to a complete stranger, just because they look good? Should you compromise your sanity by allowing any entity into your mind? Remember, *'the road to hell is paved with good intentions'.*

And Dr. John Dee was a 'big catch' for the Dark powers – and sadly he was caught in its coils. In the end, the lying spirits (whom Dee thought were angels) deluded him into taking false messages to the political heads of Europe, into wife-swapping, and in bogus alchemical operations that landed both Dee and Kelly in prison.

In 1597 Edward Kelly died while trying to escape from the castle of a European prince whom he had swindled. Kelly died as he had lived, a tool of malignant forces. And Dee returned to his homeland a broken man. Back in England, the other White magicians spurned Dee, he was tainted and they knew it. Once, Dee had been an advisor to the royal court – but now his career was finished. No one would have anything more to do with him. And finally, Dr. John Dee – a former scholar, magician and landowner – died penniless and alone; all because he had been seduced by 'lust for knowledge' and had become an unwitting tool of darkness.

The magical method of Dee and Kelly still survives. It is known as the *'Enochian System of Angel Magick'*; there are quite a few books on it. Many sorcerers favor it. The Enochian system was also used by the *Order of the Golden Dawn*, which gives it a certain kudos. But, it is an unclean system that uses tainted energies.

The most respected teachers of our times have all condemned Enochian Magick, they strongly discouraged their pupils from ever touching it. Those teachers include Paul Foster Case, Dion Fortune and W.E. Butler. And I support that view, because, in thirty years of esoteric work I have not seen *any* good come out of Enochian Magick. And it is because of Enochian Magick that some people have fallen into the slime-pits of hell.

The following meditation is a way of keeping aligned with The ONE, and of maintaining your spiritual integrity. It can also be used as a purification if you feel you have been polluted by some event or person.

PRACTICE 10
Taking Sanctuary in the Light

Enter your sacred place, relax, calm yourself... and focus on the Divine Indwelling within your Heart-of-Hearts. Ascend through the levels of your being – from the elemental and vegetable levels of your body... from the animal levels of your ego, and transcend them all. And simply be aware of being aware.

The eyes of your soul open... and you are encompassed by great Shining Ones, the holy angels – radiant as the first dawn, and sweet beyond all perishing. Their presence stimulates your vibration, raising you to a higher frequency... and you find yourself in a courtyard before a magnificent palace. And from inside you can hear singing, high piercing notes like stars, or crystal bells of ice.

Now you see people entering the palace, men and women clad in garments of light, and they are winged like angels! For these humans – members of our own species – have evolved to the level of angels, and some even beyond that. In the place that lies beyond, angels and humans give worship to The ONE; for they have come to know that ONE to be the Inmost center of all... and that it is All-loving limitless Light.

Now two great angels come – one bright as the sun and the other luminous as the Moon. The Archangels Michael and Gabriel flank the entrance to the palace, arching their wings over it, to form an arch: they have opened a portal of light into the holy place... and now they beckon for you to enter therein.

As you move forward those angels with whom you have auspicious connections come to attend you – angels of your Sun and Moon signs, angels of your vocation and your calling, and those celestials with whom you have made links through working the Magic of Light. Together with these bright spirits you enter into the Palace of Grace.

You step inside... it is a vast plane, an entire realm of light in which throng countless radiant beings. Beings of all evolutions in whom the Divine has become self-manifest, and through their prism-like trans-

parency the Limitless Light streams most gloriously.

In the center of the palace is a great Throne of living amber, beneath it cosmic thunder sounds, and from it universal lightning flashes forth. From one side of the Throne cascades a torrent of spiritual fire and from the other side living water pours down – for this is the point from which all flows forth – and to which all returns. And upon that Throne sits the dazzling figure of the Most Holy. The ONE Who caused all things to come into being, and Who delights in all. The rainbow radiance of The ONE upon the Throne, the sound of the thunder and the sound of the many waters has you in awe.

And yet through it all, a Voice from the Heart-of-all-things speaks to you: **'My child, look upon Me.'**

Hesitatingly you raise your eyes to the footstool of the radiant throne... to the perfect feet, and the hem of the snow-white robe... up to the belt of seven stars... up to the sacred heart that is continually ablaze with love for all... and then up to the face... that is your own face!

You give worship before this mystery of Yourself-made-perfect-in-God. You offer all aspects of your being, so that one day this spiritual reality may become embodied – and bless the Earth. And before this mystery you put your face to the ground, as your soul swoons into No-thing.

When you come to, you are outside the Palace of Grace, back in the court. The Archangels Michael and Gabriel close the portal... and from this angelic level you descend back into physical awareness – recognizing the animal, vegetable, and the mineral levels. And now you know that these are rungs on one great ladder – by which the angels descend and ascend the Worlds.

Memorize this sacred invocation and use it whenever you want or need to:

> **Holy, Holy, Holy ONE,**
> **Source of cosmic might,**
> **Send Thy hosts of angels**
> **To keep us in Thy Light.**
> **Amen.**

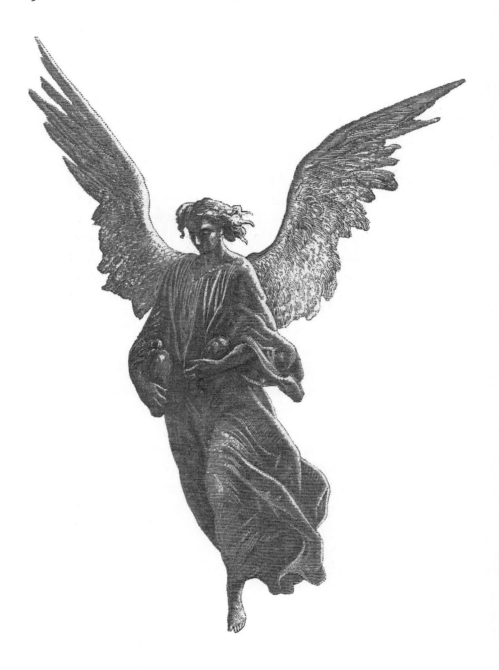

Illustration by Gustave Doré

APPENDIX III

PERSONAL ACCOUNTS OF ANGEL WONDERS

Since *'Sacred Magic of the Angels'* was first published, I have had many hundreds of letters, emails, and face-to-face conversations with people who have used this system to good result. Of course, there are far too many to include here. So I have chosen a variety of stories to illustrate this. And there has been some bad feedback – two, in fact. But I have included them too, since they are good examples of what *not* to do. I hope that these accounts will give you confidence in the material in this book – and encourage you to bring the angels into your life.

 I Gabriel healing

Sara's son had been born with a disease that left him partially blind. Then later, he was diagnosed with a fatal brain tumor. Sara writes:

> *I bought your book in Spanish, I am from Mexico… I did the petition from your book to Gabriel Archangel. I received the omens. Then in his ultrasound my son's tumor was gone. The Archangel Gabriel made a miracle for us!*

When the doctor came to see Sara after the ultrasound, he looked perplexed. He was looking around as if he had lost something… then he said: *'I don't know how. And I can't explain it, because it doesn't make any medical sense, but… but your son's tumor is gone without a trace!'*

Sara, Spain

 2 Walking again

The vertebrae of Bob's lower spine were crushed in a motor accident. The doctors said that if he was not bedridden, he would certainly at least be confined to a wheel-chair for life. With Bob's permission I wrote a petition to the Archangel Michael on his behalf.

Six months later, Bob proudly walked his daughter down the aisle at her wedding. Even the hospital staff called his case, *'unheard of – miraculous!'*

3 Transformation

I must say that the 'Sacred Magic of the Angels' is the book of my life, because all the domains of my life have changed since the moment I begun to work with angels the way David teaches there. I read many books about angels, but no one presents effective teachings like this one does.

I have daily stories to tell, because angels are always near me, I can feel them in insights, in synchronicity, in the answers they give me everytime I ask for advice or help, in the moments I know what to do because it is the way angels do. Two days ago, when I arrived from a short period of holiday, I remarked that in a pot of green plants was a white flower. I have that pot with that plants for more than 20 years and it never flourished before. I recognized there an answer from Archangel Gabriel to a request I have made. But as I said before, this kind of 'miracles' happens so often that my life have changed in a way that made me able to handle my problems, accepting them in a positive way, and above all, I am able to help others when they need comfort.

Now, I see myself as a spiritual person and I can understand my life's purpose, accept it and be prepared to be of service. If God put angels on my way to direct me, I feel that I must thank Him, by acting like an angel to the others. The moment I discovered that, I have discovered happiness. And I must thank you so much, David, for having shared with me the knowledge who leads me to feel in Heaven, while being on Earth.

Manuela, Portugal

☼ **4** **Samael transforms a life**

This young man's account speaks for itself:

> When I first discovered the 'Sacred Magic of the Angels' my body was rapidly deteriorating... I later learned that my immune system was rejecting a polyester mesh that had been used, five years earlier, to surgically repair reoccurring hernias along the midline of my abdominal wall. My only diet was one of exclusively raw milk. I had gone to several leading doctors, including the hospitals of Stanford University and the Mayo Clinic... Even to the most skilled surgeon removal of the mesh was unthinkable because of the way tissues from surrounding organs had grown into it.
>
> At the most desperate point of this crisis after numerous tests and medical dead-ends I met David and he introduced me to the forgotten ancient ways of angelic assistance. I was too sick to do so the petition, so he did it for me. First he invoked Archangel Raphael during an Easter retreat for my recovery. Within just a couple of weeks, one of the only doctors in the country that recognizes the harmfulness of meshes (and is leading a federal investigation on the matter), agreed to have mine removed. Normally the waitlist is 2-3 months, but they had an unusual opening and I was able to get scheduled in just 2 weeks. Right before my surgery David petitioned Angel Samael on my behalf – the angel who guides a physician's hand during surgery. The following week I received two omens of positive affirmation from Angel Samael.
>
> Despite the possible risks and dangers of such an operation, both before and after the surgery I was filled with a glowing confidence and peace about the outcome – 'blessed assurance' as the old hymn goes. The two and a half hour surgery was an ordeal for the bodhisattva-like doctor but it was completely successful and occurred without incident. I am told that when he came out of the operating room he had an 'other-worldly' look about him and it took several seconds for him to regain his professional composure. Despite the pain of surgery I felt immediate relief. After recovering from the wounds of surgery I started to gain my life back – my normal energy levels returned, the abdominal pain left, I was able to eat

solid food and work and exercise and travel and concentrate in ways I hadn't been able to in years. Completely opposite to the way I felt before surgery now, 20 months later, I am full of life and my vitality increases weekly. With this experience has emerged the increasing awareness of the presence of celestial helpers who are waiting for permission from us to help in a very direct and practical way to bring more light and healing and peace into our physical bodies and our world.

And there's an interesting footnote to Jim's experience:

There is more. This kind of surgery and the weeklong hospital stay was very expensive. Because I had been unable to work due to illness and had undergone countless tests and doctor visits my accounts were drained and I was unable to pay my bill. I had maxed out the financial generosity of friends and family. My debt was sent to a collection agency, which gave me a grace period of small payments before ruining my credit and taking more serious action. After trying to negotiate and exhaust every alternative I did a Qabalistic ceremony to Angel Sachiel.' Two weeks later I called the collection agency to once again try and lower my payments. Much to my bewilderment, they told me I had an outstanding balance of zero and that my debt had been paid in full with the previous month's payment. They could not explain how this happened. I still owed nearly $6,000, so I called the hospital to confirm, and they said the same thing: the remaining debt on my account was zero – without any explanation. I gave thanks to Angel Sachiel and all the invisible mediators of grace. It seemed like all my human efforts were matched by the angels on the celestial plane and then they would up the ante even beyond what I had imagined. The old saying 'If you take one step toward God then God takes one thousand steps toward you' is extra true when the angels are included.

Jim, USA

5 Gabriel & the kids

A wife, who was deserted by her husband, had been left with young children and many debts. They lived in a cramped basement flat. The children wanted bunk-beds for their bedroom so that they would have more room to play in.

I turned it into a game, and showed them how to petition Archangel Gabriel. The children loved drawing the flowing lines of the Theban script. Omens were forthcoming. And in less than a month, they had been given six sets of bunk-beds!

6 Mother & grandmother

First, when I was 15 and start to work with Archangel Raphael as taught in the book, because my grandmother had a very serious health problem and was in danger of dying. She improved very quickly after the ceremony. And my mother had a terrible pain in back – but I didn't know the angel to call. Then for help in another matter, my mother and I did an invocation of Angel Michael.

Minutes later my mother's pain stopped completely. Later that same day I was reading your book, when I read that is was Michael who heals back and spine problems!

I have more stories.

Pedro, Portugal

7 Light in the shadows

On my first visit to South Africa I led a weekend workshop on sacred ceremony. During the weekend, a man confided in me that he was preparing to do a ritual of black magic which included blood sacrifice. When I asked him why, he told that his business had been ruined, and he was bankrupt. He was so desperate, that he was willing to make a pact with the power of darkness, if that would save his family from becoming destitute.

I showed him how to make an angelic petition. He did, and then got omens. He later wrote:

The Sacred Magic of the Angels saved my soul!

Felix, South Africa

 8 My meaningful work

I have worked with the Sacred Magic of the Angels system for some years now, and it has been a wonderful journey of personal growth and deepening connection to the Divine. I am still in complete awe that answers to our heartfelt petitions come through in such diverse and beautiful ways. I recently did a petition for 'a fulfilling and well-paid job', and received plentiful omens in response. Three months later I am now a part of a visionary company that fits my value system more completely than I ever could imagine. It is a place where I can make a contribution of significance to the world, and this is only the beginning of my journey with them!

I have learned from previous petitions that the cooperative nature of the Sacred Angelic system means that my efforts are not wasted, that if something is Willed from Above I can immerse myself in working toward its realization. Because I know that The One through the agency of the Archangels is guiding me in the right direction.

The system has also introduced me to the wonder of the interconnected, benevolent, living Universe in ways that I cannot describe of because that interior experience has been beyond mere words. I am deeply, deeply grateful. Grateful that through the Divine Will beings beyond time itself come to assist us in our struggles and pain, that our prayers are heard upon high, that we are never, ever alone. I am also deeply grateful to you, David and the Rising Phoenix Foundation, through whose agency such essential and life-transforming knowledge like the Sacred Angelic system is made accessible.

Jono, South Africa

9 Debts

I have had some interesting successes using the Banishing Square and Invoking Tablet of the Moon. I had a debt problem that was resolved in a completely unexpected way. It taught me to be very open as to how a petition will be answered.

Sue, USA

10 Elijah's Jeep?

There is a spiritual community in the USA, who are not well off by many people's standards, but who are rich in the things of the Spirit. And they use the *Sacred Magic of the Angels* to meet all their needs. In fact, each member of the community has their own copy. They have had many experiences of the angels helping them. Here is one example that always makes me smile – I frequently use it at seminars and lectures.

The community's truck 'died'. But they had enough experience of angelic aid not to despair (in fact they kidded with one another: '*I wonder how the angels are going to sort this one?*'). So they petitioned for a new good truck. Notice, they didn't petition for money to buy a truck; they did the right thing and asked for the need itself to be answered. They received omens. Soon after, a member of the community went to do the monthly shop to the local supermarket. Crossing the threshold, he was met by the store's manager, who beamed at him saying: '*Congratulations, you're our one-millionth customer, and here's your prize!*' He then handed over the keys to a gleaming brand new Cherokee 4-wheel-drive truck. Yee-ha!

11 Sachiel on the job

His employers moved this man's partner to another state. It seemed that there was no way that they could live together. But then Ted petitioned Angel Sachiel, and…

About six years ago I performed the ritual. I adhered to all of the details, including the proper day of the week, Thursday, in this case.

According to David's text, there are indicators in the days following the ritual (omens). A bee would have been the one in my case and, in fact, a bee did show up in a very prominent way. It is remarkable, though, that within days of performing the ritual, the very thing being sought (a position in my niche profession) was presented in its most ideal form, at the most ideal institution, without any effort or searching on my part!

Attending a luncheon meeting, I walked into the room and was promptly told by one of the hosts that her institution had for

several months been looking for employee with my title and credent-
ials to fill an empty spot. She asked me to please consider sharing my
resume. I did and was hired one week later.

Ted, USA

12 A green apple on the Tree of Life

A woman wrote to me because she had followed the instructions in
my book, but she had not got a single omen. Concerned, I replied,
asking her to confide her request, in case she had made some error.

She replied:

I am in love with a man, and I want him very much because I know
that we would be perfect together.

On a Friday I petitioned Anael for the man to fall in love with
me. On the next day, Saturday [notice she didn't wait for omens-
of-consent], *I wrote to Uriel, for the man to divorce his wife.* [still no
waiting for consent] *and on the day after that, Sunday, I petitioned*
Archangel Michael to make the man marry me. And nothing!

I suggested that she should read what was written about trusting
the universe to bring the right person. And I told her that I could not
help her with this – she then told me that I was a fraud, charlatan and
bogus. Oh well.

13 The rose of love

I had been single and lonely for some years. Eventually I reached the
point where I was ready to love so I made a petition to Angel Anael.
Strong omens came in abundance and so I waited. When the time-
span was nearly up, somebody who I had been keen on for some time
let me know that they were keen on me too – but there were many
complications.

But the omens following gave me the courage to fearlessly reach
out. It may not sound that amazing written down but it did change
my life and sent me in a new direction.

My home, partner, work, vehicles and tools have all mostly
come to me from making petitions to the angels.

Alex, UK

14 Against all odds

What we wanted seemed impossible and everyone was quick to tell us. We wanted to sell our 160 acre retreat center so that we could be in a more accessible place for service. It was during the middle of the housing crisis with the least amount of buyers ever. It was during the middle of the economic collapse in which no one was spending money and the banks weren't giving out loans. Our property was surrounded by a black, charred and burned-out forest, and was in an extremely remote location which – the real estate agents said – would make it undesirable for buyers because of the soaring cost of gas. And we needed almost the full asking price.

After nearly one year of having it on the market we didn't have a single showing of the property. During that time we learned of the 'Sacred Magic of the Angels' and were surprised to discover how it could be called upon for even the most practical circumstance like selling real estate. We began to perform the ritual of Jupiter associated with Angel Sachiel... and made offerings to the Devas and guardians of the land invoking the blessings of The ONE upon them. After doing the ritual three times we had our first showing in the dead of one of the coldest, wettest winters on record. The potential buyers wanted it immediately, fell in love with it and made an offer. They had plans to create a retirement care facility but their funding fell through and they could not find other resources. After four months there was a second showing. This buyer also fell instantly in love with the property, and couldn't live without it – even though he saw it on one of the stormiest winter rains of the season. He wanted to build a non-profit place of retreat for healers and people involved in service 'to come and recharge their batteries'. It was a perfect match. By the fifth moon he made a cash offer for the full price of what we needed. And by the sixth moon we closed on the deal. We were overwhelmed with gratitude to the one Source of all, and deeply thankful to David and Benjamin for mercifully reintroducing this lost Art to our generation in these dark and difficult times.

John, USA

 15 Eleventh-hour wonder

The landlord had sold the building that I was living in, and I still hadn't yet found a new home. So, I petitioned Archangel Uriel on a Saturday morning for an 11th hour miracle for a new (and affordable!) home. The same afternoon I saw a huge double rainbow, so I knew my petition was answered. Two days later, I found an advert for a flat – twice the size and at half of the rent that I had been paying. I phoned and the woman who placed the advert said she had just walked through the door. Apparently there were lots of messages from prospective tenants on the answering-machine, but since I happened to catch her (and 'we clicked' over the phone), she offered to show me the place first. It turned out to be perfect; and I was also able to bring in a dear friend to live with me, who had also been in need of a home.

Catharine, USA

 16 Help & protection

I have used the Shield of the Warrior-Angel a few times. Once to protect me from my landlord who was a sociopath and a slum-lord. The house ended up going into foreclosure and a new very nice person bought it. Whenever I would use the Shield my landlord seemed to not bother me for long periods of time. I also used an angelic petition in regards to an offer my roommate put on a house. We were almost at the end of the lease, but my roommate did get the house.

Bonnie, USA

17 What I failed to include...

A few years ago a man wrote to me from the Congo in Africa. He was very disappointed with my book because I had not included some information that it was essential for him to have: the Words-of-Power that would force the angels to obey his commands!

18 Last minute protection

In the days before the book was first published, a man consulted me for help. He had to go to Lebanon because of a family matter, but the country was a powder-keg at the time. I made an Angel Lumiel Protection Square for him to carry in his wallet.

Months later he came to see me again. While he was in Lebanon war had erupted. Anyone who could, tried to flee the country. The international airport was chaos. But he did get onto the very last flight out of there, before it was attacked by the military. He saw the tanks firing on the terminal buildings from his plane in the air – just after take-off.

19 Gentle reminder

I have used the petitions a number of times with success. Once I petitioned Angel Anael to assist in reconciling a very difficult relationship situation. The angel responded with an omen of 'a wind fall of apples'. And sure enough, I kept running into the person concerned in the most unlikely places.

But due to the stress of the situation, I forgot to burn the petition after the alloted number of days, and eventually was shown an apple with a bite out of it. This was a gentle and humorous reminder that the deal was to be met and it was time for me to finish the process.

Lee, USA

20 Ongoing communion

These practices have become an integral part of my spiritual life and have deepened my ongoing communion with the Angelic Kingdom.

Pam, USA

NOTES

PREFACE

1 To learn more visit *www.sacredmagicoftheangels.com/trainer*

CHAPTER 1 IN THE BEGINNING

1 St. Thomas Aquinas, *Summa Theologica*
2 These primary lines of force are sometimes called the
 Rings-Pass-Not, or the Cube of Space.
3 Charles Williams, *The Place of the Lion*,
 (Grand Rapids, MI: Eerdmans, n.d.)
4 William Blake, 'The Tygre', in *Blake: Complete Writings*,
 edited by Geoffrey Keynes,
 (London: Oxford University Press, 1966), lines 3-4
5 Also called the Seven Interior Stars
6 Samuel Taylor Coleridge, *Biographia Literaria*,
 edited by George Watson (Boston: C.E. Tuttle, 1993), p. 167
7 2 Corinthians 12:2
8 *Rakiyah* – the Palace of Serenity
9 *Shehakim* – the Heaven of Sincere Service
10 And Dionysius' *Mystical Theology* is probably the most profound
 Western exposition of the Absolute – comparable to the teachings of
 Nagarjuna on *Shunyata*.

CHAPTER 2 THE ANGELS OF LIGHT

1 Hebrews 1:7
2 The 'time-orbit' of an angel is the maximum amount of time it takes
 for that angel to bring about the results for what has been petitioned.
 Archangel Michael's time-orbit is one year, but I have known him to

bring results eight days after invoking him, and up to 360 later. The time-orbit means that some time *within* that allotted span of time the result *will* manifest.

3 Tzadkiel and the Chasmalim are the angels of *Chesed*, the fourth Sphere on the Qabalistic Tree of Life.

4 This is just one way of phrasing your petition.

5 See Appendix 1

6 See Appendix 1

7 A trilithon is a structure consisting of two large vertical stones, supporting a third stone set horizontally across the top (lintel). The most famous ones are those of Stonehenge in England and those in the Megalithic temples of Malta. From the Greek: 'having three stones'.

8 Grace (Hebrew: *Mezla*)

9 The *Menorah* from Solomon's Temple

CHAPTER 3 MOON MAGIC

1 Sufi Ruzenbehan Baqli

2 Dion Fortune, *The Sea Priestess*,
 (York Beach, ME: Samuel Weiser, 1978)

3 *Clavicula Solominis, The Key of King Solomon the King*,
 translated and edited by S.L. MacGregor-Mathers,
 (York Beach, ME: Samuel Weiser, 1972; London: RKP, 1972)

4 A hidden tradition is that these mysteries of the Archangel Gabriel may be used to invoke those angels whose mysteries and rites are unknown or doubtful; for example, Archangel Asariel of Neptune.

CHAPTER 4 ANGELIC HEALING

1 Malachi 4:2

2 This invocation can be used at any sickbed.

3 See *The Authorized Daily Prayer Book of the United Hebrew Congregations of the British Commonwealth of Nations* (London, 1962)

4 Qabalah teaches that there are Seven Heavens, from *Vilon* up to *Araboth*.

5 Tzaphkiel is the archangel of Binah on the Tree of Life. His name means the 'Contemplation of God'.

6 As an example: Stalin faced death with great terror.

7 For more understanding about helping the newly dead, I highly recommend *'Testimony of Light'* by Helen Greaves.

CHAPTER 5 BY THEIR SIGNS YE SHALL KNOW THEM

1 Psalm 91

2 *Ratzon Kether* = the Divine Will

3 *Occult* literally means 'hidden'.

4 A symbol or figure with occult significance.

5 'Please' is spelt as 'plez', 'flight' as 'phlite', and 'archangel' as 'arkanjel', etc.

6 A similar discipline is used by monks and nuns when doing the daily prayers alone (not collectively); they speak the prayers 'on the breath', forming the words inaudibly with their lips.

7 The concept of correspondences goes back to ancient times. A table of correspondences is a list of concepts, beings and/or items that share a mystical connection, or are interconnected through their sphere of influence, or their energy. If used appropriately, they enhance each other, and therefore the magical work in which they are applied.

8 On a Wednesday, with yellow paper and black ink, put Raphael's callsigns along the top, and then address the petition thus:
'To Angel Cassiel of Saturn, through Archangel Raphael, may... etc.'

CHAPTER 6 THE ANGELS OF NATURE

1 A Qabalistic saying

2 This was the dawn of a new 'Day of Brahma', when *'the morning stars sang together and all the sons of God shouted for joy'*.

3 In ancient Egypt the Earth was the god Geb, and he was the consort of Nuit, the Star goddess.

4 Malkuth is the tenth Sphere of the Tree of Life.

5 Sandalphon is also known as the 'Prince of Prayer'.

6 Netzach (meaning 'Victory') is the seventh Sphere on the Tree of Life.
7 Peter Valentine Timlett, *The Twilight of the Serpent*
 (London: Corgi Books, 1977), p. 160.
8 *Prana* or *chi* is the Universal Radiant Energy.
9 From *The Immortal Hour* by Fiona Macleod
10 The Hermetic tradition calls the center of the planet the 'Laboratory of
 the Holy Spirit'.
11 See Geoffrey Hodson's magnificent book *Kingdom of the Gods*
 (Adyar, India, Theosophical Publishing House, 1955) for pictures of
 Devas based on Reverend Hodson's seership
12 Reverend G. Vale Owen, The Battalions of Heaven
 (London: Greater World Association, 1959), pp. 151 – 152.

CHAPTER 7 THE TALISMANS OF POWER

1 Psalm 63:7
2 *Shaddai-El-Chai* is the Divine name of Yesod, the ninth Sphere of the
 Qabalistic Tree of Life.
3 This talisman also appears in *The Greater Key of Solomon*,
 a very misunderstood medieval book.
4 The numbers in this square refer to certain Tarot cards:
 9 ='The Hermit', 1 ='The Magician', 7 ='The Chariot', 6 ='The Lovers',
 3 ='The Empress', 4 ='The Emperor', and 5 ='The Hierophant'.
 This magic could be woven with the cards alone, but that is too
 advanced at this stage.
5 In other words, the Spirit of the Law, not legal manipulations
6 This seal also appears in *The Greater Key of Solomon*. The Hebrew is
 the seventh verse of Psalm 113.
7 Coins like a gold sovereign, or a gold dollar, are excellent magical
 lenses for financial workings for prosperity and abundance.
8 There have been some claims that Angel Lumiel is really Lucifer –
 but impure sorcerers put this around. In 30 years of working with
 this system, I have seen nothing but good results emanate from the
 Square of Lumiel.
9 Symbol of the Physical body

10 Symbol of the Etheric body

11 Symbol of the Mind

12 Symbol of the Soul

13 Symbol of overall well-being

14 Yetzirah, the realm of the angels

CHAPTER 8 ANGELS IN OUR LIVES

1 From the hymn *'Lead Kindly Light'*, written by Blessed John Henry Newman

2 *Daniel*, chapter 10: verses 13-21

3 Tolkien uses this theme in his book *'The Silmarillion'*. The *Ainur*, a group of eternal spirits – who are the offspring of The ONE's thought – make the Great Music, that is the basis of all Creation.

4 *'Mars'* by Holst and *'Flight of the Valkyries'* by Wagner also stir the Seraphim.

5 From the ceremony *Solemn Benediction of the Blessed Sacrament*, of the Apostolic Church of the Risen Christ, 2010

6 *'Then the mind, which is now Christ, communicates unto the angelic hosts in the Holy-of-holies, the spiritual Eucharist, of which the terrestrial is but the type and faint shadow. After this it rises again unto the place where there is no longer vision, to be united unto the Tree of Life, unto the Universal Essence.'* Written by Hierotheos, the teacher of Dionysius the Areopagite

7 The wall of bodhisattvas

8 *Gehenna* – Hell

9 Proverbs 20:27

10 Job 29:3

CHAPTER 9 INTERCESSION

1 *Book of Tobit*, 12:15

2 And before jumping to conclusions – it was a *female* practitioner that the husband was consulting.

3 *The Zohar* was published in 13th century Spain by Moses de Leon.

4 Practice 8, page 178
5 It is more effective if the *'Temple-of-the-Heart'* meditation is part of your regular spiritual practice.
6 The *Kether* of Briah, in the Seventh Heaven

CHAPTER 10 DESTINY

1 A Qabalistic aphorism
2 From *'Higher Worlds, Inner Journeys'* by David Goddard, a Rising Phoenix Foundation mentored course (2008)
3 'Enoch' means 'initiated'
4 Some of the others known in the Western tradition are Elijah, Jesus, Sarah-bat-Asher, and Mother Mary. And there are many cases in the East too, who also attained the *Qasshat-Aur-Zelem*: the 'Body of Rainbow Light'.
5 'Metatron' means 'near the Throne'
6 *'When I die I shall be as the angels, and when I die to the angels, what I shall become, you cannot imagine.'* Rumi
7 Hebrews 1:5
8 From a ritual invocation
9 Psalms 46:10
10 Psalms 55:22

APPENDIX I THE TREE OF THE LIVING ONES

1 A Qabalistic aphorism
2 Spelt 'Cabala' in Latin, and 'Kabbalah' in modern Israeli Hebrew
3 The Tree maps out all of the four worlds *(Olhamoth)*: the Divine realm, the Spiritual (archangelic), the Astral (angelic) and the Physical.
4 These 'mystic fruits' are called 'Sephiroth'.
5 The *Chayoth ha'Qodesh*
6 Strictly speaking, the Elohim (mentioned in Chapter 1) are the Seven Archangels of the Sephiroth of Formation, but to avoid confusing the reader, I used the name of some of their 'lieutenants': Angels Cassiel, Sachiel, Samael and Anael. The traditional Elohim are: Tzaphquiel of

Binah, Tzadkiel of Chesed, Khamael of Geburah, Michael of Tiphareth, Haniel of Netzach, Raphael of Hod and Gabriel of Yesod.

7 Hebrew for the planet Saturn

8 *Shekinah* – the Pillar of Fire that unites Below to Above

9 Hebrew for the planet Jupiter

10 Hebrew for the planet Venus

11 'Walking the Worlds' is travelling the Paths and Spheres of the *Tree of Life,* and meeting the archangels in their own realms. This is how a Qabalist forges their personal relationship with the Angelic Hosts. I personally mentor students through these journeys; for more details visit *www.sacredmagicoftheangels.com/higherworlds*

12 For details and dates of the annual *Graceful Gatherings of Angels* go to *www.sacredmagicoftheangels.com/gathering*

13 *Ibbur* – the soul of a Sage

14 The *koshen*

15 *Eheyeh* – 'I Am'

APPENDIX II THE DARK MIRROR

1 Not to be confused with books of falsehood, like the so-called *'Keys of Enoch'.*

APPENDIX III PERSONAL ACCOUNTS OF ANGEL WONDERS

1 He used *The Ceremonial of Jupiter,* which is available from the Rising Phoenix Foundation website.

OTHER COURSES, PROGRAMS & MEDITATIONS

THE SACRED MAGIC FELLOWSHIP

Become a Charter Member to the SACRED MAGIC FELLOWSHIP
14-Day Trail Membership (Only $1)

What's the FELLOWSHIP all about?

Being a member of the sacred magic fellowship means you get to:

◆ Renew and deepen your spiritual connection each month with a new Sacred Angelic meditation... plus, empower your soul with angelic splendor... evolving your sacred relationship with these amazing angelic forces...;

◆ Uncover your Inner-Light, through the power of Personal Invocation with the Angels;

◆ Invite the Angels to be near you — whenever, wherever with New Rituals and Sacred Ceremonies;

◆ Sacred Angelic teachings and lectures from David Goddard himself (it's like having David visit your home);

◆ Tele-seminars with David: From the comfort of your home, you can have your questions answered. Send your questions through your own Private SACRED MAGIC FELLOWSHIP website. And David will answer as many questions about Sacred Magic as we have time for in each call.

◆ Bonus Gift if you join today: A special Blessed Sacred Magic Badge setting you apart as a true and committed light-worker;

◆ Up to the minute information about Angelic events and retreats all across the world — more specifically, in and near *you*. (Plus you get a Fellowship discount when you attend one of David's Angelic events.)

◆ And there are always gifts and bonus giveaways to Charter Members.

Start your 14-day trial for only $1. And see just what the **SACRED MAGIC FELLOWSHIP** is all about.

If the fellowship speaks to your desire to connect with the angelic powers, if working closely with David Goddard — and if continuing to discover more about the angelic realms and its powers strike a cord deep inside you, then the **SACRED MAGIC FELLOWSHIP** is your home.

Learn more about this one-of-a-kind **FELLOWSHIP** dedicated to spreading light across the world and universe.

www.sacredmagicoftheangels.com/fellowship

SACRED ANGELIC MAGIC COURSE

The follow-up course to David Goddard's best selling first edition book 'Sacred Magic of the Angels'.

'Sacred Magic of the Angels' goes even deeper into Sacred Magic.
It shows you more ways you can apply the ancient science of 'Calling the Angels' to help with life's struggles. (This is new material that could not be included in the current publication of Sacred Magic of the Angels.)

In **SACRED ANGELIC MAGIC**, David looks at the *Shining Ones*, the *Language of Angels*. How *Cycles and Seasons* affect magic. The ways in which Life if webbed together. Types of *Sacred Power. Creating Protection and Abundance*. Being in *The Divine Presence*. The true use of *Jewels and Crystals* for magic, and finally, David delves into the mystery of *The Hosts of Light*.

To read more visit *www.sacredmagicoftheangels.com/sam*

MENTORED PROGRAMMES

HIGHER WORLDS – INNER JOURNEYS

Apply today and be personally mentored by David Goddard as you path-work the Tree of Life, just like sages, saints and mystics have done for centuries.

You will be a personal student of David Goddard. As you are guided and shown how to move through the mystical Tree of Life... Begin forging life-long relationships with the inner guides, Archangels and Masters. And visit the Higher Worlds, with its Temples 'made without hands'.

You will require discipline, commitment and a willingness to face your inner-self. But as any 'Walker-between-the-Worlds' will tell you – you cannot find a more fulfilling experience than to Pathwork the Tree of Life. With the guidance and help of a true Spiritual Teacher – David leads you through the mystery, wonder and inspiration hidden behind the veil of the Tree of Life.

> 'This is a wonder-full and unique opportunity – a real investment for your soul. Having studied diverse aspects of Qabalah for several years, I really admire and appreciate the way 'Higher Worlds' combines so many facets of the Mysteries to bring the Tradition to life. Alchemical theory, Tarot symbolism, angelic communication and contact with the Inner Teachers are all seamlessly woven together in an experiential way that deepens one's knowledge of the macrocosm. First-hand encounters with the beings of the Upper Worlds and familiarity with the paths of light helps us to grow into our-Selves and develop our awareness of the more subtle aspects of life in a way that mere intellectual speculation and book-learning could never achieve on their own. Thank you Rising Phoenix Foundation!' RICARDO, UK

To read more and apply to become a 'Walker-between-the-Worlds' visit
www.sacredmagicoftheangels.com/higherworlds

HOW TO MASTER ASTRAL TRAVEL

Imagine stepping out of your body and onto the Astral worlds. Filled with its wonders and amazing places. Travel at the speed of thought. See across time and space as you look into the Akashic records or remotely view places. Connect with Masters and Ascended Sages. This is the most thorough and complete program on Astral Travel – EVER.

*'just ****** brilliant! It contains the ENTIRE Great Work!'*

After you complete Stage 1, David leads you through the Adept's System to Astral Travel.

Discover more at ***www.sacredmagicoftheangels.com/astraltravel***
And apply today...

LOOKING FOR MORE?

Find more courses, programs and meditations by David Goddard, exclusively at ***www.sacredmagicoftheangels.com/shop***

CD TRACKS

1	PRACTICE 1	The Temple of the Angels
2	PRACTICE 2	Circle of the Moon
3	PRACTICE 3	Litany of Raphael the Archangel
4	PRACTICE 4	Rite of Archangel Sandalphon
5	PRACTICE 6	Daily Angelic Ritual
6	PRACTICE 7	The Fount of Mercy
7	PRACTICE 8	Temple of the Heart